759
LOW

# 50 PAINTINGS
## YOU SHOULD KNOW

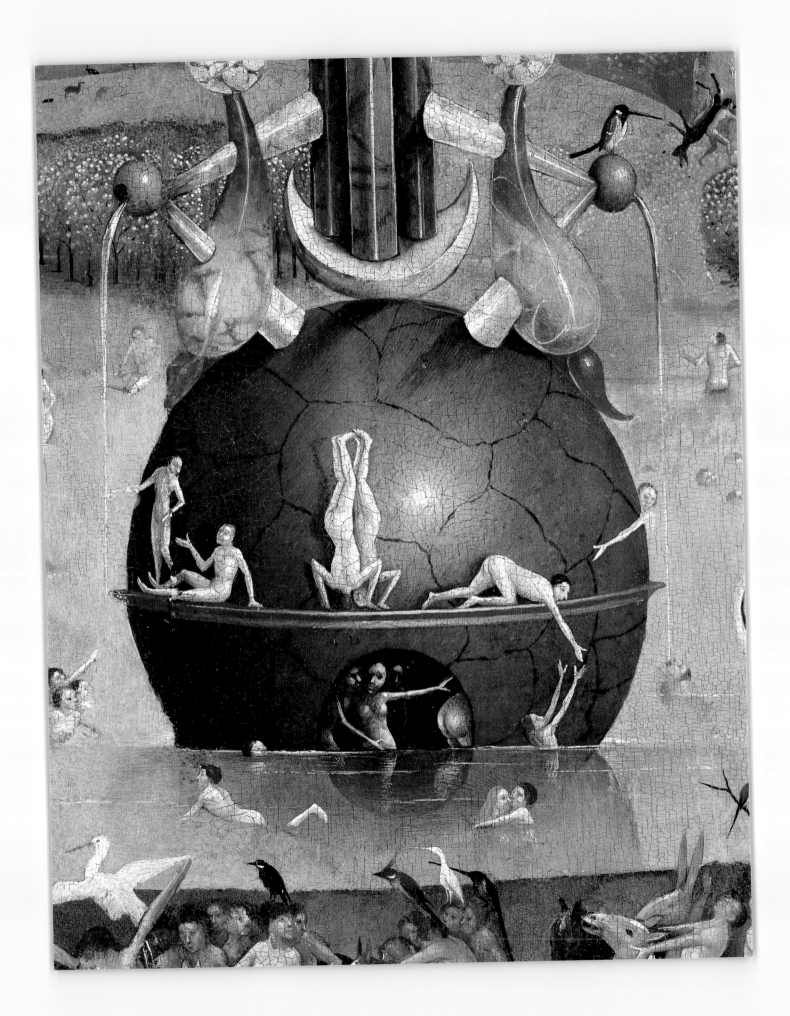

# 50 PAINTINGS
## YOU SHOULD KNOW

Kristina Lowis
Tamsin Pickeral

Prestel

Munich · Berlin · London · New York

Front cover from top to bottom:
Michelangelo, *The Creation of Adam*, see page 4
Edward Hopper, *Nighthawks*, see pages 160–161
Wassily Kandinsky, *Impression III (Concert)*, see page 138
Claude Monet, *Impression–Sunrise*, see page 108
Frontispiece: Hieronymus Bosch, *The Garden of Earthly Delights*, detail, see pages 36, 37
Pages 10–11: Sandro Botticelli, *The Birth of Venus*, detail, see page 28

Prestel Verlag
Königinstraße 9
80539 Munich
Tel. +49 (0) 89 242 908-300
Fax +49 (0) 89 242 908-335

Prestel Publishing Ltd.
4 Bloomsbury Place
London WC1A 2QA
Tel. +44 (0) 20 7323-5004
Fax +44 (0) 20 7636-8004

Prestel Publishing
900 Broadway. Suite 603
New York, N.Y. 10003
Tel. +1 (212) 995-2720
Fax +1 (212) 995-2733

www.prestel.com

The Library of Congress Control Number: 2009921890

British Library Cataloguing-in-Publication Data: a catalogue record for this book is available from the British Library. The Deutsche Bibliothek holds a record of this publication in the Deutsche Nationalbibliografie; detailed bibliographical data can be found under: http://dnb.ddb.de

Project management by Claudia Stäuble
Translated from the German by Paul Aston, Rome
Copy-edited by Chris Murray, Chester
Timeline by Rahel Goldner
Cover and design by LIQUID, Agentur für Gestaltung, Augsburg
Layout and production by zwischenschritt, Rainald Schwarz, Munich
Picture research by Claudia Rayling
Origination by ReproLine Mediateam
Printed and bound by Druckerei Uhl GmbH & Co. KG, Radolfzell

Printed in Germany on acid-free paper

ISBN 978-3-7913-4198-9

# CONTENTS

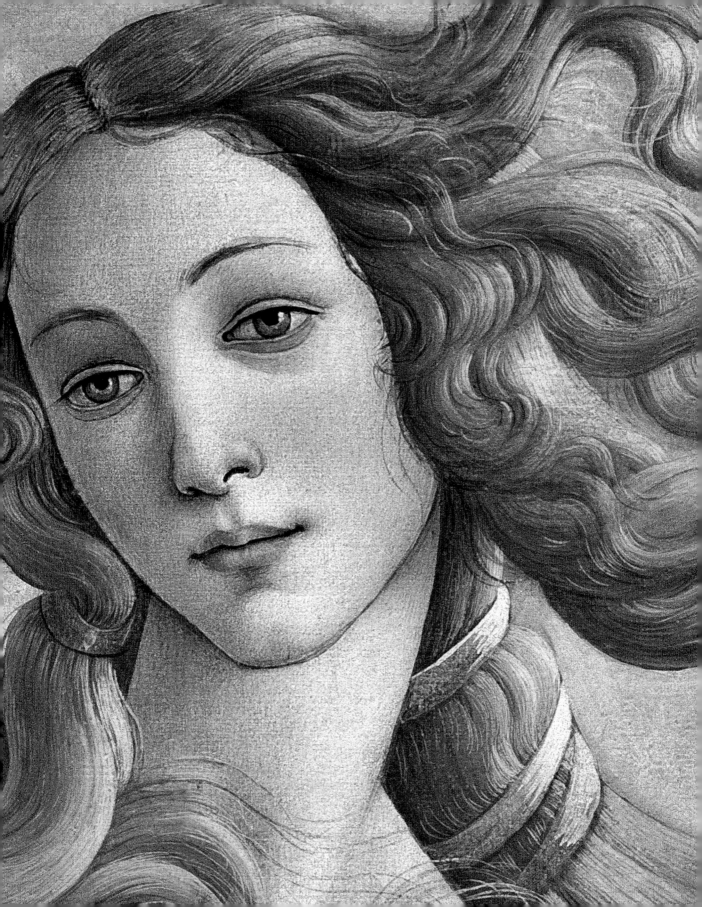

DUCCIO DI BUONINSEGNA

SIMONE MARTINI

**1210** Francis of Assisi founds
the Franciscan order

**1250** Florence gets a democratic
constitution

**1268** Amiens Cathedral completed

**C. 1220–1230** Model book or sketchbook of
master-builder Villard de Honnecourt

**1271** Marco Polo becomes the Great
Khan's governor of Yangzhou

| 1210 | 1215 | 1220 | 1225 | 1230 | 1235 | 1240 | 1245 | 1250 | 1255 | 1260 | 1265 | 1270 | 1275 | 1280 | 1285 | 1290 | 1295 |

Giotto di Bondone, *The Wedding at
Cana* (Scenes from the Life of Mary
and Christ), c. 1303–1306, fresco,
185 x 200 cm, 3rd picture, middle row,
left wall, Arena Chapel, Padua

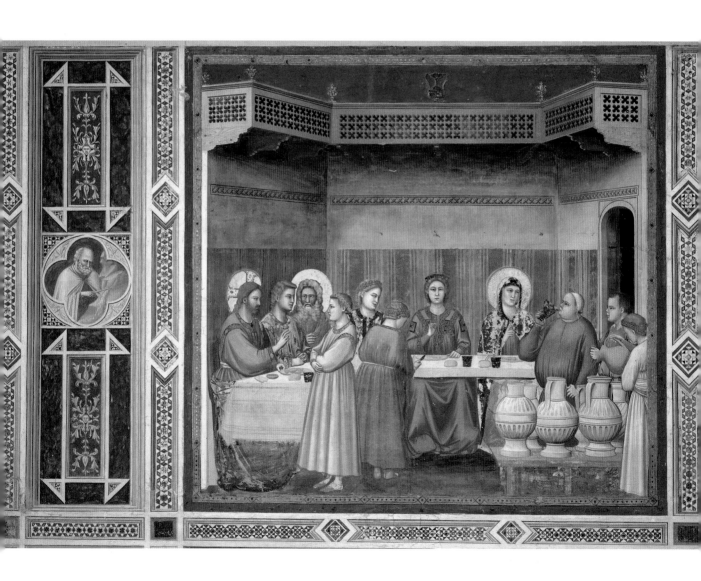

1314 Palazzo Vecchio built in Florence

1353 Giovanni Boccaccio writes
the *Decameron*

1347 Black Death
ravages Europe

1355 Charles IV crowned
Holy Roman Emperor

1378 The Papacy moves
to the Vatican

1300 1305 1310 1315 1320 1325 1330 1335 1340 1345 1350 1355 1360 1365 1370 1375 1380 1385

GIOTTO DI BONDONE

# THE ARENA CHAPEL

*Though an early work in Giotto's career, the extensive program of frescos in the Arena Chapel in Padua remains one of his masterpieces and a foundation work in Western art. The completed chapel was so magnificent that it outraged the neighboring monks of the Eremitani church, who lodged a formal complaint.*

It was in a small chapel in Padua that Giotto, the recognized master of the Early Renaissance, breathed new life and direction into the visual arts by producing a fresco scheme of vibrant naturalism, of passion, poetry, and depth. Today his work in the Arena Chapel, seen as reflective of the emerging concepts of Renaissance art, is considered a milestone in the evolution of Western painting.

The chapel itself, with its simple façade and plain red-brick walls gives little clue to the breadth and scope of the frescos housed within. It was built in around 1300 on the site of an old Roman amphitheatre from which it takes its name, the Arena Chapel. The unassuming building is also known as the Scrovegni Chapel after Enrico Scrovegni, who used part of his considerable fortune to fund the building. His reasons for commissioning the chapel were twofold and somewhat conflicting. His father, Riginaldo, had amassed a huge fortune as a money lender, a business frowned on by the Church and many citizens. Such was Riginaldo's notoriety that Dante Alighieri included reference to him in his epic *Divine Comedy*, singling him out as the usurer in the *Inferno*. Enrico inherited the fortune and added to it through his own money lending activities. Following his father's death in 1289 he decided to expiate both his own sins, and his father's, by building a chapel. He commissioned Giotto to decorate the interior with an elaborate fresco scheme incorporating reference to usury and the pious contrition of sins.

The theme of usury is strongly evident and is reflected in the prominently placed scene *Judas Being Paid for Betraying Christ*, which appears on the north side of the chancel arch. The scene is one of understated drama and threat, emphasized by the malignant, black, satanic figure who clutches the shoulder of Judas with a long-fingered grip. Usurers appear again in the terrifying *Last Judgment*, stricken in death and tellingly hanging from the cords of their own moneybags.

As a further act of piety, and to remove association of greed from the Scrovegni, the chapel was dedicated to the Virgin of Charity in 1304 by Pope Benedict XI. The lavishness of the chapel's decorative scheme, however, was seen as a deliberate flaunting of wealth, conflicting with the theme of contrition, and Enrico was accused of creating the building that was a personal memorial and a symbol of his power. The exact date of Giotto's frescos in the chapel is unknown, though he is thought to have begun work no earlier than 1303 and to have finished by 1306. This allows a short time for such an expansive scheme, which suggests he had a large and well-organized team of artists assisting him. The cycle consists of two main themes, those being the Life of the Virgin and the Life of Christ, and covers the

c. 1267 Born Giotto di Bondone in Vespignano near Florence.
1290 Thought to have worked as an assistant to Cimabue in Assisi.
1300 Paints frescos at the papal palace.
1302–1305 Paints frescos for the Scrovegni Chapel in Padua.
1309 Paints more frescos for the basilica in Assisi.
1310 Works at Old St Peter's in Rome.
1325 Paints the Peruzzi Chapel in Santa Croce in Florence.
1328 King Robert of Anjou summons him to Naples.
1334 Appointed master of works at the cathedral in Florence.
1337 Dies 8 January in Florence.

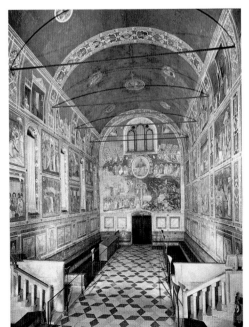

left:
View of the Arena Chapel

above:
Paolo Uccello, *Giotto di Bondone*, detail from *Five Famous Men (The Fathers of Perspective)*, c. 1500–1565, tempera on wood, 42 x 210, Musée du Louvre, Paris

Giotto di Bondone, *Resurrection of Lazarus* (Scenes from the Life of Mary and Christ), c. 1302, fresco, 185 x 200 cm, 4th picture, middle row, left wall, Arena Chapel, Padua

entire interior, laid out in simple and interrelating sequences. The scenes unfold over three tiers with a fourth monochrome lower level depicting personifications of Virtues and Vices, while the whole of the West wall is devoted to Giotto's magnificent and terrifying *Last Judgment*.

The story begins with the Virgin's parents Joachim and Anna on the upper level of the south wall and is read from east to west, starting with *Joachim's Expulsion from the Temple*. The sequence involves six panels, the last of which is *Joachim and Anna at the Golden Gate*, which reflects Giotto's striking ability to render emotion. The couple are seen kissing tenderly in joy, having both experienced a vision of their impending child. The narrative of the Life of the Virgin starts on the upper level of the north wall, and again comprises six panels, which are read from west to east, beginning with *The Birth of the Virgin* and ending with *The Virgin's Return Home*. The Incarnation and Infancy of Christ sequence begins

on the chancel arch that leads to the chapel's altar, and is separated from the Life of the Virgin paintings by the Annunciation panel. The Life of Christ panels continue on the middle tiers of the south and north walls, while the themes of Passion, Resurrection, Ascension and Pentecost also start on the chancel arch, and then continue along the bottom tier of the south and north walls. One of the most striking of these panels is the *Betrayal*, where Judas has clasped Jesus in a "traitor's" embrace. It is the second rendering of a kiss in the sequence, the first being Joachim and Anna, and could not be more different in emotion. Contrasting the two images highlights Giotto's supreme skill at evoking subtle atmosphere and mood, bringing great humanity, for the first time, to religious imagery. The sense of drama and profound feeling, along with the convincing naturalism of his scenes and the fluid, bold interpretation of his subject matter, made the frescos highly influential on subsequent early Renaissance cycles.

Giotto di Bondone, *Lamentation* (Scenes from the Life of Mary and Christ), c. 1303–1306, fresco, 185 x 200 cm, 3rd picture, bottom row, left wall, Arena Chapel, Padua

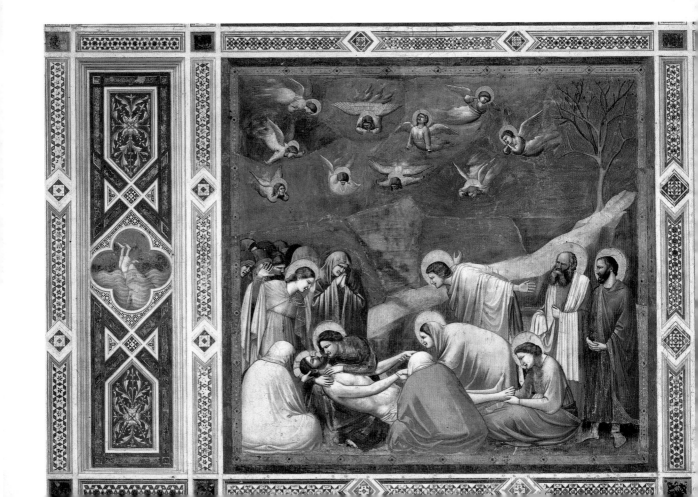

**1337** Beginning of the Hundred Years'
War between England and France

**1381** Venetian hegemony in the
Mediterranean after the victory
over Genoa

1320  1325  1330  1335  1340  1345  1350  1355  1360  1365  1370  1375  1380  1385  1390  1395  1400  1405

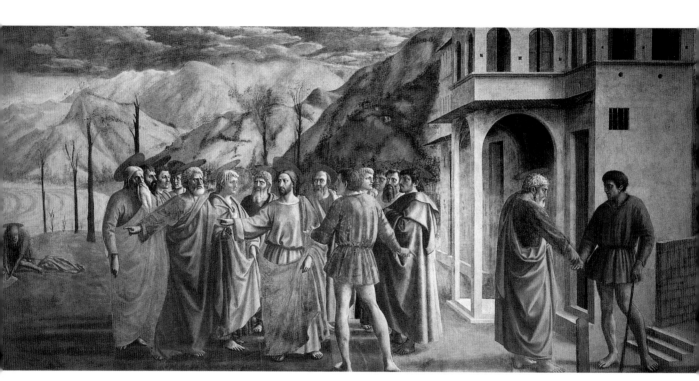

Tommaso Masaccio, *The Tribute Money*,
1425–1427, fresco, 255 x 598 cm,
Brancacci Chapel, Santa Maria del
Carmine, Florence

**1431** Joan of Arc dies

**c. 1412** Discovery of central
perspective by Filippo Brunelleschi

**1435** Leon Battista Alberti's
treatise *De Pictura*

**1432** *Ghent Altarpiece* (Jan van Eyck)

**1455** Invention of printing (Gutenberg)

**1453** Constantinople falls to the Ottoman Turks

**1492** Columbus sails to
America for the
first time

**1469–1492** Lorenzo de' Medici rules Florence

1410  1415  1420  1425  1430  1435  1440  1445  1450  1455  1460  1465  1470  1475  1480  1485  1490  1495

TOMMASO MASACCIO

# THE TRIBUTE MONEY

*With its convincing use of perspective, its broad sense of space, and its extraordinary characterization, Tommaso Masaccio's* The Tribute Money *was soon recognized as a groundbreaking work in the "re-birth" of Western art and had a huge influence on his contemporaries.*

Widely regarded as the father of Italian Renaissance painting, Masaccio was praised by both contemporaries and successive artists, from Giorgio Vasari and Leonardo da Vinci to Eugène Delacroix. In his striking naturalism, his use of convincing three-dimensional space, his subtle handling of light, and his recollection of classical precedents, he had a profound influence on many artists of the period, including Tommaso Masolino, with whom he collaborated, Fra Angelico and Andrea Mantegna. Vasari later described the Brancacci Chapel, where the celebrated fresco *The Tribute Money* is housed, as the spiritual home of Florentine artists, naming as many as twenty-five artists who had studied the works there.

The Brancacci Chapel and its adjoining church of Our Lady of Carmel are home to a number of art works, but none to equal in finesse or fame the fresco scheme by Masaccio (primarily) and Masolino, the cycle in its entirety being a masterpiece of Renaissance art. Painted between 1425 and 1427, the frescos depict scenes from the life of St Peter, with Masaccio's *The Tribute Money* being of especial importance. The older artist, Masolino—once thought to have been Masaccio's teacher, though this claim has now been disproved—was responsible for, among other scenes, *Adam and Eve in the Earthly Paradise* and *Original Sin* in the upper registers of the chapel. Left unfinished by both artists, the cycle was completed in c. 1481–1485 by Filippino Lippi.

Masaccio's *The Tribute Money* was soon heralded as a work of unsurpassed genius. The scene reveals his great innovativeness and narrative skills through his fluid synthesis of three separate incidents in one seamless image arranged in a convincing composition. At first glance the picture appears to be structured on strong horizontal lines, but it is actually based on a semi-circular composition, with the central group forming the focal point. This was a device used in classical times which was then resurrected in Early

Christian art before being given physical form during the Renaissance in the architectural works of Filippo Brunelleschi. Further classical references include the robes of the figures and also their poses, such as that of Peter and the tax collector, which Masaccio based on antique sculptures.

Derived from an account in the Gospel of St Matthew, the fresco records the moment when Jesus arrived in Capernaum with his Apostles. In the central group of figures, who are richly colored and strongly expressive in demeanor, a tax collector is making his request for tribute money, and Jesus is indicating to Peter how to meet the man's demands. To the left of this group Peter is seen again, pulling a fish from the waters of Lake Genezaret and removing a coin from its mouth; on the right he appears once more, this time paying the money to the tax collector in front of a house. Full of vivid animation, suspense and tension as the onlookers witness the events unfolding, the scene is strongly characterized by explicit and intricate details. It is this naturalistic detail—from the tiny but detailed open mouth of the fish to the distant landscape and the facial expressions captured throughout—that makes the work so breathtaking. The strong structure of the picture, based on Masaccio's inherent understanding of linear perspective, is also evident, and it was this in particular that influenced artists such as Uccello and Piero Della Francesca.

**1401** Born Tommaso di Ser Giovanni di Mone (or Tommaso Cassai) 21 December in San Giovanni Valdarno.
**c. 1417** Moves to Florence.
**1422** Admitted to the painters' guild in Florence.
**1424** He and Masolino begin work painting the Brancacci Chapel in Santa Maria del Carmine, Florence.
**1428** Follows Masolino to Rome to work on the frescos at the church of San Clemente. Dies the same year.

left:
Paolo Uccello, *The Battle of San Romano*, c. 1456, tempera on poplar, 183 x 319 cm, National Gallery, London

above:
Giorgio Vasari, *Tommaso Masaccio*, 1550, engraving

**1334** The campanile of Florence Cathedral
built to plans by Giotto

**1387** *Fra Angelico

**1341** Petrarch crowned poet laureate
on the Capitol in Rome

**1375** † Italian writer Giovanni Boccaccio

**1400** Beginning of
humanism in
Germany

| 1320 | 1325 | 1330 | 1335 | 1340 | 1345 | 1350 | 1355 | 1360 | 1365 | 1370 | 1375 | 1380 | 1385 | 1390 | 1395 | 1400 | 1405 |

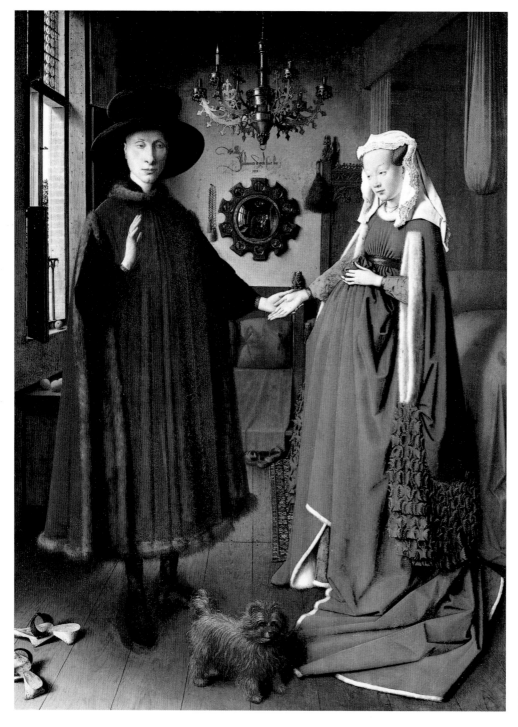

Jan van Eyck, *The Arnolfini Portrait*,
1434, oil on wood, 81.8 x 59.7 cm,
National Gallery, London

**c. 1410** The Limburg brothers paint the *Très Riches Heures* Book of Hours for the Duc de Berry    **1434–1464** Cosimo de' Medici rules Florence

**1453** *Martin Luther

**1419** First Defenestration of Prague (Hussites)

**1492** First voyage of discovery to America by Columbus

1410   1415   1420   1425   1430   1435   1440   1445   1450   1455   1460   1465   1470   1475   1480   1485   1490   1495

## JAN VAN EYCK

# THE ARNOLFINI PORTRAIT

*This little painted wooden panel is full of mystery. Ever since art historian Erwin Panofsky wrote a famous study of it in 1934, 500 years after Van Eyck painted it, the work has fascinated scholars and academics—and the public. Some of its secrets may have been revealed, but its exact meaning remains elusive.*

What may have appeared obvious to the painter and his contemporaries has had to be re-constructed half a millennium later in intriguing attempts at explanation (though in ways that perhaps say more about today's interests, knowledge and perceptions than Van Eyck's). This double portrait is an icon not only of art history itself but also of art writing. This was the work that Panofsky used to develop his iconological method and so interpret the hidden symbolism that in his view lay behind the objects depicted.

But regardless of any possible symbolism, the painting is immediately striking, even to the untrained eye. Two people, a man and a woman, stand in an interior. They are nobly dressed and radiate a solemn and quiet dignity and pride. The bright, intense colors and the refined technical execution are particularly conspicuous.

These two figures are generally taken to be Giovanni Arnolfini and his wife, Giovanna Cenami. They both came from rich Italian families that had settled in Brussels. Giovanna has placed her right hand in Giovanni's left-hand, and with her left hand holds the heavy fabric of her dress gathered in front of her. She looks towards him, whereas he looks straight ahead. The clues to the painting's meaning are provided by the objects around them. The first clues are the furnishings of the room: a bed and a chair, so this is a bedroom. In front of the couple is a dog, while in the left foreground is a pair of shoes on which street dirt can still be seen. Finally, above the enigmatic mirror on the back wall is the signature of a painter. All the perspective lines of the picture lead to this small round mirror, in which we can see the "witnesses" to the scene: two people are present, who in a figurative sense could be the painter and the viewer. Van Eyck confirms his own presence with the inscription *Johannes Eyck fuit hic 1434* ("Johannes Eyck was here, 1434"). Because of these circumstances, it is presumed that this picture functioned as the equivalent of a notarial attestation of a

betrothal—a confirmation of marriage. A series of elements in the picture accord with the interpretation Panofsky provided in his study: the single candle on the candelabra (the presence of Christ, faithfulness and belief), the man's gesture (a vow), the little dog (fidelity). Likewise the sandals visible in the background of the picture and the carved representations on the chair and mirror can be interpreted in religious terms.

In 1434, painting with oils was still a rarity, and Van Eyck was its most important exponent. This new method was particularly well suited to reproducing various materials, such as wood, metal, fur, skin, fabrics, and mirror glass, as well as the subtleties of light, all of which Van Eyck rendered with extraordinary skill.

The two people are neither saints nor donors wanting to immortalize themselves in connection with their good deeds for the Church. They are also not rulers, whose portraits would of be a matter of course. They are prosperous citizens testifying to their good standing by commissioning a celebrated painter who was in the service of Duke Philip the Good of Burgundy. Their double portrait is both an exquisite paintings and a complex document whose meaning is constantly being refined and revised.

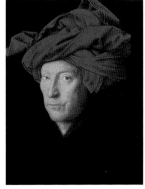

**c. 1390** Born near Maastricht.
**1422** Enters the service of John of Bavaria in The Hague.
**1425** Becomes court painter and servant of Philip the Good, Duke of Burgundy.
**1427–1428** Visits Tournai.
**1428** Paints the portrait of Isabella of Portugal.
**1430** Moves to Bruges.
**1432** Completes the *Ghent Altarpiece*.
**1441** Dies 23 June in Bruges.

Jan van Eyck, *Portrait of a Man in a Turban*, possibly a self-portrait, 1433, oil on wood, 26 x 19 cm, National Gallery, London

**1347** Black Death ravages
Europe

**1363** Work begins on building
the Kremlin

**1378** The papacy moves to the Vatican

**1401** *Masaccio

| 1330 | 1335 | 1340 | 1345 | 1350 | 1355 | 1360 | 1365 | 1370 | 1375 | 1380 | 1385 | 1390 | 1395 | 1400 | 1405 | 1410 | 1415 |

Fra Angelico, *The Madonna of the
Shadows*, c. 1450, fresco and tempera,
193 x 273 cm, Museo di San Marco,
Florence

HIERONYMUS BOSCH

1491 Henry VIII crowned king
of England
1464 † Cosimo de' Medici    1490 *Annunciation* (Sandro Botticelli)
1455 War of the Roses breaks out in England    1486 Maximilian becomes king of    1503–1505 *Mona*
the Holy Roman Empire    *Lisa* (Leonardo)

1420   1425   1430   1435   1440   1445   1450   1455   1460   1465   1470   1475   1480   1485   1490   1495   1500   1505

FRA ANGELICO

# THE ANNUNCIATION

*Fra Angelico (the "angelic brother") became famous for both his skill as an artist and his piety as a man (he was beatified by Pope John Paul II in 1982, and declared the patron of Catholic artists). Both qualities are wonderfully apparent in* The Annunciation, *a work unsurpassed in beauty and spiritual resonance.*

Still largely intact, Fra Angelico's decorative fresco scheme at the Dominican convent of San Marco in Florence is among the most important cycle of its kind from the Renaissance. The commission for the enormous undertaking was awarded around 1440, with the project eventually including the altarpiece and over fifty other frescos, making it the largest surviving scheme from the workshop of one artist. As with many artistic endeavors at this time in Florence, the restoration of San Marco was funded by Cosimo de' Medici, who is thought to have spent thirty-six thousand ducats on the convent, commissioning the architect Michelozzo di Bartolomeo to design and rebuild much of the fabric of the complex, including the church and the library, in 1437. Significantly, this was the first public library to be opened since Antiquity, and contained over eight hundred books on theology, the classics, science, and jurisprudence, making it a supreme symbol of Renaissance humanism.

The Dominican Order adhered to strict rules and traditions, with the friars living in simple and humble cells and following a life of devout worship and contemplation. Fra Angelico's decorative scheme was intended to aid their meditations, to inspire their intellectual ruminations, and to exhort them to follow the Order's codes of behavior. The frescos could not have been executed by a more highly qualified artist, since he was himself a man of devout integrity, and had taken his own religious vows in 1423. It is this element of sincere reverence that lends works such as *The Annunciation, The Madonna of the Shadows,* and *The Adoration of the Magi* their particular luminous and spiritual quality. Of the many frescos executed at San Marco, *The Annunciation* on the south wall of the north corridor is one of the most deeply moving and most brilliantly devised, reflecting the artist's subtle understanding and manipulation of perspective. Begun around 1441, it was positioned with great deliberation, opposite the top of a flight of stairs that linked the dormitory

with the cloister on the floor below. Fra Angelico conceived the painting as an illusionary window, complete with windowsill, frame and lintel, thus opening up the space to make it seem as though the viewer is looking out into a garden and cloistered area. Those walking towards the fresco were meant to experience a sense of moving into a fictional space that brings the sacred nature of the scene into the perceived world of physical reality.

The brilliant light that bathes the scene in which the Archangel Gabriel appears to the Virgin Mary was painted by Fra Angelico to match the actual, natural light source that flooded the area from a window to the left in the end wall of the corridor. The angel and Mary are sensitively wrought, their delicate facial features expressing pure and vivid emotion. The angel is expectant and beatific, his face framed by tendrils and curls of golden hair, and his wings a masterful display of color and pattern. Mary leans towards him, humble and intelligent, with the vitality of her expression suggesting her knowledge of the profound significance of the moment and her intellectual reconciliation to it. She is seen in a similar pose in another, smaller, Annunciation that the artist painted in Cell 3 as a private meditative work. The perspective of the painting is not strictly accurate, but this would appear to have been a deliberate move by the artist, who used simple rules of geometry and freehand artistry to create the architectural space. The slight distortion in the perspective enhances the fact that this is a celestial scene, which although depicted with a sense of reality, remains nonetheless chiefly a motif for meditation and inspiration, designed to stimulate both mind and soul.

1390–1395 Born Guido di Pietro in Vicchio near Florence.
1418–1422 Enters the Dominican monastery in Fiesole as Fra Angelico.
1435 The Fiesole Dominicans take over the monastery of San Marco in Florence.
1438 Cosimo de' Medici commissions him to paint frescos for San Marco in Florence.
1445 Goes to Rome to do work in the Vatican.
c. 1451 Returns to Fiesole and is appointed prior at the monastery.
1453 Settles in Rome again.
1455 Dies in Rome.

Joachim von Sandrart, *Fra Angelico*, 1675–1679

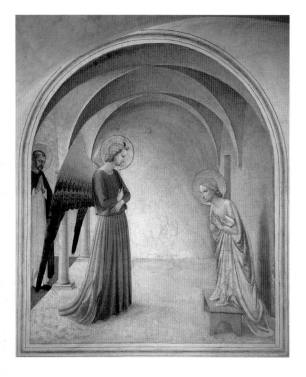

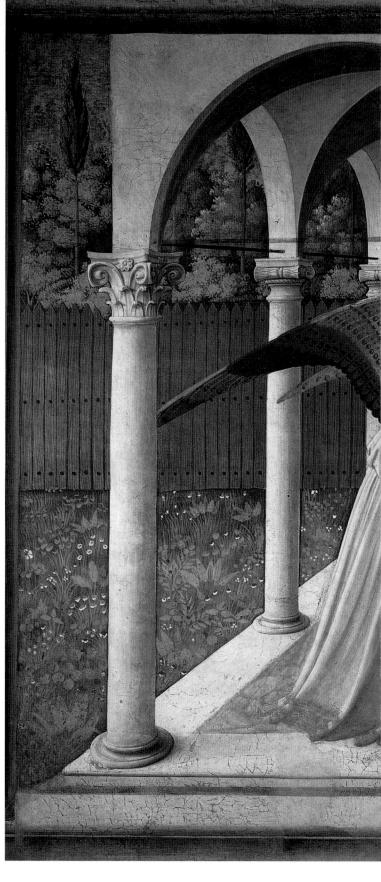

above:
Fra Angelico, *The Annunciation*,
c. 1437/45, fresco 230 x 297 cm, north
corridor, San Marco monastery, Florence

right:
Fra Angelico, *The Annunciation*, c. 1440,
fresco 190 x 164 cm, Cell 3, upper floor,
San Marco monastery, Florence

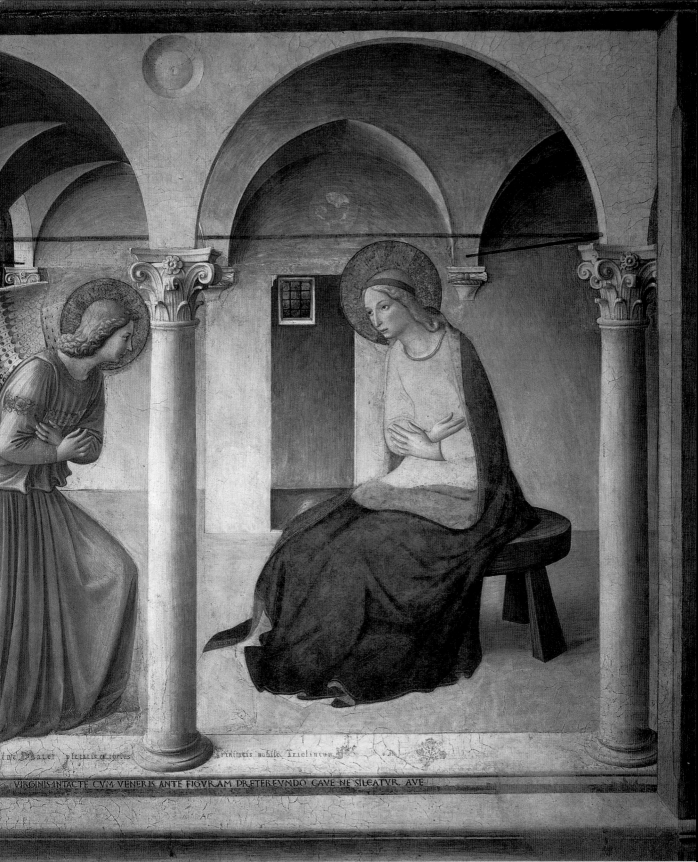

VIRGINIS INTACTE CVM VENERIS ANTE FIGVRAM PRETEREVNDO CAVE NE SILEATVR AVE

**c. 1412** Discovery of central perspective
by Filippo Brunelleschi

**1405** Zheng Hé sets off on his first journey

**1444** *Donato Bramante

| 1370 | 1375 | 1380 | 1385 | 1390 | 1395 | 1400 | 1405 | 1410 | 1415 | 1420 | 1425 | 1430 | 1435 | 1440 | 1445 | 1450 | 1455 |

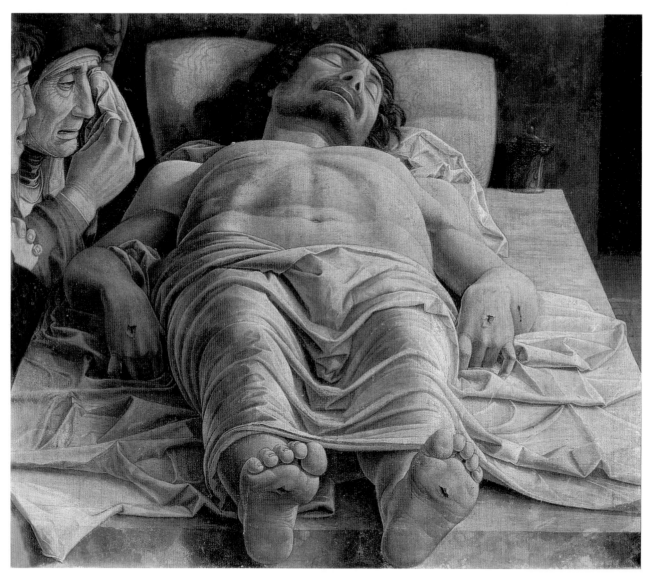

Andrea Mantegna, *The Dead Christ*,
c. 1480, oil on canvas, 66 x 81.3 cm,
Pinacoteca di Brera, Milan

LUCAS CRANACH THE ELDER

**1501–1504** *David (Michelangelo)*   **1517** Start of the Reformation

**1455** Invention of printing (Gutenberg)      **1475** *Michelangelo      **1506** Work begins on new St Peter's at the Vatican      **1529** Ottoman Turks at gates of Vienna

**1534** Act of Supremacy makes Henry VIII head of the Church of England

1460   1465   1470   1475   1480   1485   1490   1495   1500   1505   1510   1515   1520   1525   1530   1535   1540   1545

ANDREA MANTEGNA

# THE DEAD CHRIST

*In this extraordinary painting Andrea Mantegna depicted a familiar theme—the Lamentation over the Body of Christ—but in an entirely new and dramatic manner with startling perspective and foreshortening, and with a harrowing sense of pathos.*

Though Mantegna's life and works are among the best documented of any Renaissance artist, one of his most famous paintings, *The Dead Christ*, remains veiled in mystery. Dates for its creation provided by historians range over fifty years, with the most plausible period given as around 1480–1490. This indicates that Mantegna undertook the work sometime towards the end of his long sojourn in Mantua under the patronage of the Gonzaga family, or shortly after his trip to Rome in around 1488–1490. The significance of the work was recognized during Mantegna's lifetime, and it was, fittingly, placed at the head of the artist's catafalque when he died. It is one of the most extraordinary paintings of the period, the size and composition of the picture suggesting a slab in a morgue. The figure of Christ is foreshortened to such an extent that the body appears deformed, though this in fact matches the swollen contours of a body gripped by death. This use of virtuoso and illusionistic perspective was typical of Mantegna, who had employed it to great—though very different—effect for the oculus in the ceiling of the Camera degli Sposi. His development of this type of compositional structure with daring illusionary effects influenced a number of Renaissance artists, and can be seen, for example, in the works of Correggio, especially his ceiling paintings such as *The Death of St John* (1520–1524) in the Church of San Giovanni Evangelista, Parma. Mantegna's usual innovative devices and bold compositions, both of which are defining features of his work, paled beside those of *The Dead Christ*, which was without precedent and far ahead of its time, predicting elements of 16th-century Mannerist art. Mantegna's painting is a masterful rendition of death in its most realistic and tortured form, the misery and cold despair of the work, sharpened by its restrictive tonality and palette, being relentless. The wrinkled feet, punctured with nail holes, are the feet of a real man, a biting naturalism that deepens the image's intense pathos. From the feet the eyes

are led towards the hands, again punctured, and curled in the agony of death. But it is the face of the dead Christ that is perhaps most compelling and profoundly, utterly, sad. The figure is flanked on the left by three people who hover on the very edge of the image. One of them, barely discernible, is indicated only by a horrified open mouth, the severe cropping emphasizing the disquieting nature of the scene.

Despite his intense interest in depiction of naturalistic detail, Mantegna also looked to antiquity and classical precedents. His figural works, including *The Dead Christ*, are strongly sculptural in concept, reflecting both ancient sculpture and the works of Donatello, and often include sharply defined drapery, as illustrated by the cloth covering the body of Christ. Mantegna's oeuvre is characterized by such innovations, with *The Dead Christ* being remarkable above all for its dramatic perspective.

**c. 1431** Born in Isola di Cartura (now also Isola Mantegna) near Padua.
**c. 1441** Becomes a pupil of Francesco Squarcione in Padua.
**c. 1448** Leaves Squarcione's workshop.
**1454** Marries Nicolosia Bellini, sister of painter Giovanni Bellini.
**1456** Appointed court painter to Ludovico II Gonzaga in Mantua.
**1456–1459** Paints the altarpiece for the high altar of San Zeno in Verona.
**c. 1488** Sets off for Rome.
**1490** Returns to Mantua.
**1506** Dies 13 September in Mantua.

left:
Correggio, *The Death of St John*, 1520–1524, fresco, 940 x 875 cm, San Giovanni Evangelista, Parma

above:
Giorgio Vasari, Andrea Mantegna, 1550, engraving

Andrea Mantegna, *Di sotto in sù* ceiling fresco in the Camera degli Sposi, 1465–1474, fresco, Castello di San Giorgio, Palazzo Ducale, Mantua

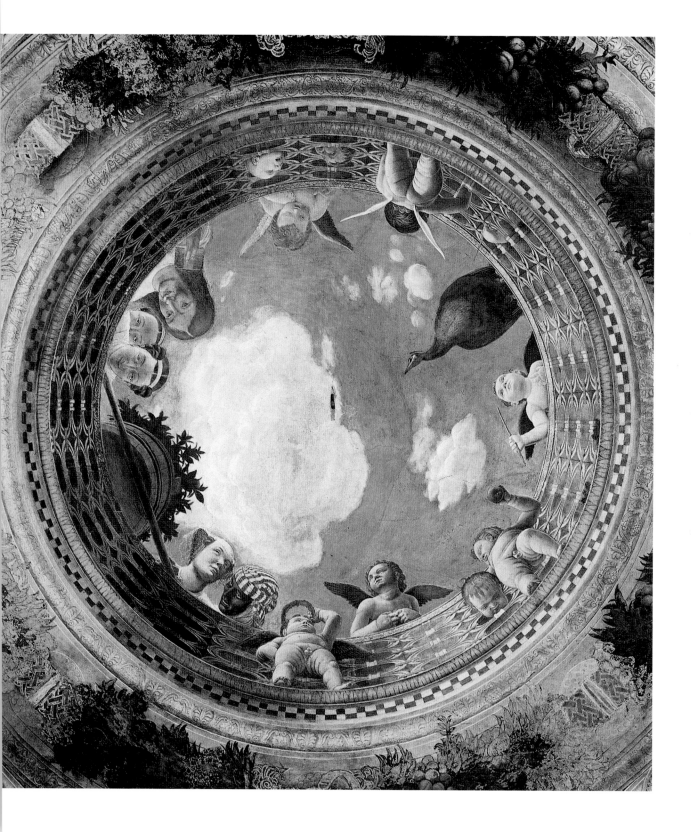

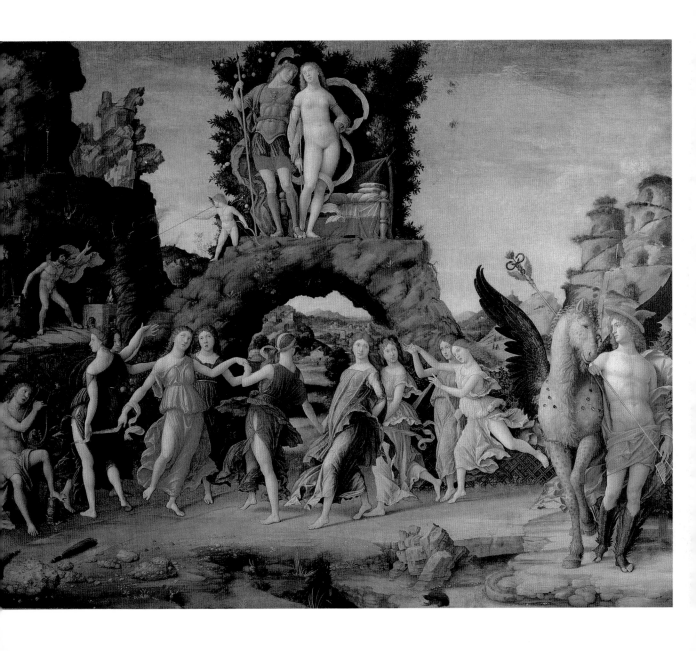

Andrea Mantegna, *Parnassus*, 1497, oil on canvas, 160 x 192 cm, Musée du Louvre, Paris

**1414** Rediscovery of Vitruvius's *Ten Books on Architecture* (catalyst for architectural writings of the Renaissance)

**1441** † Jan van Eyck, Flemish painter

1380  1385  1390  1395  1400  1405  1410  1415  1420  1425  1430  1435  1440  1445  1450  1455  1460  1465

Sandro Botticelli, *The Birth of Venus*,
c. 1490, tempera on canvas,
184.5 x 285.5 cm, Galleria degli Uffizi,
Florence

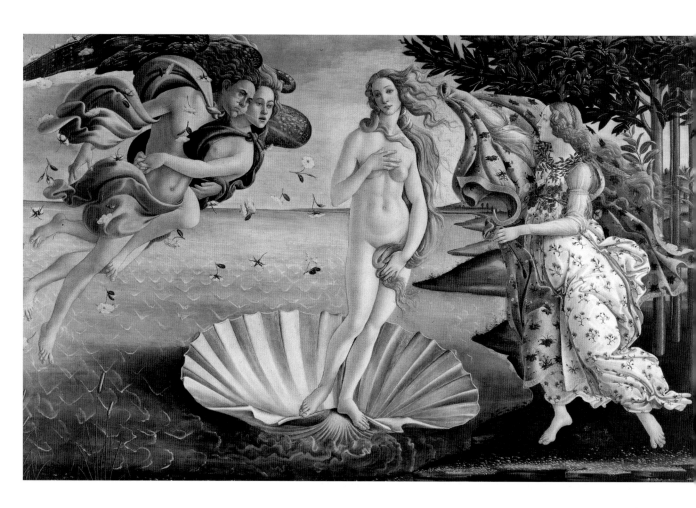

ALBRECHT DÜRER

TITIAN

1508 *Andrea Palladio        1519 Work starts on construction        1541 Spain conquers the Mayan
                                   of the château at Chambord              Empire in Central America
1472 Dante's *Divine Comedy*        1512–1514 *Sistine Madonna* (Raphael)   1541 Michelangelo completes the
     printed for the first time                                            Sistine frescoes
                                   1520 Magellan circumnavigates the globe  1546 Fugger wealth at its peak
                                                                                with 4m guilders in assets

1470   1475   1480   1485   1490   1495   1500   1505   1510   1515   1520   1525   1530   1535   1540   1545   1550   1555

SANDRO BOTTICELLI

# THE BIRTH OF VENUS

*Sandro Botticelli's image of the goddess of love is one of the most celebrated examples of a sensual yet ethereal form of feminine beauty. She is still so convincing that her many anatomical inconsistencies pale into insignificance in the light of her power to fascinate and delight.*

There was no precedent for Botticelli's magnificent *Birth of Venus* in his own era; one of the earliest nude female models to appear in the Renaissance, she was a figure drawn from the artist's own extraordinary imagination. Some years earlier he had painted *La Primavera* (c. 1482), a similar celebration of love and beauty, which includes a particularly beautiful rendering of the Three Graces, who are depicted draped in flowing and diaphanous cloth. Reflecting an exquisite form of female beauty, these two paintings are the highpoint of his achievement. Representing an ideal of beauty that had not been seen since antiquity, they had an enormous influence on subsequent artists.

In her chaste pose and demure yet sensuous appeal, Venus faintly echoes ancient models, in particular the so-called *Venus Pudica*. She veers from the classical, however, in the fluidly modeled contours of her body, which flow with sinuous and serpentine grace, and particularly in the character of her face, with its luminous eyes and thoughtful, almost sad expression. A painting of an extraordinary beauty, that far surpasses that of other nudes of the period, it contains a depth of emotion and meaning difficult to quantify.

The origins of the painting are unclear. One account—which, though it cannot be verified, adds to its charm—is that it was commissioned by Giuliano di Pero de' Medici to commemorate his love for Simonetta Cattaneo Vespucci. Simonetta was a renowned beauty who lived at Portovenere, a small coastal town whose seas were said to have been the birthplace of Venus. Botticelli is also reputed to have greatly admired the beauty of Simonetta; he used her likeness in several of his paintings, and on his death was buried in the Church of Ognissanti near her grave.

Combining poetical concepts and emulating the antique in Renaissance terms, Botticelli's allegorical paintings reflected the humanist views of the times, and especially those of his patron, Lorenzo de'

Medici. The lyrical content of paintings such as *The Birth of Venus* recalled the writings of the humanist poet Angelo Poliziano, and in particular of his long unfinished poem *Stanze*, which describes Giuliano di Pero de' Medici's love for Simonetta in allegorical terms. The writings of Leone Battista Alberti, whose ideas had been formative in the development of

1444 OR 1445 Born Alessandro di Mariano di Vanni Filipepi in Florence.
1465–1467 Works in the workshop of painter Filippo Lippi.
1470 Sets up his own workshop.
1472 Admitted to the Compagnia di San Luca painters' fraternity.
1475 The Medici become his most important clients.
c. 1478 Paints *Primavera*.
1480 Pope Sixtus IV summons him to Rome.
1492 Lorenzo de' Medici dies. He comes under the spell of fanatical Dominican monk Savonarola.
1510 Dies 17 May in Florence.

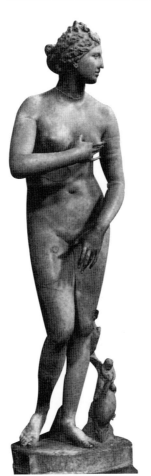

left:
*Medici Venus* (*Venus Pudica*), 1st cent. AD, marble, 153 cm, Galleria degli Uffizi, Florence

above:
Sandro Botticelli, *Self-Portrait* (detail from the *Adoration of the Magi*), c. 1477/78, tempera on wood, 111 x 134 cm, Galleria degli Uffizi, Florence

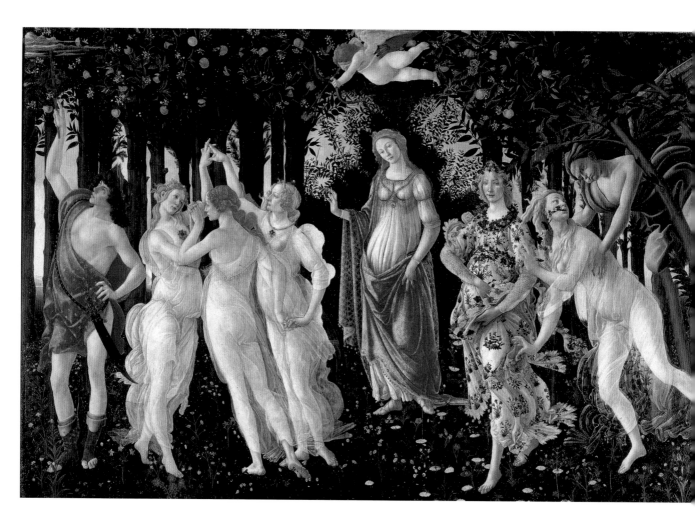

Sandro Botticelli, *La Primavera*, c. 1482,
tempera on poplar, 203 x 314 cm, Galleria
degli Uffizi, Florence

Lorenzo de' Medici's own humanist beliefs, also greatly influence Botticelli, above all through his essays on painting, *De Pictura* (1435), and on architecture, *De Re Aedificatoria* (published post-humously in 1485).

Remarkably, *The Birth of Venus* escaped Girolamo Savonarola's "bonfire of the vanities" in 1497, despite its strongly pagan character and the inclusion of the naked woman. Savonarola, the influential Dominican priest and leader of Florence from 1494 to 1498, was fiercely hostile to what he saw as immorality in the arts, and was responsible for the destruction of many Renaissance paintings, manuscripts, and books. Some believe that Botticelli himself, after a crisis of faith, destroyed some of his own early works on the bonfire of vanities.

Sandro Botticelli, *Calumny of Apelles*, c. 1491–1495, tempera on wood, 62 x 91 cm, Galleria degli Uffizi, Florence

**1453** Ottoman Turks capture
Constantinople

**1469–1492** Lorenzo de' Medici
rules Florence

**1485** Leon Battista Alberti's
*Ten Books on Architecture*
first published in full

1410　1415　1420　1425　1430　1435　1440　1445　1450　1455　1460　1465　1470　1475　1480　1485　1490　1495

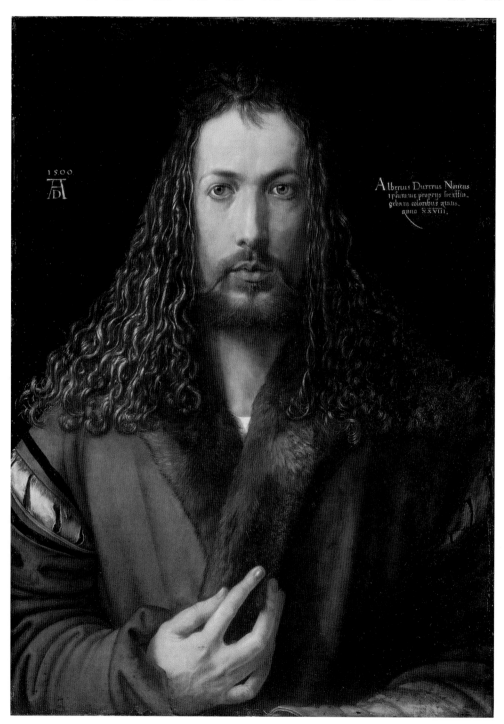

Albrecht Dürer, *Self-Portrait*, 1500,
oil on wood, 67 x 49 cm, Alte Pinako-
thek, Munich

1504 *Betrothal of the Virgin* (Raphael)

1511 *Giorgio Vasari

1541 Michelangelo completes
the Sistine frescoes

1564 *William Shakespeare
1564 † Michelangelo
1558 Elizabeth I crowned queen of England
1571 Battle of Lepanto puts an end
to Turkish naval supremacy

1500 1505 1510 1515 1520 1525 1530 1535 1540 1545 1550 1555 1560 1565 1570 1575 1580 1585

ALBRECHT DÜRER

# SELF-PORTRAIT AT TWENTY-EIGHT

*To stress the amazing lifelikeness of Albrecht Dürer's self-portrait, the anecdote of Dürer's dog was frequently told—the faithful dog is supposed to have mistaken its painted master for the living artist.*

Dürer observed things with astonishing accuracy and was able to reproduced them convincingly down to the finest detail. His depictions of a piece of turf, a hare, and his old mother are all justly famous. His paintings and drawings, prints, and writings on art theory are extraordinarily important for the history of art. That he himself was aware of this greatness is borne out particularly well by this very confident self-portrait.

He looks directly at the viewer calmly and with great dignity. Nothing diverts attention from him, neither a landscape nor an interior. All there is to see is the artist in an expensive fur mantle against a dark background. He has placed his right hand, index finger extended, against the hem of his mantle. Also included, to unequivocally establish his identity, are his monogram and the inscription *Albertus Durerus Noricus / ipsum me propriis sic effingebam coloribus / anno XXVIII* ("Dürer painted himself here with his own [or immortal] colors in his 28th year"). He wears his hair long and unbound. A pose of this kind was normally the reserve of religious painting, in particular images of Christ, especially those in Byzantine art.

Like the hand of God, the hand of the artist is the tool of his creation. It is particularly emphasized, as its works make the artist the image of God. His divine face is supposed to have appeared on the *sudarium* (the Veil of Veronica) without human assistance. Pictures of this cloth are formally closely related to Dürer's self-portrait. Is this supposed to imply that there are supernatural things at work in this picture as well? At any rate, the symbolic trio of God, the Son of God, and the artist are thus described. The question is: who is playing what part?

In 1500, Dürer was an important, prosperous citizen of the city of Nuremberg. He puts himself confidently in the picture, building undoubtedly both on his social position and also his self-assurance and artistic mastery. With the Renaissance—initially south of the Alps but soon throughout Europe—man moved center stage as the apex of divine creation. Dürer regularly did self-portraits, in this way analyzing both his appearance and his personality. He drew his first self-portrait at the age of thirteen, when he was—as he himself wrote—still a child. At the age of twenty-two he painted himself as dashing youth holding flowers, and in a later self-portrait as an elegant gentleman in front of a landscape. With Dürer, the personality of the creative artist became a subject in its own right.

1472 Born 21 May in Nuremberg, Germany.
1484 Draws a self-portrait as a child.
1486 Apprenticed to painter Michael Wolgemut.
1490–1494 Spends his journeyman years in the Upper Rhineland.
1494 Marries Agnes Frey.
1495 Makes his first trip to Italy.
1498 Makes the woodcut series of the Apocalypse.
1500 Paints his *Self-Portrait in a Fur Coat.*
1505–1506 Travels in Italy.
1526 Donates the *Four Apostles* to Nuremberg City Council.
1528 Dies 6 April in Nuremberg.

Albrecht Dürer, *Self-Portrait*, 1498, oil on wood, 52 x 41 cm, Museo Nacional del Prado, Madrid

1473 *Nicholas Copernicus

1390 1395 1400 1405 1410 1415 1420 1425 1430 1435 1440 1445 1450 1455 1460 1465 1470 1475

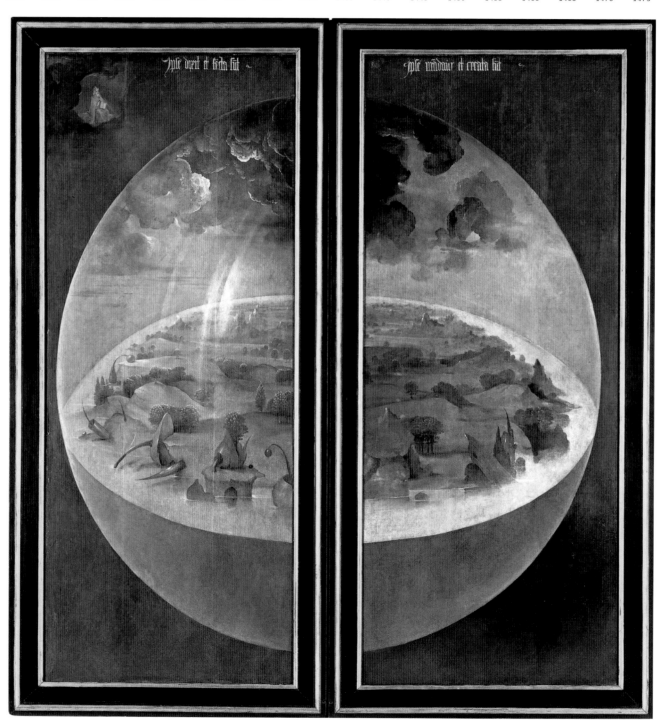

| | | | | | | | | | | | | | | | | | |
|---|---|---|---|---|---|---|---|---|---|---|---|---|---|---|---|---|---|
| 1480 | 1485 | 1490 | 1495 | 1500 | 1505 | 1510 | 1515 | 1520 | 1525 | 1530 | 1535 | 1540 | 1545 | 1550 | 1555 | 1560 | 1565 |

**1492** Columbus's first voyage to America

**1495–1497** *Last Supper* (Leonardo da Vinci)

**1514** Niccolò Machiavelli writes *Il Principe*

**1517** Luther nails his 95 Theses to the door of Wittenberg Castle chapel

**1535** Michelangelo appointed top Vatican sculptor, painter and architect

**1550** Vasari's *Lives of the Painters* published

**1546** Fugger wealth at its peak

**1555** Peace of Augsburg ends religious wars in Germany

**1562** Religious wars break out in France (Huguenots)

## HIERONYMUS BOSCH

# THE GARDEN OF EARTHLY DELIGHTS

*There is a paradox in the works of Hieronymus Bosch: his view of life was deeply pessimistic—weak and sinful, man is prey to vice, folly and stupidity and so in constant danger of eternal damnation—and yet he represented this fallen world with a sensuous richness of invention, humor, color and form that never ceases to fascinate and enchant.*

One of the most innovative and original of artists, Hieronymus Bosch, whose works preceded the Surrealist movement and Salvador Dalí by four hundred years, broke all the rules. His paintings assail the viewer with a profusion of color, a bizarre fantasy, and an intricate iconography; highly complex works that have elicited a great deal of debate, they need to be scrutinized very carefully.

Little documentation pertaining to the artist's life or paintings survives, which deepens the mystery surrounding him. An enigmatic figure, he has been seen both as a heretic who derived his fantastical creations through a knowledge of witchcraft and alchemy, and as a particularly devout Catholic. His complex iconography shows that his works express religious and moralizing messages, and that he had a pessimistic view of mankind—his works warn vividly that carnal desires lead to the downfall of the soul and so to eternal damnation.

When closed, the exterior of the side wings of the triptych reveal a luminous sphere representing the earth on the third day of its creation, a land of shimmering water and of vegetation on the cusp of evolution. It is an image that hints at the organic growth about to occur, but gives no indication of the hellish world secreted behind the two side panels. When the triptych is opened, the full extent of Bosch's nightmarish concept of humanity is revealed with searing originality and vision—a world whose parallel can be found only in the works of Salvador Dalí, such as his *First Days of Spring* (1929) and *The Temptation of St Anthony* (1946). The inside of the left wing continues the theme of evolution, with the grisaille earth of the front being replaced by a lush and verdant Eden, brilliant with jeweled colors. Closer inspection uncovers the irony and latent sexuality of the scene. Strange, unsettling creatures emerge from the surreal landscape; death is already subtly present in the foreground among the creatures, as a cat carries off a mouse, while the newly formed Adam and Eve pose on either side of the Creator as

two sexualized beings, Eve in particular being symbolic of fecundity.

The large central panel, which presents a profusion of flesh and debauchery, is divided into three horizontal areas. In the foreground, the so-called spawn of Adam and Eve couple and indulge in frenzied activity, while in the middleground an excited cavalcade encircles a pool. In the background, by contrast, which is full of strange beasts swimming in a lake and of fantastical structures of pink or blue, the mood is more placid, even bucolic. The sequence is closed on the right-hand wing with a terrible, horrifying finality. Here Judgment and Retribution are meted out, human vices being punished in a landscape now barren and dark. Over the scene presides the "Man Tree" of Death, rising from one of the ponds, his torso a smashed egg and limbs rotten tree branches, as well as (in the foreground) Satan the Devourer, a frightening bird-beaked frog who devours his prey with wicked relish.

As with most of his work, the patron and intended location of *The Garden of Earthly Delights* are unknown, though it likely to have been commissioned by a private patron and intended for a secular setting, despite being a triptych, a format commonly used in altarpieces.

**c. 1450** Born in 's-Hertogenbosch near Eindhoven, the Netherlands.

**1481** Marries a patrician's daughter Aleid van de Meervenne.

**1486** Admitted to the Brotherhood of Our Lady.

**1488–1492** Paints the wings of the main altar in Sint Jan's church in 's-Hertogenbosch at the behest of the Brotherhood of Our Lady.

**1516** Buried 9 August in 's-Hertogenbosch.

left page:
Hieronymus Bosch, *The Creation* (rear side of the wings of *The Garden of Earthly Delights* triptych), 1480–1490, grisaille on wood, 220 x 195 cm, Museo Nacional del Prado, Madrid

left:
Salvador Dalí, *The Temptation of St Anthony*, 1946, oil on canvas, 114.3 x 144 cm, Museo Nacional Centro de Arte Reina Sofía, Madrid

above:
Hieronymus Bosch, *Self-Portrait* (detail from the left inside leaf of the *Temptation of St Antony* triptych), c. 1500, oil on wood, side panels each 131.5 x 53 cm, National Museum of Ancient Art, Lisbon

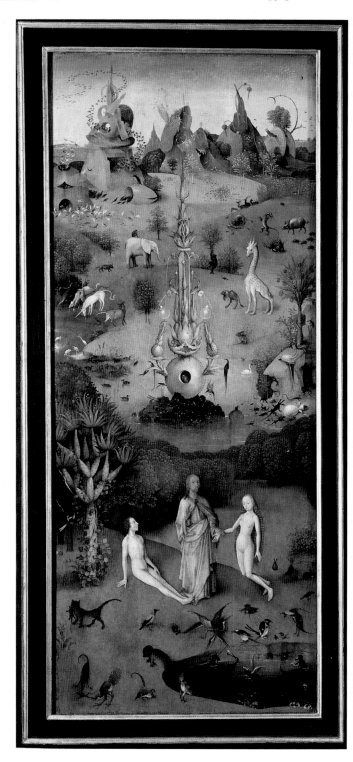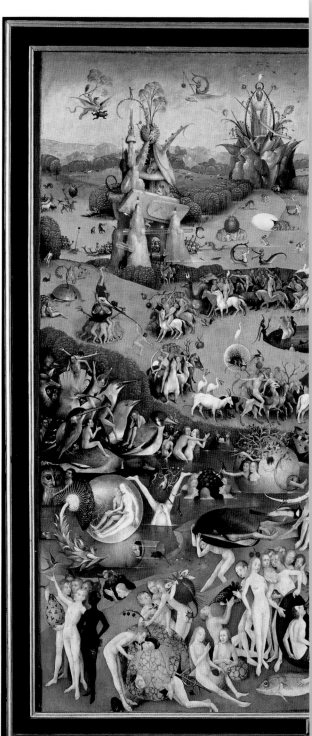

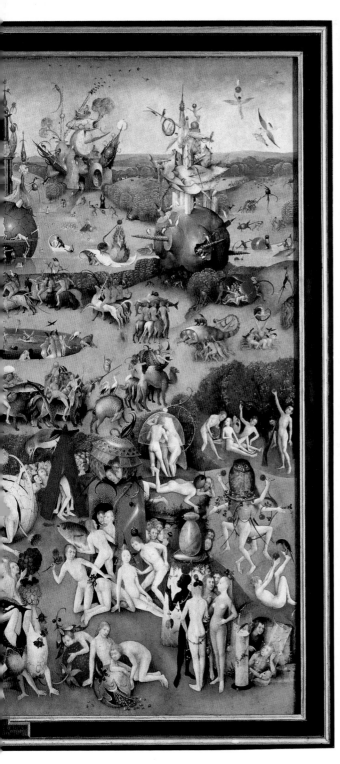
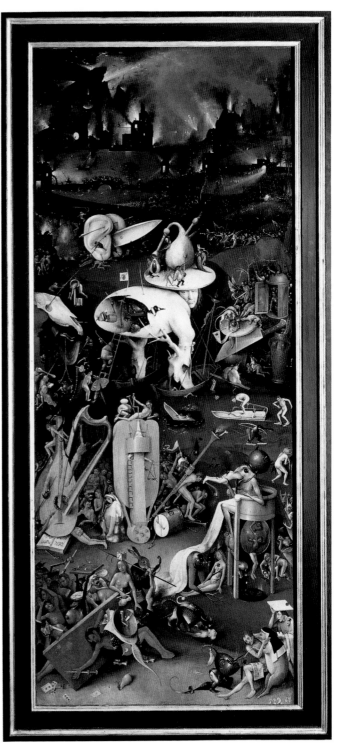

Hieronymus Bosch, *The Garden of Earthly Delights* (overall view of the *Creation / The Garden of Earthly Delights / Hell* triptych), 1480–1490, oil on wood, 220 x 195/390 cm, Museo Nacional del Prado, Madrid

**1453** Constantinople falls to
the Ottoman Turks

**1472** Dante's *Divine Comedy*
first printed

1400  1405  1410  1415  1420  1425  1430  1435  1440  1445  1450  1455  1460  1465  1470  1475  1480  1485

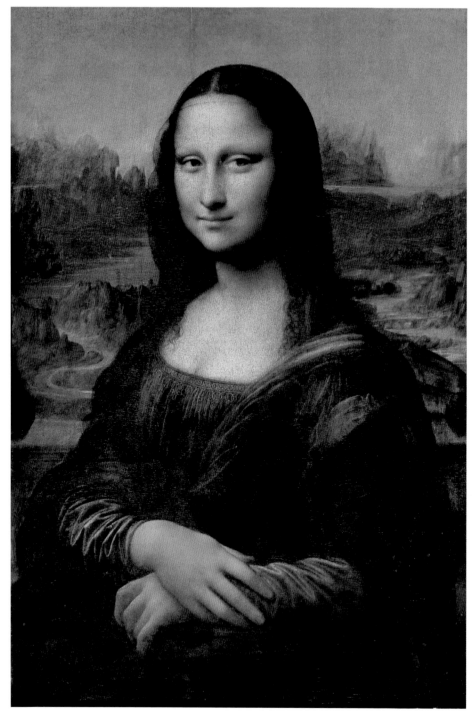

Leonardo da Vinci, *Mona Lisa (La Gioconda)*,
1503–1506, oil on poplar, 77 x 53 cm, Musée du
Louvre, Paris

ANDREA PALLADIO

1506 Foundation stone laid for
new St Peter's in Rome
1510 *School of Athens* (Raphael)

1491 Henry VIII becomes
king of England

1532 Spain embarks on con-
quest of the Inca realm

1526 Mogul Empire in India established

1567 *Claudio Monteverdi
1567–1571 Villa Rotonda
(Andrea Palladio)

1571 Battle of Lepanto puts an end
to Turkish naval supremacy

1490 1495 1500 1505 1510 1515 1520 1525 1530 1535 1540 1545 1550 1555 1560 1565 1570 1575

LEONARDO DA VINCI

# MONA LISA

*The* Mona Lisa *is perhaps the most iconic image in Western art. Recent research has shed new light on the identity of the sitter, a Florentine "wife and mother," and on the origins of the commission, but this has not dispelled the haunting sense of mystery her subtle smile and gaze still convey.*

The enigmatic young woman who stares with quiet assurance from da Vinci's canvas has become one of the most famous of all time; she is the "leading lady" of the art world, and there are few if any portraits that match the *Mona Lisa* in fame, virtuosity or mystery. For many years the identity of the model had been the subject of much conjecture, which deepened the intrigue surrounding her. This mystery was laid to rest in 1991 with the publication of an inventory dating from 1525 drawn up by Leonardo's long time assistant, Gian Giacomo Caprotti, which includes a reference to *Mona Lisa*. This reveals that she was Lisa di Noldo Gherardini, who married Francesco del Giocondo in 1495. Leonardo was given the commission for the painting in 1503, shortly after Giocondo had moved to a large new house, and not long after Lisa had given birth to the couple's second son. Within Giocondo's social circle it was not unusual for the mother of a family to be commemorated in portraiture, a fact that makes this identification all the more plausible.

Much has also been made of the delicate black veil that Lisa is wearing, which has often being interpreted as a sign of mourning. This was not in fact the case. Black veils were a fashion accessory for married women, and indicative of their marital status and virtuousness. This custom was Spanish in origin, but spread slowly to Italy, popularized through the union of such celebrated couples as Lucrezia Borgia and Alfonso d'Este (married in 1502). It is perhaps because Leonardo knew this couple that he suggested Lisa should wear a black veil for her portrait.

Only six portraits by Leonardo survive, and of these only the *Mona Lisa* and *Ginevra de' Benci* (c. 1474) include a landscape background, the others—such as the exquisite *Lady with an Ermine* (c. 1488–1490) and *La Belle Ferronnière* (c. 1490–1495)—having a dark and neutral backdrop. The landscape in the *Mona Lisa* is as breathtaking and beautiful as the woman herself, and was brilliantly contrived by the artist to encompass key qualities of Lisa, so that one becomes an extension of the other.

The precise date of the portrait is unclear, though it is known that Leonardo worked slowly and sporadically on the painting over a number of years. That he took some time over the composition is clear from a drawing by Raphael, *Young Woman on a Loggia* (1504), probably made after seeing Leonardo's initial stages of the painting. Raphael's drawing shows that while Leonardo's early composition included a landscape background it contained more architectural features, which divided the work more firmly than in the final version. In time, he reduced the architectural element to a simple balustrade, which serves to frame the figure, pushing her to the front of the canvas and framing the landscape setting, which takes on its own separate expansive pictorial space.

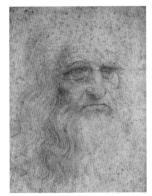

1452 Born 15 April in Vinci near Florence.
1469 Trains in the workshop of Andrea del Verrocchio.
1472 Qualifies as a master of the Compagnia di San Luca painters' confraternity in Florence.
1482 Prince Ludovico Sforza summons him to Milan. In the 1490s, he paints his *Last Supper* at the church of Santa Maria delle Grazie in Milan.
1500 Returns to Florence.
1513 Pope Leo X invites him to Rome.
1516 Visits King Francis I in France.
1519 Dies 2 May at Château Clos Lucé near Amboise, France.

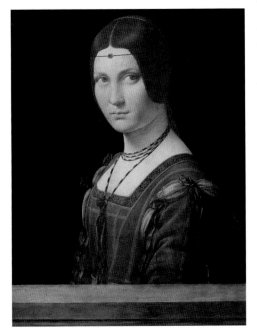

left:
Leonardo da Vinci, *La Belle Ferronière*, c. 1490–1495, oil on walnut, 63 x 45 cm, Musée du Louvre, Paris

above:
Leonardo da Vinci, *Self-Portrait*, c. 1516, red chalk drawing, 33.2 x 21.2 cm, Biblioteca Reale, Turin

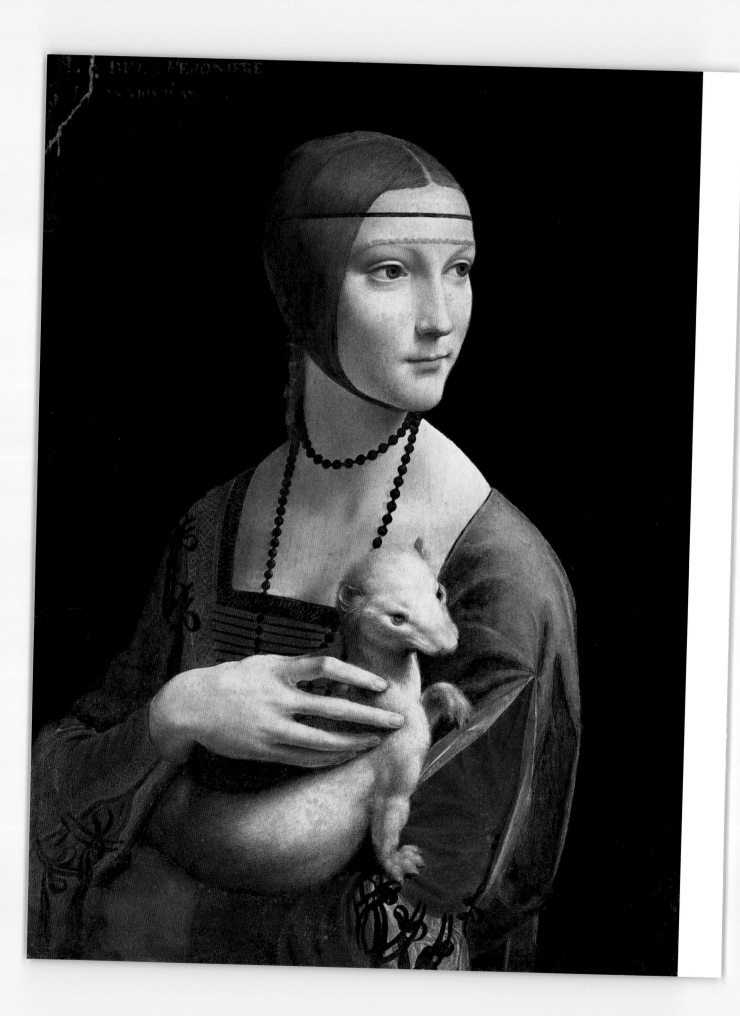

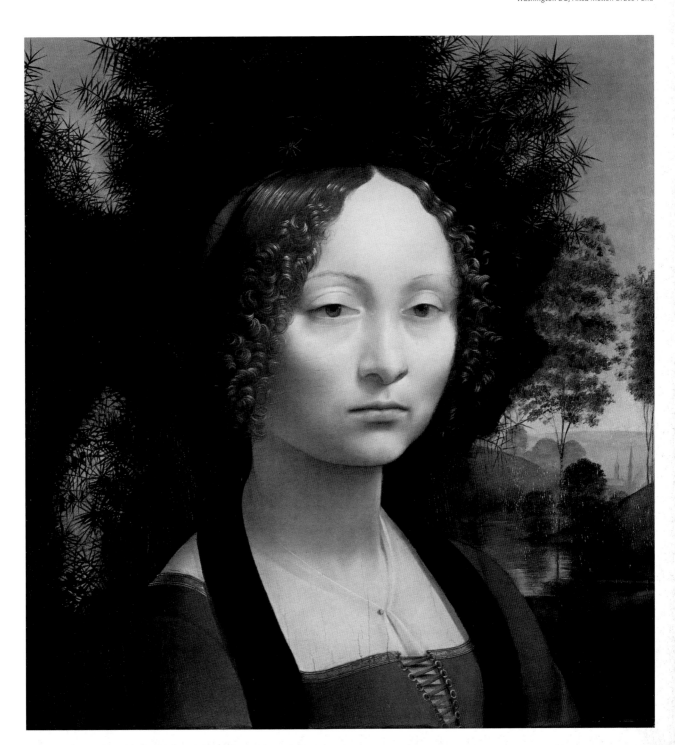

**1438–1527** Heyday of the Inca empire

**C. 1455** Gutenberg prints the Bible

**1476** Chimù empire in Peru reaches
its greatest extent

1410   1415   1420   1425   1430   1435   1440   1445   1450   1455   1460   1465   1470   1475   1480   1485   1490   1495

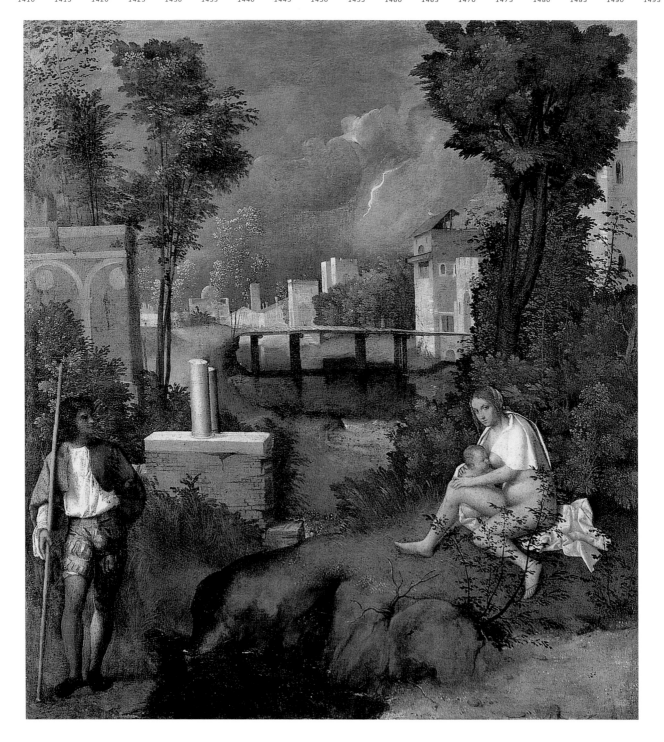

1571 † Benvenuto Cellini

1503–1505 *Mona Lisa* (Leonardo)  1519 Charles V becomes Holy  1562 Religious wars break out in France (Huguenots)
Roman Emperor

1518 *Tintoretto  1555 Nostradamus writes  1574 † Giorgio Vasari
his *Prophecies*

1500 1505 1510 1515 1520 1525 1530 1535 1540 1545 1550 1555 1560 1565 1570 1575 1580 1585

GIORGIONE

# LA TEMPESTA

*Though Giorgione's career was brief, spanning just fifteen years, he had a profound impact on the development of Venetian art. Today his fame rests chiefly on his small, mysterious and lyrical works such as* La Tempesta, *which reflect a deep love of nature.*

There are few paintings quite as enigmatic as Giorgione's little *La Tempesta*, and few artists. Facts surrounding his life and works remain scant, but what is indisputable is the importance of Giorgione's paintings for the development of 16th-century Venetian art. Today he is recognized as one of the founding fathers of Renaissance art, his influence profound and far reaching; in his own day Vasari called him one of the propagators of "modern" (i.e. Renaissance) art, Leonardo da Vinci being another.

Along with his *Three Philosophers* (c. 1508–1509), *La Tempesta* is the most elusive of his paintings, and both works have been the focus of long debate over the precise nature and purpose of their subjects. This sense of mystery and originality was character-istic of Giorgione's work, and even his seemingly straightforward paintings, for example his *Castelfranco Altarpiece* (c. 1505), include unusual elements, such as a raised throne or an extensive landscape background. Landscape was in fact a defining feature of Giorgione's work, and he treated it with the same attention he lavished on his figures. Lyrical and poignantly evocative of mood or atmos-phere, his landscape backgrounds, as clearly seen in *La Tempesta*, are imbued with a captivating sense of mystery. The landscape in *La Tempesta* dwarfs the figures of the soldier and the woman (often referred to as the "gypsy"), making them almost incidental; the woman in particular seems out of place and ill at ease in her surroundings.

There is no definite explanation for the strange subject of this painting, though there are several plausible theories. Of these the most straightforward is that the scene is a painted "poesy," a visual rendering of a lyrical poetic thought; the subjects depicted are not significant in themselves but in the role they play in creating a sense of beauty, mood and atmos-phere. It would seem too simple, however, to dismiss further interpretation, and the inclusion of a soldier and a woman suckling a child are too specific to be explained away as merely poetic elements. Other theories put forward suggest the work is an allegory, either for concepts or for a specific contemporary event. It could, for example, be a representation of strength or courage (alluded to by the broken columns and the soldier) and charity (the woman suckling the child), both of which are susceptible to the vagaries of fate, suggested by the growing storm. It has also been seen as a political allegory of the recapture of Padua by Venetian forces in 1509, an interpretation based in part on the minute heraldic devices on the buildings in the background, which are thought to relate to the Venetian lion and the motif for Padua. Yet other interpretations see the subject as an obscure episode from the Old Testament, contemporary literature, or classical mythology. What is certain is that Giorgione changed the composition of the painting: X-rays have revealed that underneath the standing soldier on the left there was originally a seated naked woman, a discovery that further complicates our understanding of the artist's intentions for the work.

1478 Born Giorgio da Castelfranco in Castelfranco in the Veneto. Trains in Venice under Giovanni Bellini, then returns to Castelfranco.
c. 1505 Goes back to Venice and works there at the Fondaco dei Tedeschi.
c. 1508–1510 Paints his *Sleeping Venus*.
1510 Dies in Venice.

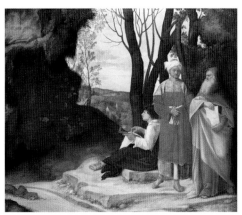

left page:
Giorgione, *La Tempesta*, c. 1510, oil on canvas, 78 x 72 cm, Accademia, Venice

left:
Giorgione, *Three Philosophers*, c. 1508–1509, oil on canvas, 123.8 x 144.5 cm, Kunsthistorisches Museum, Vienna

above:
Giorgione, *Self-Portrait as David*, c. 1500–1510, oil on canvas, 52 x 43 cm, Herzog Anton Ulrich-Museum, Brunswick

**1469–1492** Lorenzo de' Medici
rules in Florence

**1485** *Birth of Venus* (Botticelli)

**1506** Work starts or
St Peter's in R

| | | | | | | | | | | | | | | | | | | |
|1425|1430|1435|1440|1445|1450|1455|1460|1465|1470|1475|1480|1485|1490|1495|1500|1505|1510|

Michelangelo Buonarroti, *The Creation of
Adam*, 1511, ceiling fresco, Sistine Chapel,
Papal Palace, Vatican City

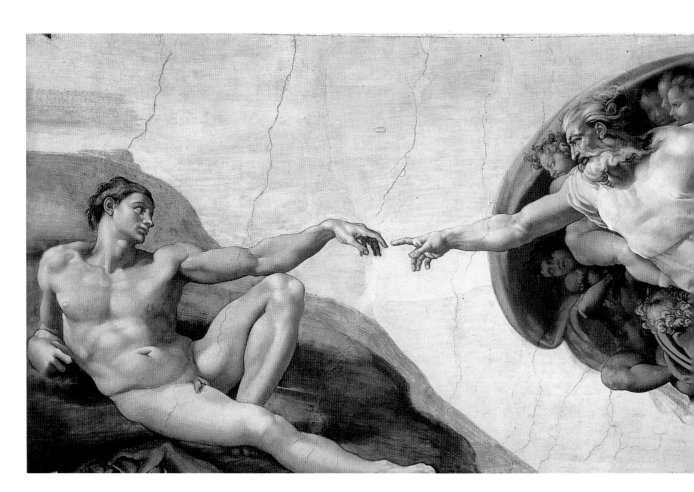

PIETER BRUEGEL THE ELDER

1514 † Donato Bramante

1526 Mogul Empire established in India

1576 Rudoph II becomes
Holy Roman Emperor

1567 *Claudio Monteverdi

1590 Dome of St Peter's
completed in Rome

1588 Destruction of the
Spanish Armada

1599 *Diego Velázquez

1515 1520 1525 1530 1535 1540 1545 1550 1555 1560 1565 1570 1575 1580 1585 1590 1595 1600

MICHELANGELO

# THE CREATION OF ADAM

*There are few works of art quite so famous or universally recognized as Michelangelo's* The Creation of Adam. *It is a compelling image of immense yet restrained power in which the whole drama of the Creation, and the longing for the divine, are concentrated into a the small gap separating the fingers of Adam and God.*

Michelangelo signed the contract to decorate the Sistine Chapel ceiling in 1508 with some reluctance and after much persuasion by Pope Julius II. Four years later the enormous project was complete after a Herculean effort, and just in time, for some months later Julius II died. Throughout a long career of virtually unequalled achievement,

Michelangelo's Sistine Chapel ceiling remains the culmination of his work and it can still, some five hundred years after it was painted, resonant with a extraordinary power.

Of the different narrative scenes depicted, *The Creation of Adam* and *The Last Judgment* are two of the most powerful and famous, though over twenty years separates them. As with much of the scheme for the ceiling, Michelangelo broke new ground with *The Creation of Adam*, depicting the scene in an entirely innovative and emotive manner. Adam can be seen languorously perched on the rim of a blue-green earth, his outstretched arm balanced across his knee. Michelangelo was already experimenting with his approach to anatomy, depicting Adam with a monumental torso, based on classical precepts but distorted, enlarged and made even more heroic than his antique models. This emphasis on the torso would be seen to even greater effect in the figure of Christ in *The Last Judgment*.

God the Father in the Creation scene combines the omnipotence of Christ in *The Last Judgment* with a protective manner as he cradles the figures around him. He appears with violent but contained energy, in contrast to the lethargic Adam, and is surrounded by cherubs and angels as he reaches out to pass the spark of life to Adam through his outstretched finger. Fully extended in a powerful line, the muscled arms of God and Adam focus attention on the small gap between their fingers. The expression on God's face is one of intense concentration, while Adam's appears wistful, awaiting the life about to be passed to him. The female figure who peers from under God's arm has been variously interpreted as Eve, already extant in God's mind, as Sophia (Wisdom), who according to Proverbs was by God's side during Creation, and (though with less plausibility) as the Virgin Mary. The two dark angels below God are commonly perceived as Lucifer and Beelzebub, whose fall from grace was caused by their rebellion against God.

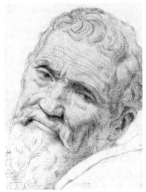

1475 Born Michelangelo Buonarroti 6 March in Caprese near Florence.
1488 Trains with Ghirlandaio.
1489 Lorenzo de' Medici admits Michelangelo to his academy.
1505 Pope Julius II commissions his tomb from him.
1508 Begins painting the Sistine Chapel.
1529 Appointed military engineer in Florence, and forced into exile in Venice.
1535 Pope Paul III appoints him the Vatican's principal sculptor, painter and architect.
1541 His *Last Judgment* is unveiled in the Sistine Chapel.
1546 Becomes architect of St Peter's.
1564 Dies 18 February in Rome.

Daniele da Volterra, *Michelangelo Buonarroti*, c. 1548–1553, black chalk, Tylers Museum, Haarlem

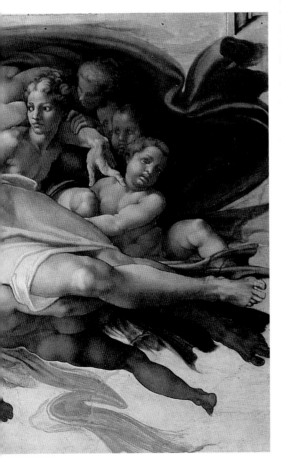

Michelangelo Buonarroti, *Sistine Chapel Ceiling*, 1508–1512, fresco, 137 x 390 m, Sistine Chapel, Papal Palace, Vatican City

The Creation of Adam marks a stylistic change in the course of the Sistine ceiling, which can be divided into two. The first part of the ceiling, painted between 1508 and 1510, comprises the first five baysof the ceiling, everything from the Prophet Zachariah to the top of The Creation of Adam, and the spandrels of those bays. There followed a break of approximately six months before Michelangelo resumed work in February 1511. The change in his style when work began again was dramatic and effective. He reduced the number of figures in the narratives, simplified the compositions, and enlarged the size of the individual figures. This gave the narratives greater impact, making them more readily seen and understood from far below, and emphasizing the emotive power of the figures. The ceiling was finally unveiled on All Saints' Day in 1512, with the second half of the ceiling having progressing much more quickly than the first. The commission for Michelangelo to repaint the altar wall in the chapel (with The Last Judgment), a task that involved destroying works by Pietro Perugino (1446–1524), did not come until 1533, this time from Pope Clement VII. Once again Michelangelo was reluctant—and once again he created a work of extraordinary drama, energy, and conviction.

**1431** Joan of Arc dies

**1455** War of Roses breaks out in England

**c. 1482** *La Primavera* (Botticelli)

**1432** *Ghent Altarpiece* (Jan van Eyck)

**1492** Columbus's first voyage of discovery to America

1425 1430 1435 1440 1445 1450 1455 1460 1465 1470 1475 1480 1485 1490 1495 1500 1505 1510

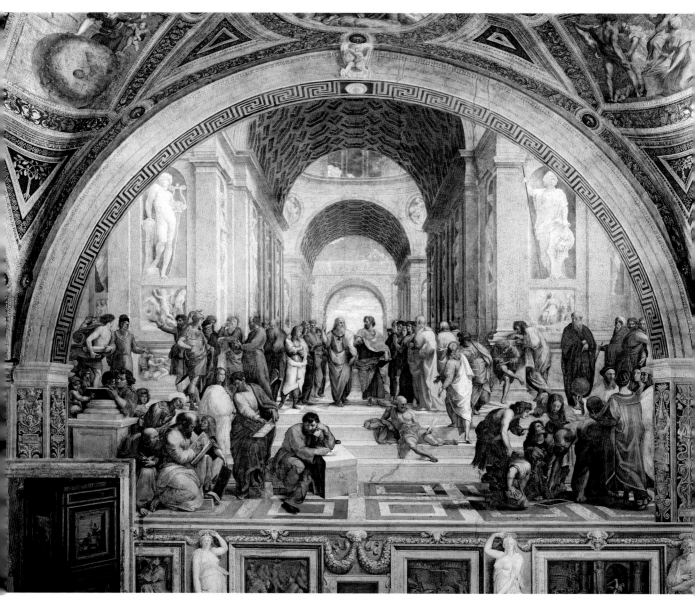

Raphael, *School of Athens*, 1510, fresco,
width max. 770 cm, Stanza della
Segnatura, Vatican Palace

**1517** Luther's 95 Theses (start of Reformation)

**1529** Ottoman Turks at the gates of Vienna

**1541** Michelangelo's *Last Judgment* in the Sistine Chapel unveiled

**1564** *William Shakespeare

**1571** Battle of Lepanto puts an end to Turkish naval supremacy

**1590** Dome of St Peter's in Rome completed

1515  1520  1525  1530  1535  1540  1545  1550  1555  1560  1565  1570  1575  1580  1585  1590  1595  1600

RAPHAEL

# SCHOOL OF ATHENS

*One of the greatest works of the High Renaissance, Raphael's* School of Athens *is the very embodiment of the Renaissance humanists' love of classical learning, of the Church's power and confidence, and of his supreme skills as an artist.*

Raphael left Florence in 1508 and travelled to Rome, summoned there by Pope Julius II to undertake an extensive redecoration of the Vatican Palace. Julius had made clear the year before that he did not appreciate the existing decorative scheme, painted by Pinturicchio (c. 1454–1513), in the apartment rooms of the second floor in the Vatican Palace, and had accordingly moved to the floor above, instigating an extensive program of redecoration.

The first room to be painted was the Stanza della Segnatura, in which Julius's library was located, although it later served as the Signatura Gratiae tribunal. Raphael based the decorative scheme of the room on the concept of harmony between classical antiquity and Christianity, addressing the humanist division of knowledge into theology, philosophy, poetry, and jurisprudence. The complex *School of Athens* represents philosophy. In the large central arch the figures of Plato (left) and Aristotle are framed. Their eloquent gestures show them to be deep in philosophical debate, their serene wisdom providing a calm focal point for the animated figures arranged around them. Raphael included the likeness of some of his contemporaries in the scene, with Plato widely thought to be based on Leonardo da Vinci. The classical architectural setting of monumental proportions adds to the weight and resonance of the intellectual group depicted. The architecture also alludes to Bramante's plans for St Peter's, which similarly combined classical antiquity and Christianity. Many of the figures can be identified. Socrates can be seen in the group to the left of Plato, adopting a characteristic hand gesture (touching the index finger of his left hand with the fingers of his right hand, as though enumerating the points of his argument) and addressing his students, including the Athenian general Alcibiades, depicted as a soldier.

In the foreground on the left is the seated figure of Pythagoras, writing on a tablet, the figures around him representing Grammar and Music. On the right side in the foreground Euclid bends down to demonstrate Geometry using his compass, while behind him Astronomy is represented. The figure of Euclid bears some similarities to Raphael's contemporary Bramante, while the young man looking directly from the scene to the far right of Euclid is a self-portrait by Raphael. The figure seated on the marble steps in the foreground, rather incongruously dressed and booted compared to the others, is believed to be the Greek philosopher Heraclitus, possibly shown with the features of Michelangelo. Raphael's depiction of this figure is different from his depiction of the others, being weightier and more massive in concept, which strongly suggests the influence of Michelangelo's newly uncovered Sistine Chapel ceiling. Sprawling behind Heraclitus is Diogenes, who in compositional terms perfectly balances Heraclitus.

It is the overriding balance and harmony of the fresco that lends it such immediate impact, maintaining a pervasive sense of classical calm despite the agitated gestures and varied poses of the many figures keenly debating. This is arguably the most satisfactory of the four large scenes Raphael painted in this room, the others being *The Disputa, Parnassus,* and *The Cardinal Virtues.*

**1483** Born Raffaello Santi in Urbino, presumably 6 April.
**1500** Apprenticed to Perugino in Perugia.
**1504** Travels to Florence.
**1508** Pope Julius II summons him to Rome.
**1512–1514** Paints his *Sistine Madonna.*
**1513** Works for Julius's successor Leo X.
**1514** Leo X appoints him architect and master of works at St Peter's.
**1520** Dies 6 April in Rome.

left:
Raphael, *Parnassus,* 1510/11, fresco, width max. 650 cm, Stanza della Segnatura, Vatican Palace

above:
Raphael, *Self-Portrait,* 1509, oil on wood, 45 x 35 cm, Galleria degli Uffizi, Florence

ANDREA MANTEGNA

**C. 1455**  Gutenberg prints the Bible

**1452**  *Leonardo da Vinci

**1472**  Dante's *Divine Comedy* first printed

**1444**  *Donato Bramante

**1519**  Charles V
becomes Holy
Roman Emperor

| 1435 | 1440 | 1445 | 1450 | 1455 | 1460 | 1465 | 1470 | 1475 | 1480 | 1485 | 1490 | 1495 | 1500 | 1505 | 1510 | 1515 | 1520 |

Grünewald, *The Isenheim Altarpiece*,
closed: *Crucifixion / Lamentation of
Christ / St Anthony and St Sebastian*),
1512/13–1515, oil on wood, approx.
336 x 598 cm, Unterlinden Museum,
Colmar

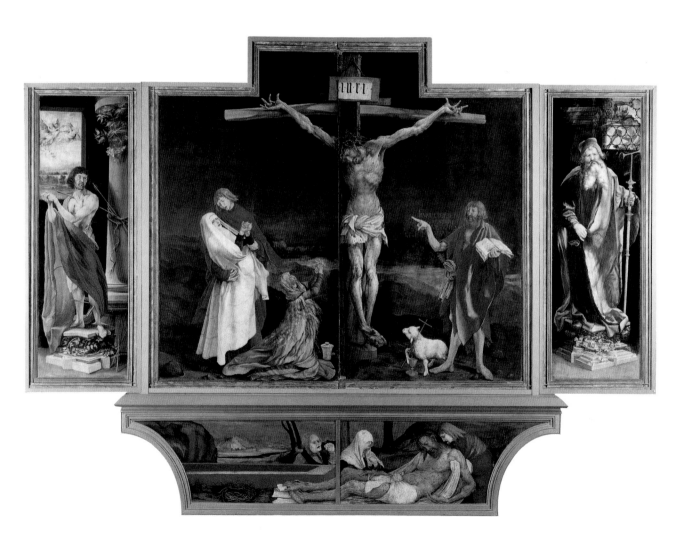

1520-1521  Magellan circumnavigates the globe

1562  Religious wars break out in
France (Huguenots)

1555  Nostradamus writes his *Prophecies*

1571  Benvenuto Cellini dies in Florence

1600  *Claude Lorrain

| 1525 | 1530 | 1535 | 1540 | 1545 | 1550 | 1555 | 1560 | 1565 | 1570 | 1575 | 1580 | 1585 | 1590 | 1595 | 1600 | 1605 | 1610 |

MATTHIAS GRÜNEWALD

# THE ISENHEIM ALTARPIECE

*Rightly considered one of the most important works of the German Renaissance, Matthias Grunewald's magnificently eclectic and intensely emotive* Isenheim Altarpiece *combines brutal depictions of pain and suffering with radiant images of celestial bliss.*

Tucked away in the foothills of the Grand Ballon d'Alsace and partway between the mediaeval towns of Colmar (now in France) and Basel (Switzerland) is the Monastery of Saint Anthony. It was here that Grünewald's masterpiece the *Isenheim Altarpiece* was first located before being moved to the Unterlinden Museum in Colmar. The monastery was home to a specialist hospital run by the Antonine monks, who treated skin diseases of the worst kind, including conditions brought on by the plague and by a type of fungus that caused a disease known as Saint Anthony's Fire.

The imposing altarpiece was initially funded by the monastery's patron, Johan de Orliaco, who commissioned Nikolaus Hagenauer and Desiderius Beichel to produce a sculptural group. Following Orliaco's death, Guido Guersi, a wealthy Sicilian, commissioned Grünewald to produce painted panels to be incorporated with the sculptures. Once finished, the altarpiece was used as the first part of the patients' healing process. The sick were led past the work and allowed to reflect, before being treated with medical and further spiritual remedies, on the image of the crucified Christ.

Complex in design and iconography, the altarpiece is full of innovative and surprising details, not least the unusual scenes and subjects depicted. Structurally, the work comprises three hinged wings, that originally folded back separately, on which there are nine painted panels by Grünewald. Today it is displayed in separate sections at the museum so that it can be viewed as a whole, but this was not the original intention. For the majority of the time, and during

most of the week, the polyptych would have been kept closed, so that the exterior bearing the pitiful and tortured image of the crucified Christ, flanked by St Anthony and St Sebastian (patron saint of the plague), was visible. On religious occasions, such as Sundays and various holy days, the first wing would be opened to reveal *The Annunciation*, *The Incarnation*, and *The Resurrection*; and on the days that celebrated the patron saints of the monastery the second wing would be folded back to reveal the sculpted figures by Nikolaus Hagenauer and Desiderius Beichel. The third wing includes Grünewald's *The Temptation of St Anthony* and *The Meeting of St Anthony and the Hermit Paul*. Grünewald's painted panels represent some of the most accomplished and unusual works of his time, with *The Incarnation*, comprising of the scenes of *The Angel Concert* and *Madonna in the Garden*, being among the most striking. In *The Angel Concert* on the left side of the panel, enigmatic figures perform a celestial concert surrounded by rich garlands and an

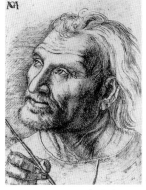

C. 1475–1480  Born Mathis Gothart-Nithart in Würzburg.

1504–1505  Documented as a painter in Aschaffenburg.

1511  Paints a panel on Dürer's *Heller Altar* in Frankfurt.

AFTER 1517  Enters the service of Albrecht von Brandenburg, Archbishop of Mainz.

1528  Dies 31 August in Halle an der Saale.

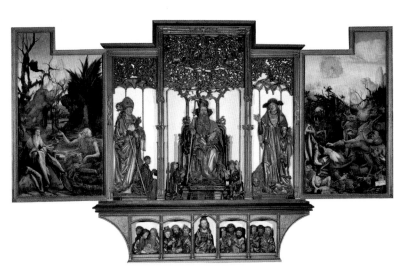

right:
Grünewald, *The Isenheim Altarpiece (The Meeting of St Anthony and the Hermit Paul, The Temptation of St Anthony*, gilt sculptures of SS Anthony, Augustine and Jerome, Christ and an Apostle), 1512/13–1515, Unterlinden-Museum, Colmar

above:
Grünewald, "Self-Portrait," early 17th century, pen and chalk on paper, 31.1 x 20 cm, Gemäldegalerie, Kassel

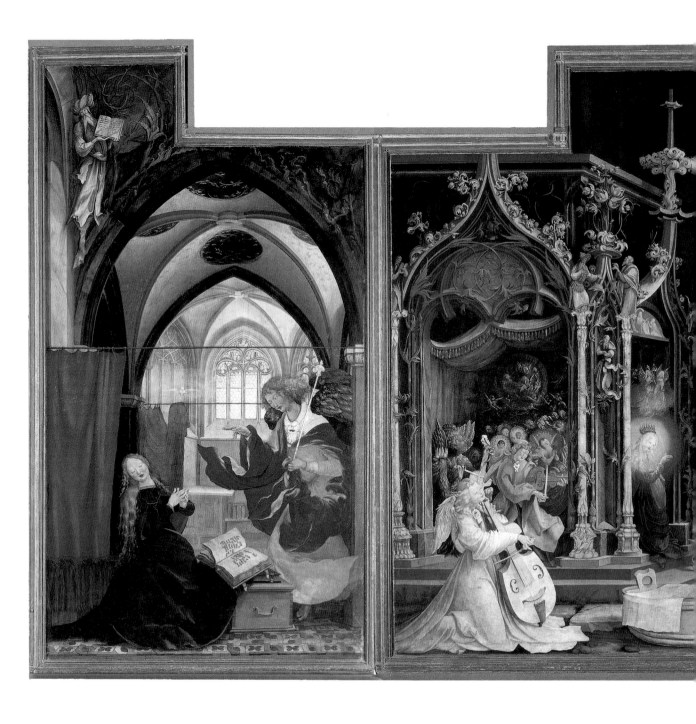

elegant architectural framework. This scene represents a profusion of activity and heady emotion, a small pocket of vibrant and harmonious delight that contrasts with the serenity of the adjacent *Madonna in the Garden*. This underlines the most immediately felt aspect of the altarpiece, its eclectic mix of styles, colors and moods. Of particular note is the

artist's use of brilliant color to convey or elicit an emotional response, most admirably demonstrated in *The Resurrection*. Here the figure of Christ rises in a golden light that is so brilliant that the soldiers fall back dazzled—a radiance that forms a truly mystical mantle around Christ as he ascends to heaven, free of the shackles of the earthly abode.

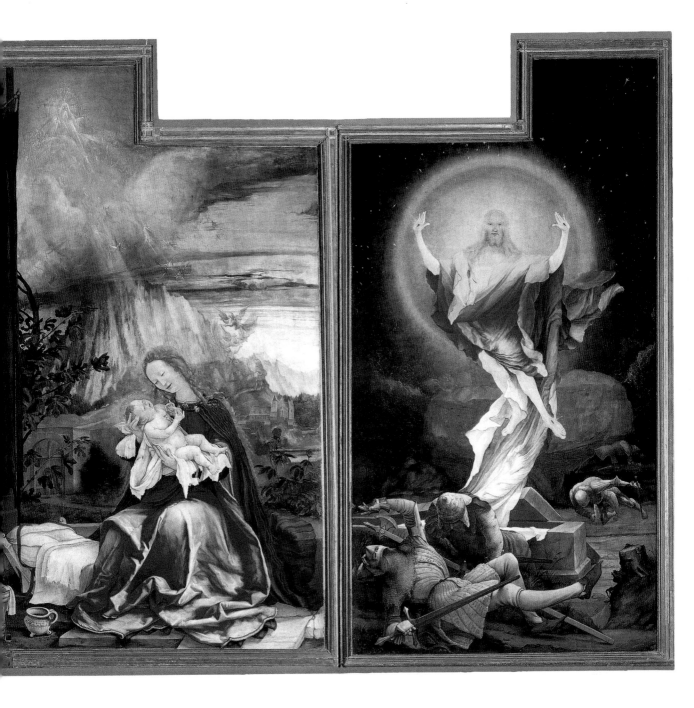

VERONESE

TINTORETTO

GIORGIONE

**1501** Michelangelo begins work
on the statue of David

**1453** Constantinople falls to
the Ottoman Turks

**1471** *Albrecht Dürer

**1492** Columbus's first voyage
of discovery to America

**1514** Niccolò Machiavelli
writes *Il Principe*

| 1450 | 1455 | 1460 | 1465 | 1470 | 1475 | 1480 | 1485 | 1490 | 1495 | 1500 | 1505 | 1510 | 1515 | 1520 | 1525 | 1530 | 1535 |

Titian, *The Venus of Urbino*, 1538, oil on
canvas, 119 x 165 cm, Galleria degli Uffizi,
Florence

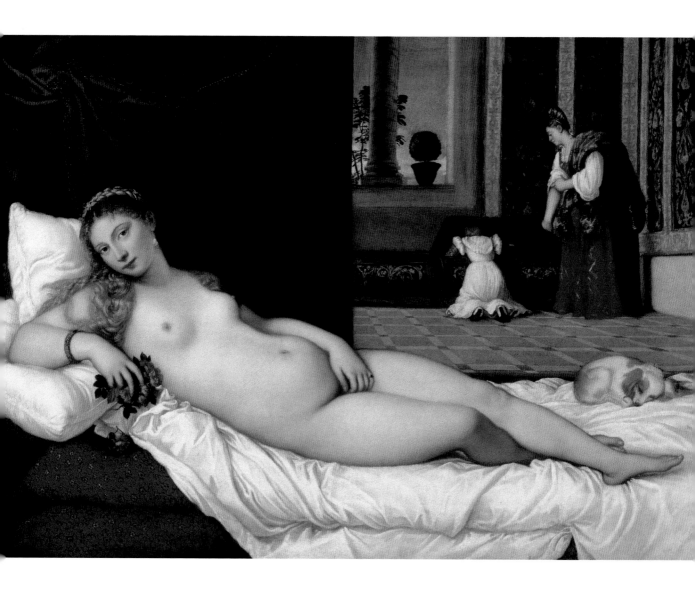

1555 Peace of Augsburg ends religious
wars in Germany

1571 Battle of Lepanto puts an end
to Turkish naval supremacy

1602 Dutch found Cape Colony
in South Africa

1624 Founding of
New Amsterdam
(New York)

1618 Thirty Years'
War breaks
out

1540   1545   1550   1555   1560   1565   1570   1575   1580   1585   1590   1595   1600   1605   1610   1615   1620   1625

TITIAN

# THE VENUS OF URBINO

*The little spaniel at the feet of "Venus" was most probably included as a symbol of fidelity and love, suggesting that this work was made to commemorate the marriage of Guidobaldo della Rovere to Giuliana Varano. It may well have been a much-loved family pet, for it appears again in Titian's portrait of Guidobaldo's mother, Eleonora Gonzaga della Rovere.*

There are few women in art who have caused quite such controversy and debate as Titian's famous "Venus" of Urbino, except perhaps her direct modern counterpart, Edouard Manet's *Olympia* (1863). There has been much debate over the supposed purpose of *The Venus of Urbino*—whether it is a piece of Renaissance erotica, a commemorative work, or an allegory—and also over the identity of the figure. She has through the years been alternatively vilified and praised. In *Tramp Abroad* (1880), Mark Twain said the painting was "the foulest, the vilest, the obscenest picture the world possesses," while Titian's contemporary Giorgio Vasari, describing the subject as a "young Venus, reclining, with flowers and certain fine draperies around [her]," claimed that it was the most beautiful nude Titian had ever painted.

Some of the mystery surrounding the recumbent and ravishing figure has been dissipated. The painting is now known to have been painted for Guidobaldo della Rovere, the son of Francesco Maria della Rovere, Duke of Urbino, in 1538, the year Francesco Maria died. Titian had enjoyed a long and fruitful relationship with Francesco Maria, which extended to Guidobaldo, and had painted many portraits for this powerful family. But *The Venus of Urbino* represented a new direction for the artist and his patrons. She is nude, provocatively so, and manifestly in an everyday contemporary setting instead of a respectable classical or mythological context. She is most commonly interpreted as a symbol of marital love, a view supported by the dog (a symbol of fidelity) and by the maids, who clearly establish a domestic setting. The chest the maids are searching could be a *cassone* (chest) traditionally commissioned by bridegrooms in which their wives stored their trousseaux, while the roses in "Venus's" right hand are customarily representative of love. Such details support the supposition that the painting was made to commemorate the marriage of Guidobaldo to Giuliana Varano in 1534.

The work is unquestionably one of eroticism, and differs greatly in this respect from Giorgione's earlier painting *The Sleeping Venus* (c. 1510). Giorgione can be largely credited with devising the motif of the recumbent nude female figure, and also with setting the female nude in a landscape setting. There exists no true precedent for Giorgione's image, and it became one of the most influential in terms of pose. Titian was very familiar with the painting; he had in fact completed it after Giorgione's untimely death. When he came to paint his own Venus decades later, however, he turned her from the celestial, goddess-like and sleeping figure of Giorgione's creation into a clearly defined, earthy, sensuous, watchful and alluring woman. Titian's Venus is masterfully provocative, from the blush of her fine cheeks and the swell of her breast to her curled fingers that rest (or caress) her pudenda. It was not uncommon at this time, and into the 17th and 18th century, for paintings of an explicitly erotic nature to be commissioned to commemorate a marriage or an engagement, such works being intended for private viewing only. It is probable, though not proven, that this was the intended role of *The Venus of Urbino*.

C. 1477 OR 1488 Born Tiziano Vecellio
in Pieve di Cadore.
1508 Works with Giorgione in Venice.
1513 Pope Leo X invites him to Rome,
but Titian turns him down.
1530 Paints the coronation picture of
Emperor Charles V.
1533 Charles V appoints him his per-
sonal painter and ennobles him.
1541 Awarded an imperial pension.
1545 Works for Pope Paul III in Rome.
1548 Charles V takes him with him to
the Diet of Augsburg.
1553 Works for Charles's son Philip II.
1576 Dies 27 August in Venice.

left:
Edouard Manet, *Olympia*, 1863, oil on canvas, 103.5 x 190 cm, Musée d'Orsay, Paris

above:
Titian, *Self-Portrait*, c. 1550, oil on canvas, 96 x 75 cm, Gemäldegalerie, Staatliche Museen, Berlin

Titian, *Assunta*, 1516 –1518, oil on wood,
690 x 360 cm, Santa Maria Gloriosa dei
Frari, Venice

right page:
Titian, *The Crown of Thorns*, 1570, oil on
canvas, 280 x 182 cm, Alte Pinakothek,
Bayerische Staatsgemäldesammlungen,
Munich

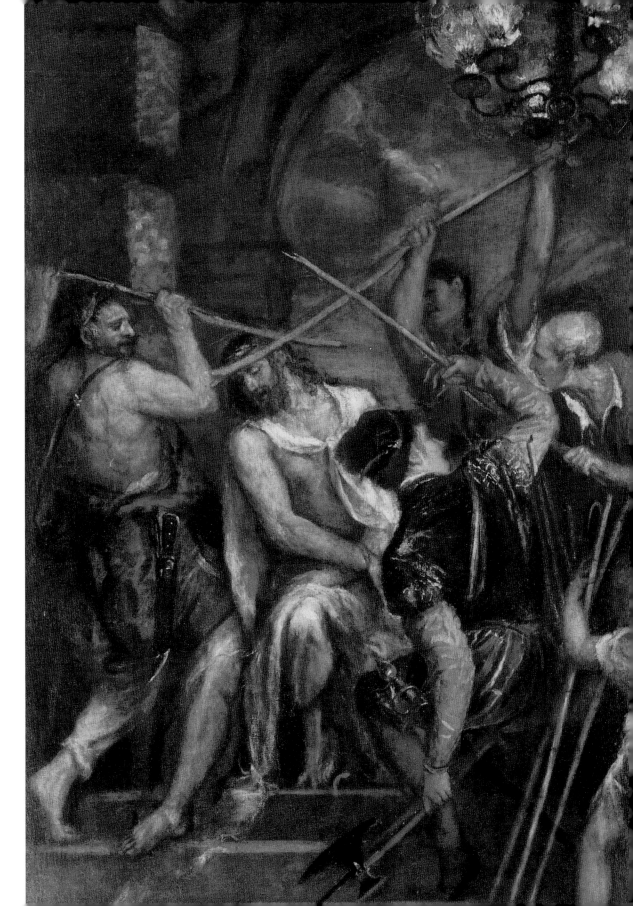

**1506** Work starts on new
St Peter's in Rome

**1492** Moorish rule in the Iberian peninsula ends
with the reconquest of the kingdom of Granada

**1517** Luther's 95 Theses (start
of the Reformation)

**1534** Act of Supremacy makes
Henry VIII head of the
Church of England

**1541** Michelangelo completes
the Sistine frescoes

| 1460 | 1465 | 1470 | 1475 | 1480 | 1485 | 1490 | 1495 | 1500 | 1505 | 1510 | 1515 | 1520 | 1525 | 1530 | 1535 | 1540 | 1545 |

right:
Veronese, *The Supper in the House of Levi*,
1573, oil on canvas, 555 x 1,280 cm,
Galleria dell'Accademia, Venice

below:
Veronese, *The Wedding at Cana*, 1563,
oil on canvas, 669 x 990 cm, Musée du
Louvre, Paris

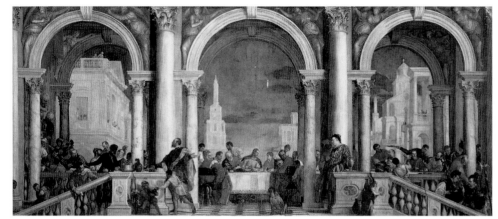

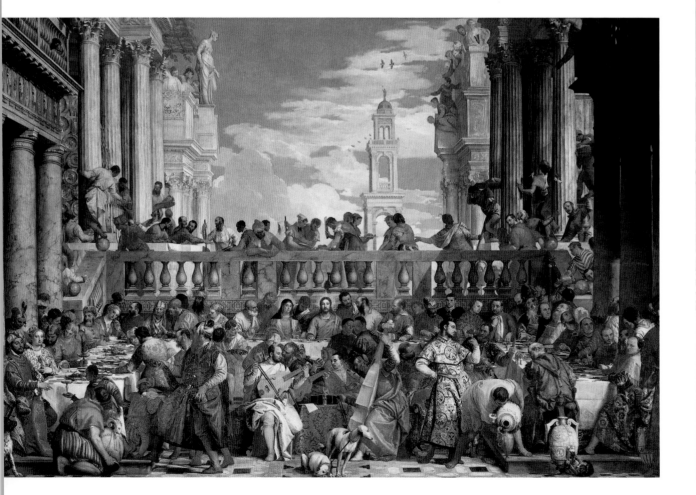

**1605** Publication of the first part of
Cervantes' *Don Quixote*

**1633** Trial of Galileo
by the Inquisition

**1618** Thirty Years' War breaks out

**1609** Galileo constructs his astronomical
telescope in Venice

| 1550 | 1555 | 1560 | 1565 | 1570 | 1575 | 1580 | 1585 | 1590 | 1595 | 1600 | 1605 | 1610 | 1615 | 1620 | 1625 | 1630 | 1635 |

PAOLO VERONESE

# THE WEDDING AT CANA

*As the original was appropriated by Napoleon Bonaparte, and now hangs in the Louvre in Paris, a digital image of Paolo Veronese's* The Wedding at Cana *can now be seen in the setting for which the huge painting was originally intended, the Church of San Giorgio Maggiore in Venice.*

Veronese was the consummate painter of banquets and feast. He addressed the theme several times during his career, and on each occasion constructed complex yet fully integrated multi-figural compositions. Such paintings include *The Supper in Emmaus* (c. 1560) and *The Supper in the House of Levi* (1573), with the virtuoso *Wedding at Cana* being arguably the finest of his banquet scenes. It comprises over one hundred and thirty figures, many of whom were recognizable contemporaries of the artist. His self-portrait is included as the man in a white tunic in the foreground playing a lyre, and the portrait of Titian as the man sitting opposite him. The number of figures included in paintings was a subject that became contentious particularly in the 17th century, when the inclusion of too many figures was deemed by some artists to show a lack of skill in eliciting expression and atmosphere through individual gestures. Veronese characteristically depicted many individuals, which allowed him to demonstrate his great skill as a draughtsman, and to emphasize the vitality of a busy scene. In some instances, however, artists were allegedly paid according to how many people they depicted, which undoubtedly influenced the numbers involved!

*The Wedding at Cana* depicts a story from the New Testament that relates how Jesus and the Disciples were invited to a wedding feast at Cana. When the wine ran out Jesus instructed men to fill jugs with water, which he then turned into wine. This was the first of his seven miracles. Veronese has incorporated classical and contemporary elements into the painting, the architectural setting being predominantly classical and the people's clothes variously classical, contemporary and even Oriental. Further, he created a seamless collaboration of the secular and the sacred, from the heavy silver Renaissance dining ware to a range of religious symbols. Amid all the activity, the seated figure of Christ is the focal point in this enormous canvas, and he is the only figure to stare directly out, establishing contact with the viewer. Above his head servants slaughter an animal, widely supposed to be a lamb and symbolic of the forthcoming sacrifice of Christ. The detail in this work is extraordinary, ranging as it does from the dwarf in the foreground on the left holding a parrot to the dog poking its nose through the balustrade at the top left and the cat playing on its back on the right, small incidents that lend the scene a sense of immediacy and vitality.

The painting was commissioned in 1562 to hang in the refectory of the Benedictine monastery of San Giorgio Maggiore, Venice, and was, despite its vast size, finished the following year. Of particular interest in this connection is the fact that although the many figures in the work interact with each other, none is speaking. This relates to the strict code of silence kept by Benedictine monks in their refectories. The work remained in the monastery until 1797, when it was taken by Napoleon Bonaparte during his invasion of Italy, and returned with him to Paris. This marked the start of an eventful life for the work, which has suffered considerably since. During its initial transit to Paris the canvas was cut in half, and then stitched back together again in France. After the invasion and during attempts at conciliation, the painting was not returned, though others were, and in its place a work by the French artist Charles Le Brun was sent to Italy. During the Franco-Prussian war (1870–1871) it was allegedly rolled up and stored in a box, undergoing a similar fate during World War II. In 1989 it was partially restored at the Louvre, then in 1992 it was damaged twice: firstly when water leaked from an air vent, and then when it fell from the wall and the canvas was torn in five places.

**1528** Born Paolo Caliari in Verona.
**1548** Moves to Mantua.
**1553** Moves to Venice.
**c. 1561–1562** Commissioned to paint Palladio's Villa Barbaro in Maser.
**1563** Paints *The Wedding at Cana.*
**1573** Paints *The Feast at the House of Levi.*
**1588** Dies 19 April in Venice.

Veronese, detail from *The Supper at the House of Levi* (supposedly a self-portrait), 1573, oil on canvas, 555 x 1280, Galleria dell'Accademia, Venice

**ALBRECHT ALTDORFER**

**1488** Portuguese navigator Bartolomeu Diaz is the first
European to sail round the Cape of Good Hope

**1492** Columbus's first voyage
of discovery to America

**1524–1526** Peasants' War
in Germany

| | | | | | | | | | | | | | | | | | |
|---|---|---|---|---|---|---|---|---|---|---|---|---|---|---|---|---|---|
| 1470 | 1475 | 1480 | 1485 | 1490 | 1495 | 1500 | 1505 | 1510 | 1515 | 1520 | 1525 | 1530 | 1535 | 1540 | 1545 | 1550 | 1555 |

Pieter Bruegel the Elder, *The Tower of
Babel*, 1563, oil on oak, 114 x 155 cm,
Kunsthistorisches Museum, Vienna

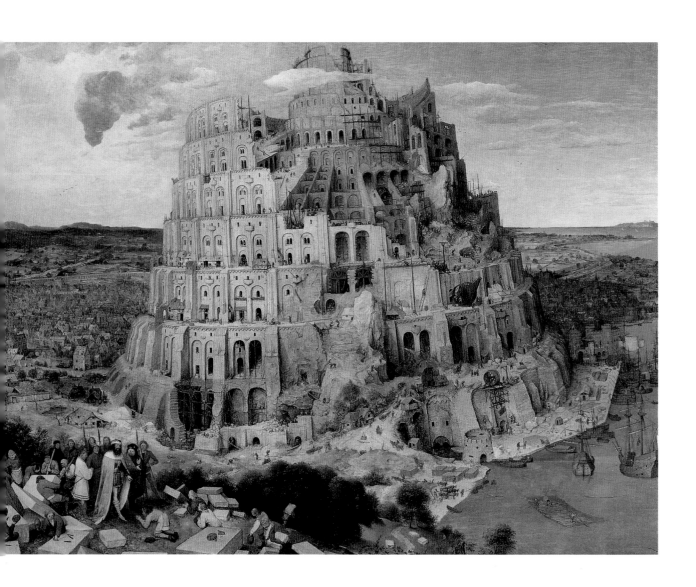

**1620** The *Mayflower* lands
in America

**1609** Johannes Kepler
publishes
*Astronomia Nova*

**1639** East India Company
founds Madras

**1558** Elizabeth I crowned
queen of England

**1624** Founding of New Amsterdam
(New York)

**1618–1648** Thirty Years' War

**1643** Louis XIV becomes
king of France

1560   1565   1570   1575   1580   1585   1590   1595   1600   1605   1610   1615   1620   1625   1630   1635   1640   1645

## PIETER BRUEGEL THE ELDER

# THE TOWER OF BABEL

*Setting a biblical story in a contemporary Netherlandish setting, Pieter Bruegel created a compelling allegory that some consider just as relevant today as in the 16th century—of the dangers posed by human arrogance and pride.*

Bruegel embodied moralizing themes into many of his paintings, one of the most compelling being *The Tower of Babel*. It is a complex painting, into which he wove a number of allusions and themes, above all the dangers of human pride. He took the subject from a story in the Book of Genesis that relates how the people of Babel (Babylon) wished to build a great tower with its top in the heavens—not for the glory of God but as a mark of man's accomplishment. On seeing what they were doing, God gave each person a different language, so that they were unable to communicate and in the ensuing confusion work faltered and the tower finally collapsed. Bruegel painted this subject on three occasions, with the version from the Kunsthistorisches Museum being the largest and most complex in structure and theme. The tower itself, which is rendered in minute and exacting detail, recalls the ruins of the Colosseum in Rome, which Bruegel had seen ten years earlier. Significantly, this is the only classical structure the artist ever depicted, even though he produced numerous Italian landscapes during his travels. The tower is depicted with monstrous proportions, hulking over the surrounding scenery and gradually collapsing inwards, unsteady at its base, an allusion to the necessity for strong spiritual foundations in man. Further, Bruegel has drawn a parallel between the opulent excesses of Rome and those of Babylon, alluding to the Roman Empire's presumption of everlasting power and the reality of its fall and decay. He also threaded reference to his contemporary Antwerp into the painting, placing the tower in a Netherlandish coastal landscape that reflects the country's wealth, which was based on sea trade and commerce. There is an implied warning here: the rapid expansion of Antwerp, seen through the busy engineers in the painting, might lead to a breakdown of order and mass confusion, resulting in the downfall of the city. This combination of ancient and contemporary references emphasizes the profundity of his message regarding the fall of

man through pride, the moral being expressed in a contemporary and so easily understood context. The subsidiary theme of the vanity of human endeavor is illustrated by the frenzied efforts of the builders, efforts which are clearly futile.

One of the most striking aspects of the painting is the detailed accuracy with which Bruegel depicted the engineering works and building techniques. His knowledge of building methods was extensive, and at the time of his death he was working on a series of paintings documenting the construction of a canal linking Antwerp to Brussels. A similar attention to detail can be seen in the painting *The Tower of Babel* by Tobias Verhaecht, which owes a considerable debt to Bruegel's earlier work, both in pictorial structure and mood, though it lacks the intensity of feeling and virtuosity of brushstroke seen in the older artist's version. Indeed it was a popular subject, especially in northern Europe, with notable versions by Marten van Valckenborch's, Frans Franken II, and Bruegel's son, Pieter, all reflecting the influence of Bruegel's innovative and compelling painting.

**c. 1526–1530** Born in Brabant.
**1551** Become a member of St Luke's
Guild in Antwerp.
**1552–1554** Travels to France and Italy.
**1563** Marries Mayken Coecke, his
teacher's daughter, and they
move to Brussels.
**1564** Their son Pieter is born.
**1565** Paints his *Seasons* pictures.
**1568** His son Jan is born.
**1569** Dies 9 September in Brussels.

left:
Pieter Bruegel the Younger, *The Tower
of Babel*, 1585–1595, oil on wood,
145 x 176.5 cm, privately owned, Brussels

above:
Pieter Bruegel the Elder, *Self-Portrait*,
c. 1565, pen drawing, Albertina, Vienna

Pieter Bruegel the Elder, *Peasant
Wedding*, c. 1568, oil on wood,
114 x 163 cm, Kunsthistorisches
Museum, Vienna

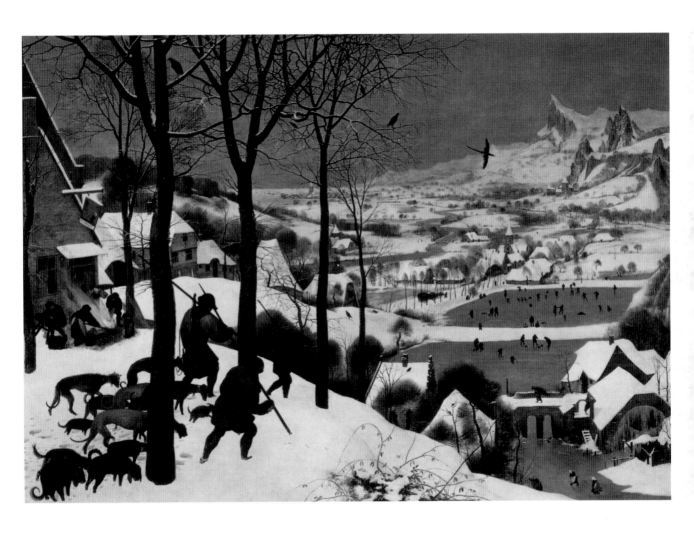

Pieter Bruegel the Elder, *Hunters in the Snow*, 1565, oil on wood, 117 x 162 cm, Kunsthistorisches Museum, Vienna

**1533** Spanish troops conquer
the Inca empire

**1562** Religious wars break out
in France (Huguenots)

1500  1505  1510  1515  1520  1525  1530  1535  1540  1545  1550  1555  1560  1565  1570  1575  1580  1585

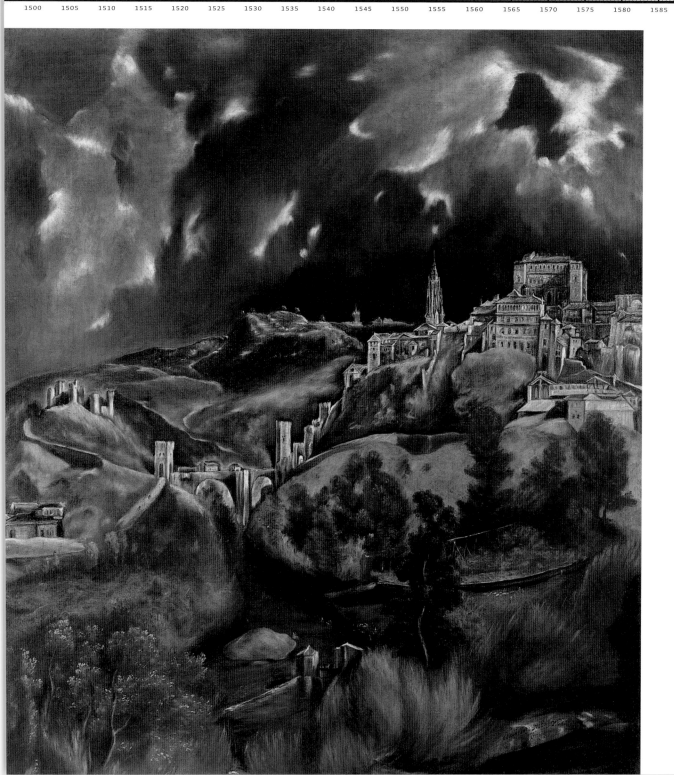

1590 Dome of St Peter's in
Rome completed

1603 Shakespeare's *Hamlet*
published in First Quarto

1624 Founding of New Amsterdam
(New York)

1649 Oliver Cromwell turns England
into a Commonwealth

1588 Destruction of the Spanish Armada

1609 Moors driven out of Spain

1648 Treaty of Westphalia ends
Thirty Year's War

1666 Fire of London

1590  1595  1600  1605  1610  1615  1620  1625  1630  1635  1640  1645  1650  1655  1660  1665  1670  1675

EL GRECO

# VIEW OF TOLEDO

*El Greco's* View of Toledo *is not only one of the earliest paintings devoted purely to landscape, it is also one of the greatest works in this genre, curiously modern in its depiction of a recognizable place transformed by an intense personal vision.*

In the late 1570s, and while living in Rome, the Greek-born El Greco dared to criticize the work of Michelangelo; and not content with slandering the most revered artist in Italy, he allegedly also squabbled with the eminent writer on art Giorgio Vasari. As a result of his ill-judged comments, potential patrons in Rome were ill-disposed to the newcomer, and towards the end of the decade he moved to Spain, visiting Madrid for a short period before settling in Toledo.

It was in this cosmopolitan center, famous for its religious tolerance and its multi-cultural heritage, that El Greco lived out his days and produced two of his most famous paintings, his *View of Toledo* and the *Burial of Count Orgaz* (c. 1586). The *View of Toledo* is one of the earliest landscape paintings in Western art. It is, typically of El Greco, a unique interpretation of the view and represents his synthesis of recognizable topographical features and a vision entirely his own. The result is a view that, while it evokes recollection of the city and its surroundings, is entirely imbued with his personal aesthetic. In this regard it is similar in approach to his portrait paintings, which likewise move beyond mere representation to create works with a profound depth of meaning. This is particularly the case felt in his late portraits, such as the mesmeric *A Cardinal* (probably Cardinal Nino de Guevara) (c. 1600–1601) and the intense *Fray Hortensio Felix Paravicino* (c. 1609). His *View of Toledo* is one of only two landscape paintings by him, the other being his *View and Plan*. This painting also depicts Toledo, but with greater cartographical accuracy, though El Greco's fantastical imagination can still be clearly seen. Other than these two landscape paintings, a recognizable view of Toledo appeared frequently in the background of his other works during the last period of his life. The *View of Toledo* presents a panorama of the city from the north, though he included only the easternmost part of it, as well as that which lies above the Tagus River. From this viewpoint the cathedral could not

have been seen, so El Greco moved it to the left of the magnificent royal palace. From there several unidentifiable buildings cling to the steep hillside that slopes down to the Roman Alcántara Bridge, which spans the Tagus River. On the far side of the bridge is the castle of San Servando and below this, resting on a magical, cloud-like form, is a cluster of smaller buildings. These also appear in *View and Plan*, suggesting their importance to the artist, though they cannot be unequivocally identified. One theory suggests that they represent the Agaliense Monastery, which was associated with Saint Ildefonso, the patron saint of Toledo.

Most striking in this landscape is the artist's conceptual interpretation of the view, which lends the work a strikingly "modern" appearance more in line with works of the late 19th and early 20th centuries. El Greco's style moved from the Byzantine-inspired works of his early career, through his humanistic rendering of Renaissance art in Rome to his thoroughly innovative late Toledo works. He was among the most original and prodigious artists of his time, with his *View of Toledo* representing him at his most original.

c. 1541 Born Dominikos
Theotokopoulos in Crete.
1567 El Greco ("the Greek) goes to
Venice.
1570–1576 Moves to Rome.
1576 Leaves Italy for Spain, settling
first in Madrid, then in Toledo.
c. 1586 Paints his *Burial of the Count
of Orgaz*.
1614 Dies 7 April in Toledo.

left page:
El Greco, *View of Toledo*, c. 1595/1600, oil on canvas, 121.3 x 108.6 cm, Metropolitan Museum of Art, New York

left:
El Greco, *Burial of the Count of Orgaz*, c. 1586, oil on canvas, 488 x 360 cm, Santo Tomé, Toledo

above:
El Greco, *Portrait of an Old Man* (presumed self-portrait), c. 1595/1600, oil on canvas, 52.7 x 46.7 cm, Metropolitan Museum of Art, New York

ANNIBALE CARRACCI

GIANLORENZO BERNINI

GEORGES DE LA TOUR

**1532** Niccolò Machiavelli's *Il Principe* published posthumously

**1555** Peace of Augsburg

**1569** Cosimo I Medici becomes Grand Duke of Tuscany

**1597** Quarto version of Shakespeare's *Romeo and Juliet* published

1520  1525  1530  1535  1540  1545  1550  1555  1560  1565  1570  1575  1580  1585  1590  1595  1600  1605

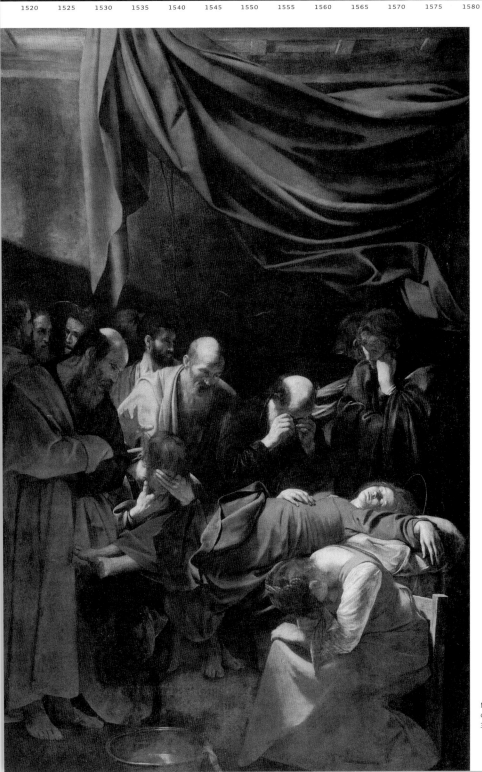

Michelangelo Merisi da Caravaggio, *The Death of the Virgin*, 1601–1605/06, oil on canvas, 369 x 245 cm, Musée du Louvre, Paris

**1618–1648** Thirty Years' War      **1643** Louis XIV becomes king of France

**1610** Monteverdi composes his *Vesper Psalms*      **1633** Trial of Galileo by the Inquisition      **1665** Great Plague devastates London

**1685** *Johann Sebastian Bach

1610 · 1615 · 1620 · 1625 · 1630 · 1635 · 1640 · 1645 · 1650 · 1655 · 1660 · 1665 · 1670 · 1675 · 1680 · 1685 · 1690 · 1695

CARAVAGGIO

# THE DEATH OF THE VIRGIN

*Caravaggio's dramatic realism is vividly illustrated by his harrowing* The Death of the Virgin. *His frank and uncompromising depiction of the dead Virgin Mary, who is hardly distinguishable from a peasant, was immediately rejected by the monks who had commissioned it.*

Caravaggio is an artists whose character and life have aroused almost as much interest as his breathtaking paintings, which are characterized by their striking realism and drama. His volatile and unstable character has become legendary. In 1606, not long after completing *The Death of the Virgin*, his irascible nature led him to kill a man called Ranuccio Tommasoni in Rome during an argument over a bet on a game of tennis. Caravaggio immediately fled the city with charges of capital punishment looming over his head.

His late Rome years from 1599 to 1606 were a time of unprecedented success for him. During this time he produced works such as *The Calling of St Matthew* (1599–1600), *The Conversion of St Paul* (1601) and *The Supper at Emmaus* (1601), all of which earned him fame and notoriety in equal parts. He had worked in Rome since around 1592 and by 1599 had developed his mature style. His unrelenting realism was not always appreciated by religious foundations, who argued that he turned sacred scenes to secular ones. This was the charge made against his monumental *The Death of the Virgin*. The painting was commissioned by Laerzio Cherubini, a papal lawyer, to hang in his private chapel in the Carmelite church of Santa Maria della Scala in Rome, but on completion the work was rejected by the monks, who were offended by the brutal realism of the dead Virgin and by the lack of any sacred symbolism. A painting of the same subject by Carlo Saraceni was hung in its place and Caravaggio's work was eventually bought by Charles I, Duke of Mantua, on the recommendation of Peter Paul Rubens.

The crucial difficulty was his depiction of Mary. Caravaggio is believed to have modeled her on a prostitute; some accounts suggest that the model was dead, having drowned in the Tiber. Mary is certainly depicted as unequivocally dead, with thick, swollen ankles, a lolling head, a face devoid of idealization, and arm flung wide. The only trace of the sacred is a thin, barely discernible halo. The brutal starkness her death scene was characteristic of Caravaggio, who was a master of realistic and highly dramatic scenes firmly based on everyday life. With *The Death of the Virgin*, the real issue was the precise nature of the death and assumption of the Virgin. Catholic doctrine states that the Virgin rose to heaven "body and soul" intact, which suggests she is did not fully die in human terms. Many 17th-century Catholic orders denied her actual death, and consequently in many paintings—such as Guercino's *The Assumption of the Virgin* (1623) and Nicolas Poussin's *The Assumption of the Virgin* (1649–1650)—she is seen as still living. Further, in Caravaggio's image none of the attending Apostles can be readily identified; they appear to be a collection of very ordinary people grieving over a very ordinary woman. For Caravaggio's supporters, it is precisely the uncompromising realism of the scene, its intense and concentrated despair, that makes it a work of true piety.

**1571** Born Michelangelo Merisi 29 September in Milan.
**1592–1606** Lives and works in Rome.
**1602–1603** Paints *Amor Vincit Omnia*.
**1606–1607** Kills a young man in a brawl and has to flee from Rome to Naples.
**1607–1608** Spends time in Malta.
**1608** On 14 July, admitted to the Order of St John, but is involved in a brawl and escapes to Sicily.
**1610** Dies in Port'Ercole, Italy, on the way back to Rome.

left:
Michelangelo Merisi da Caravaggio, *The Calling of St Matthew*, 1599–1600, oil on canvas, 322 x 340 cm, San Luigi dei Francesi, Rome

above:
Ottavio Leoni, *Portrait of Caravaggio*, c. 1621–1625, pastel drawing, 23.4 x 16.3 cm, Biblioteca Marucelliana, Florence

left page:
Michelangelo Merisi da Caravaggio, *The
Conversion of St Paul*, 1601, oil on canvas,
306 x 146 cm, Santa Maria presso San
Celso, Milan

below:
Michelangelo Merisi da Caravaggio, *The
Supper at Emmaus*, 1601, oil on canvas,
141 x 196.2 cm, National Gallery, London

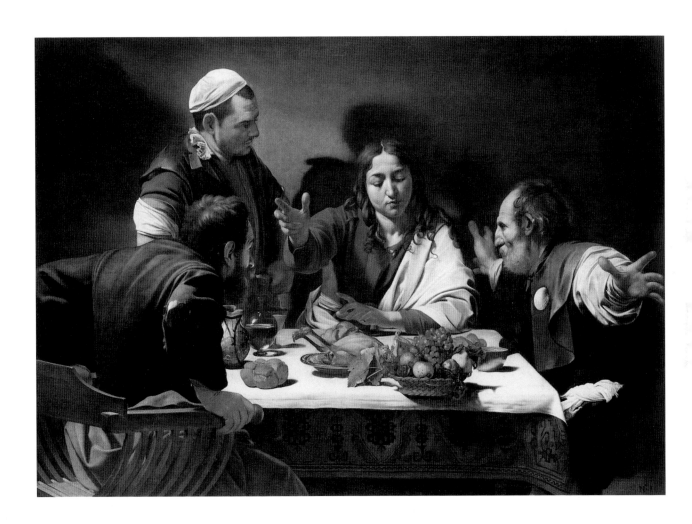

ANTHONIS VAN DYCK ▬▬▬▬▬▬▬▬▬▬▬▬▬▬▬▬▬▬▬▬▬▬▬▬▬▬▬

PETER PAUL RUBENS ▬▬▬▬▬▬▬▬▬▬▬▬▬▬▬▬▬▬▬▬▬▬▬▬▬▬▬▬▬▬▬▬▬▬▬▬▬▬▬

CLAUDE LORRAIN ▬▬▬▬▬▬▬▬▬▬▬▬▬▬▬▬▬▬▬▬▬▬▬▬▬▬▬▬▬▬▬▬

**1587** Mary Stuart executed

**1609** Moors driven out of Spain          **1618–1648** Thirty Years' War          **1641** Descartes

**1603** Shakespeare's *Hamlet* published in First Quarto                                        publishes his

**1605** First part of Cervantes' *Don Quixote* published                                      *Meditations*

in Paris

| 1560 | 1565 | 1570 | 1575 | 1580 | 1585 | 1590 | 1595 | 1600 | 1605 | 1610 | 1615 | 1620 | 1625 | 1630 | 1635 | 1640 | 1645 |

Rembrandt van Rijn, *The Night Watch*
(*The Company of Captain Frans Banning
Cocq and Lieutenant Willem van
Ruytenhurch*), 1642, oil on canvas,
359 x 438 cm, Amsterdam, Rijksmuseum

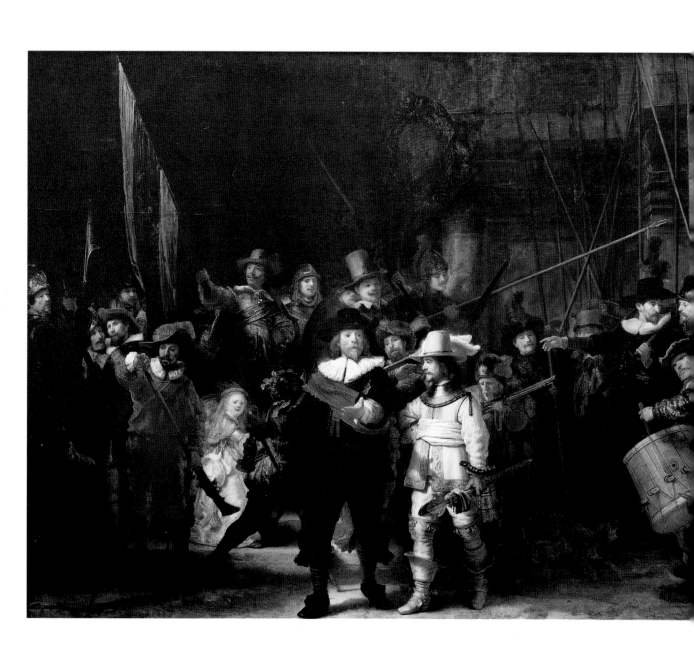

| | | **1668** Construction of Palace | | | | **1699** Conclusion of Turkish war |
| | | of Versailles begins | | | | makes Austria a great power |
| **1655** Anglo-Spanish war over | | | **1685** Peter the Great becomes | | | |
| trade in West Indies | | | Tsar of Russia | | | |

| 1650 | 1655 | 1660 | 1665 | 1670 | 1675 | 1680 | 1685 | 1690 | 1695 | 1700 | 1705 | 1710 | 1715 | 1720 | 1725 | 1730 | · 1735 |

REMBRANDT VAN RIJN

# THE NIGHT WATCH

*Rembrandt van Rijn broke new ground with almost every painting he executed. In* The Night Watch *he transformed the group portrait—until then a largely lifeless and uninspired genre—by creating a work of extraordinary dynamism and characterization.*

The title *The Night Watch* is a complete misnomers: the scene is not a military watch and it is not set at night. Its correct title is *The Company of Captain Frans Banning Cocq and Lieutenant Willem van Ruytenhurch*—the two men heavily highlighted and central to the scene. The mistake was an easy one to make, for the picture had darkened because of dirt, poor restoration, and the addition of many layers of varnish. Successive dealers and collectors have added varnish to Rembrandt's paintings for two reasons. First, to protect the painting: the value of this practice was illustrated in 1911 when a deranged young man attacked the painting with a knife—because of the glass-like varnish the surface of the painting was undamaged. Second, to give more coherence to the paint surface. Rembrandt's thick and freely applied brushstrokes concerned some critics, who felt his style showed a lack of finish and so recommended varnish as a way of reducing the apparent harshness. A complete restoration after World War II revealed in all its original intensity and richness of color a scene flooded with daylight.

The painting was commissioned by Captain Banning Cocq and seventeen members of his civil guard. Each member paid for the inclusion of his portrait with the exception of the drummer boy, who was hired for the occasion. Rembrandt also added extra figures to give the painting greater drama, though three figures on the left of the canvas were lost in the 18th century when the painting was cut down. Group portraits of this kind were not uncommon, but Rembrandt addressed the subject with characteristic and striking originality, turning the scene from an intimate portrait group into a grand history painting. His figures are lively, animated and full of character, the whole scene being one of energetic movement. With its brilliant, dazzling light effects, rich colors and infinite small details adding to the overall effect, it was one of the most revolutionary interpretations of a traditional portrait theme. Traditionally static and formal interpretations of the group portrait

include works such as Cornelis Ketel's (1548–1616) *The Company of Captain Rosecrans* (1588) and Maerten Lengele's (d. 1668) *A Company of the Hague Arquebusiers* (1660).

The military men in *The Night Watch*, called arquebusiers after their long-barreled guns, are seen moving directly towards the viewer. The intention of the gathering is not clear: it could be a military exercise or something as trivial as a hunting expedition. The small girl, brightly lit and in yellow, is a rather unusual addition to the work, and bears many symbolic elements that refer to the arquebusiers. The dead chicken she holds is a symbol of triumph over adversity, while the chicken's claws on her belt represent the "Clauweniers" (another name for the arquebusiers); she is holding their ceremonial drinking cup in her left hand, and the yellow of her dress is the color of the victory.

Intended for the Arquebusiers Hall in Amsterdam, it was one of eight commissioned portrait pieces for the Great Hall on the first floor of the building. In 1715 it was moved to the Town Hall in Dam Square, and cut down on all sides to fit into its designated space, and one hundred years later it entered the newly opened Rijksmuseum. Apart from the attack of 1911 mentioned above, it has been damaged twice since then: in 1975 a Dutch school master attacked it with a knife, causing severe damage that took four years to restore (the schoolmaster later committed suicide), and in 1990 it was sprayed with acid, though no lasting damage occurred.

**1606** Born Rembrandt Harmenszoon van Rijn 15 July in Leiden, Holland.
**1621** Apprenticed to Jacob van Swanenburgh.
**1625** Sets up independently.
**1630** Sets up a studio with several assistants.
**1634** Marries Saskia van Uylenburgh.
**1642** Saskia dies.
**1649** Employs Hendrickje Stoffels as housekeeper. She later becomes his mistress.
**1656** Declared a bankrupt.
**1663** Hendrickje dies.
**1669** Dies 4 October in Amsterdam.

Rembrandt van Rijn, *Self-Portrait as a Young Man*, 1629, oil on wood, 15.6 x 12.7 cm, Alte Pinakothek, Bayerische Staatsgemäldesammlungen, Munich

below:
Rembrandt van Rijn, *Anatomy Lesson of Dr Nicolaes Tulp*, 1632, oil on canvas, 169.5 x 216.5 cm, Mauritshuis, The Hague

right page:
Rembrandt van Rijn, *Self-Portrait with Saskia*, c. 1635, oil on canvas, 161 x 131 cm, Gemäldegalerie Alte Meister, Dresden

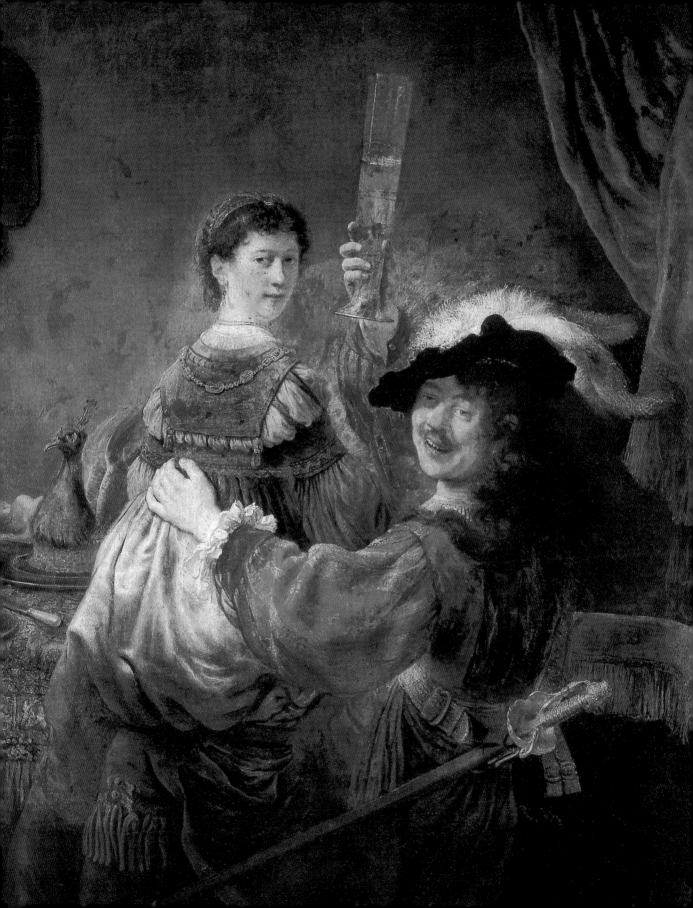

FRANS HALS

NICOLAS POUSSIN

**1609** Moors driven from Spain

**1590** Dome of St Peter's completed in Rome         **1620** The *Mayflower* lands in America

**1605** First part of Cervantes' *Don Quixote* published

**1643** Louis XIV becomes King of France

**1588** Destruction of the Spanish Armada

| 1565 | 1570 | 1575 | 1580 | 1585 | 1590 | 1595 | 1600 | 1605 | 1610 | 1615 | 1620 | 1625 | 1630 | 1635 | 1640 | 1645 | 1650 |

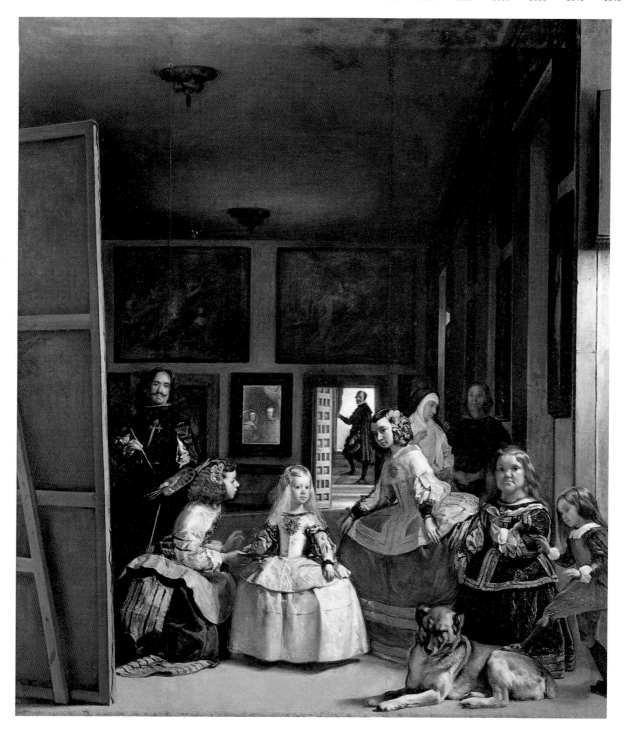

**1648** Dutch throw off Spanish rule

**1678** *Antonio Vivaldi

**1701–1714** War of the Spanish Succession

**1707** Act of Union merges kingdoms of England and Scotland

| 1655 | 1660 | 1665 | 1670 | 1675 | 1680 | 1685 | 1690 | 1695 | 1700 | 1705 | 1710 | 1715 | 1720 | 1725 | 1730 | 1735 | 1740 |

## DIEGO VELÁZQUEZ

# LAS MENINAS

*Las Meninas is the finest portrait Diego Velázquez painted of the Infanta Margarita, and one of his greatest works. His precise intentions still puzzle critics, but what is beyond dispute is the subtlety and sheer beauty of his depiction of the little girl bathed in golden light, at once magical and poignant.*

Velázquez returned to Madrid in 1651 following his years in Rome, and was shortly afterwards given the honorable title of the Palace Chamberlain to the Spanish Court. It was a mark of the respect and affection with which the Spanish Royal family held the painter, though it was also a position that made considerable administrative demands on him. In the final years of his life he concentrated primarily on portraits of the royal family, including the infinitely subtle *Philip IV of Spain* (c. 1656–57) and the precocious *Infanta Maria Teresa* (1653). Painted in 1656, and also a portrait of the royal family, *Las Meninas* is widely considered his masterpiece.

Part of the appeal of this extraordinary work lies in its paradoxical representation of fact and illusion. The painting is exquisitely, minutely detailed, with each person (excepting the guardsman to the back on the right) fully and vividly depicted. Every aspect of the work is a truthful representation. Yet at the heart of the painting lies a web of illusion and mystery, from the mirror behind the artist reflecting the king and queen, to the artist's hidden canvas. What at first glance seems real soon turns into illusion. There is no definitive explanation of the subject. It is most obviously a portrait, but it also embodies concepts such as the nobility of art, the transience of life and the illusionary nature of art. The painting depicts the beautiful Infanta Margarita, heiress to the throne, at its center, flanked by her attendants (las meninas). On the left is Maria Agustina Sarmiento, who offers the child a drink, and on the right is Isabel de Velasco, who leans towards the girl in a protective manner. In the foreground on the right appear the dwarfs Maribárbola and Nicolas Pertusato, who is tormenting the sleeping mastiff dog; behind this group is a chaperone, Marcela Ulloa, and an unidentified guardsman. To the rear of the picture, and standing in the open doorway, is the queen's chamberlain, José Nieto, while to the left of the scene is a self-portrait of the artist, who is shown scrutinizing a huge canvas. Hanging on the wall behind him, a mirror reveals the presence of the king and queen.

The setting is a room in the Alcázar, the royal palace, which was used by the artist as his studio. It is a faithful reproduction of the room, down even to the paintings hanging on the wall, which are works Peter Paul Rubens painted for the Torre de la Parada. The mirror to the rear is the focal point in the debates over the painting and its intended purpose. The king and queen are discernible in the mirror, but their actual presence in the room is ambiguous. Are they reflections of images painted on the large canvas? Or, more probably, are they reflections of the actual royal couple standing exactly where the viewer is, to the right of the artist's canvas? If this is the case, then the specific subject of the picture remains rather uncertain—for while they are shown as distant reflections, the princess, her maids, the dwarfs and even the dog are presented in vivid detail. The figures appear frozen in a moment of time, temporarily paused, perhaps to acknowledge the entrance of the royal couple. The most unusual aspect to the work, however, is the informality of the grouping, which, if the king and queen are present, makes the scene all the more incongruous. It is also significant that Velázquez included his own portrait within the family group, an allusion both to the nobility of art and to his own status in the royal household.

**1599** Baptized 6 June in Seville, Spain.
**1611** Begins his training as a painter, under Francisco Pacheco del Rio.
**1618** Marries his teacher's daughter.
**1623** Becomes court painter to 18-year-old King Philip IV in Madrid.
**1629** At the prompting of Peter Paul Rubens, he travels to Italy.
**1631** Returns to Madrid.
**1649–1651** Makes a second journey to Italy, where he buys paintings by Veronese and Titian for the king.
**1660** Dies 7 August in Madrid.

left page:
Diego Velázquez, *Las Meninas*, 1656, oil on canvas, 318 x 276 cm, Museo Nacional del Prado, Madrid

above:
Diego Velázquez, *Self-Portrait* (detail from *Las Meninas*), 1656, oil on canvas, Museo Nacional del Prado, Madrid

REMBRANDT VAN RIJN

DIEGO VELÁZQUEZ

**1600** First performance of Shakespeare's
*Midsummer Night's Dream*

**1643** Louis XIV crowned king of France

**1648** Dutch throw off
Spanish rule

**1633** Trial of Galileo by Inquisition

| 1575 | 1580 | 1585 | 1590 | 1595 | 1600 | 1605 | 1610 | 1615 | 1620 | 1625 | 1630 | 1635 | 1640 | 1645 | 1650 | 1655 | 1660 |

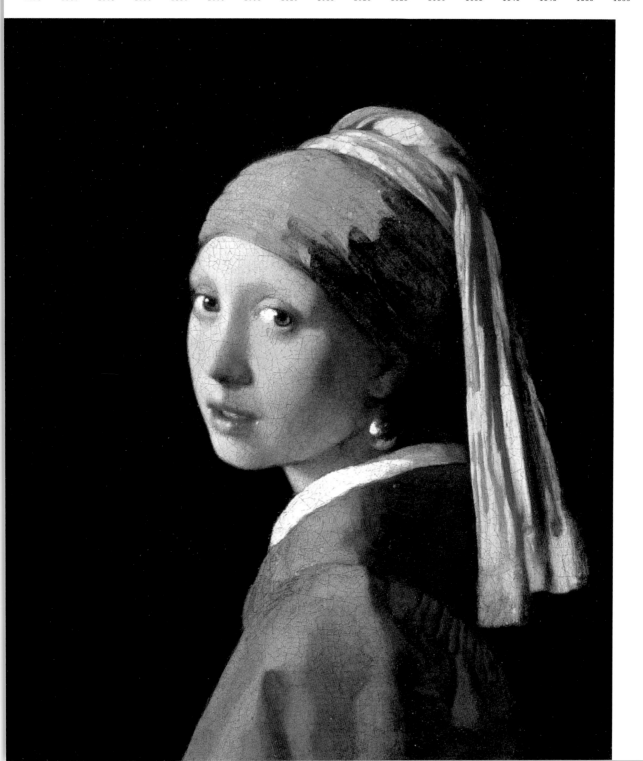

1683 Turks at the gates of Vienna again

1712 *Jean-Jacques Rousseau

1668 Construction of Palace
of Versailles begins

1685 Peter the Great becomes
Tsar of Russia

1703 Construction of Buckingham
House (later Palace) begins

1724 *Immanuel Kant

1665    1670    1675    1680    1685    1690    1695    1700    1705    1710    1715    1720    1725    1730    1735    1740    1745    1750

JAN VERMEER

# GIRL WITH A PEARL EARRING

*Painted with exquisite sensitivity to light and color, Jan Vermeer's portrait of a young woman "dressing up" in turban and jewels is an image of haunting beauty and quiet yet poignant characterization.*

There are few images quite so captivating as the *Girl with a Pearl Earring*, whose intense gaze and softly parted lips entices the viewer into her world. The mystery that surrounds the work, one of Vermeer's most famous, heightens her elusive appeal. Her identity remains unknown, although one hypothesis suggests she is Maria, the artist's eldest daughter, who would have been around twelve or thirteen at the conjectured time of the painting. It is possible, too, that she was modeled on Magdalena van Ruijven, a contemporary of Maria, and the daughter of Vermeer's primary patron, Pieter van Ruijven. The novel (and subsequent film) *The Girl with the Pearl Earring* by Tracey Chevalier suggests that the girl was a young housemaid in the Vermeer family called Griet, but this supposition is entirely unsubstantiated. Even the model's age is ambiguous; she has been cited as an adolescent, but her gaze is one of sensuous intensity that implies an awakened sexuality. In 1994 the painting, which was in a poor state, was restored to reveal a single highlight: a dash of white over light pink at the corner of her mouth that lends it a shiny moist aspect that increases the intensity of her expression.

As the girl's identity has perhaps been left deliberately vague, the painting may fall into the Dutch painting category of *tronie*, rather than that of a portrait. *Tronies*, which were studies that expressed an emotional or symbolic content, or a specific character type, had become popular during the 1630s through Rembrandt's paintings, such as *Tronie of a Young Man with Gorget and Beret* (c. 1639). Here the girl wears a turban and so represents an Oriental figure. Foreign dress, including turbans, were popular at the time in Europe, interest having been generated through the extended war against the Turks, whose remote and exotic lifestyle touched the European imagination. The turban was a motif used frequently by other artists and is seen for example in Jan van Eyck's *Self-Portrait* (1433), and in Michael Sweerts *A Boy Wearing a Turban and Holding a Nosegay*

(c. 1655–1656). Vermeer often used the same props in his paintings, and the swatch of ice-blue and warm-gold material that he used for his turban also appears in his *Allegory of Painting* (c. 1666–1667) and *Love Letter* (c. 1669–1670).

Vermeer's paintings are full of hidden meanings and symbolism, which was typical of many Dutch genre painters of the 17th century, and he included all his props with studied intent. His use of a pearl can be interpreted in one of two ways. Pearls were, and remain, sought after and expensive items, at that time owned only by the wealthy and seen as a mark of prestige and status. They were also, however, and rather conversely, linked to chastity, purity and virginity. Although pearls feature largely in Vermeer's oeuvre (which comprises just thirty-six paintings), and can be seen in eleven of his works, the one depicted in the *Girl with the Pearl Earring* is the largest and finest. It is similar to one painted by George de la Tour in his *Dice Players*, but has a warmer, more golden luster than the Frenchman's jewel.

The 1994 restoration of the painting also uncovered an extra highlight on Vermeer's pearl. A tiny flake of white paint from an earlier restoration had fallen and adhered, upside down, to the base of the pearl. X-ray revealed the impostor and, once removed, the pearl suddenly emerged with the full radiance of its original appearance.

1632 Baptized 31 October in Delft, Holland.
1635 Becomes a Catholic.
1652 Takes over his father's inn and art business on the latter's death.
1653 Marries Catharina Bolnes.
1662 The Delft painter's guild elects him president.
1671 Becomes president of the guild for the second time.
1672 Travels to The Hague to certify the authenticity of 12 works from Italy.
1675 Seeks a loan for his large family in Amsterdam. Dies the same year and is buried 16 December in Delft.

left page:
Jan Vermeer, *Girl with a Pearl Earring*, c. 1665, oil on canvas, 44.5 x 39 cm, Royal Painting Cabinet, Mauritshuis, The Hague

above:
Jan Vermeer, *Self-Portrait* (detail from *The Procuress*), 1656, oil on canvas, Gemäldegalerie Alte Meister, Staatliche Kunstsammlungen, Dresden

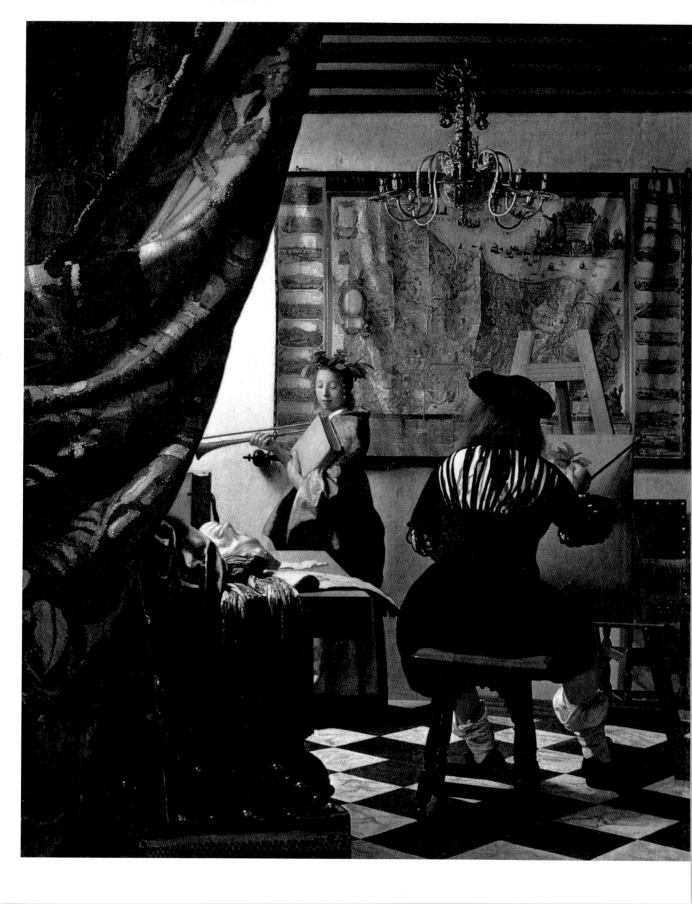

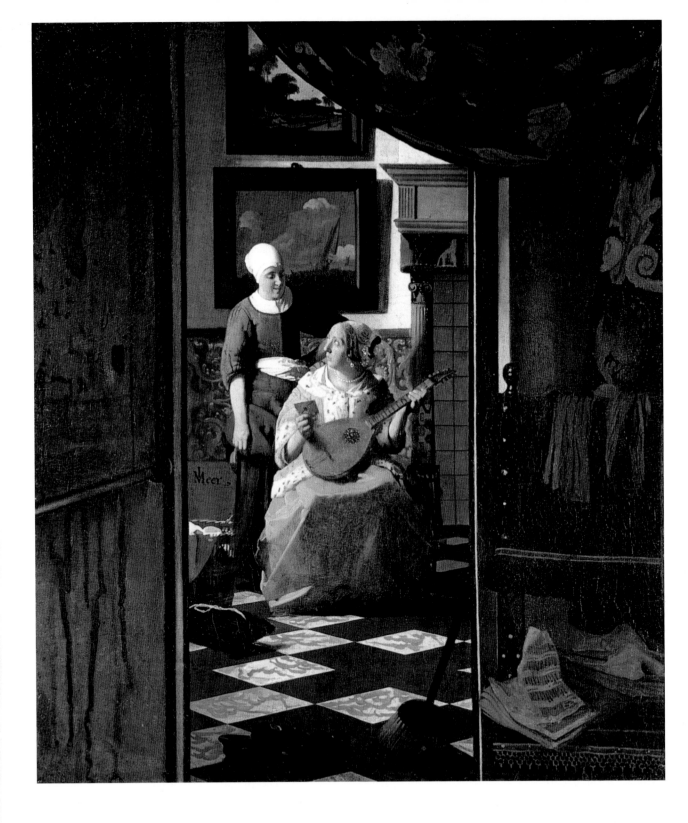

left page:
Jan Vermeer, *Allegory of Painting*,
c. 1666–1667, oil on canvas, 120 x 100 cm,
Kunsthistorisches Museum, Vienna

Jan Vermeer, *Love Letter*, c. 1669–1670,
oil on canvas, 44 x 38 cm, Rijksmuseum,
Amsterdam

ANTONIO CANOVA

**1707** Act of Union merges kingdoms of England and Scotland

**1756** *Wolfgang Amadeus Mozart

**1769** Watt's improved steam engine

**1773** Boston Tea Party

**1781** Immanuel Kant publishes the *Critique of Pure Reason*

1700 1705 1710 1715 1720 1725 1730 1735 1740 1745 1750 1755 1760 1765 1770 1775 1780 1785

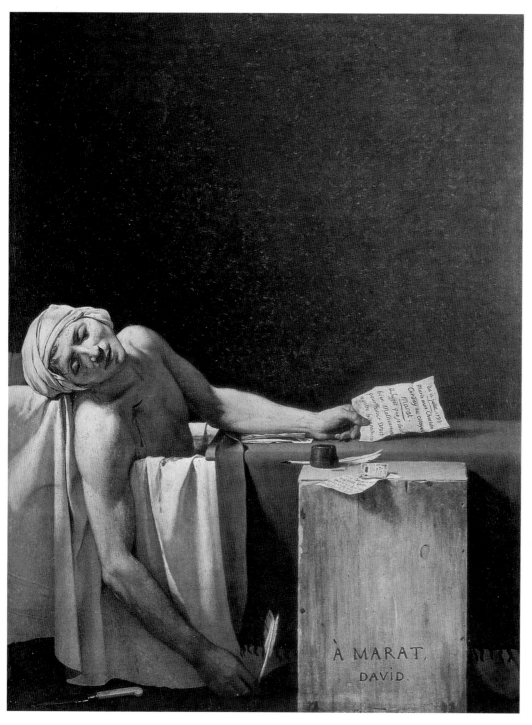

**1789** Storming of the Bastille launches French Revolution

**1805** Battles of Trafalgar and Austerlitz

**1832** Hambacher Fest in favour of German unity

**1848** Karl Marx and Friedrich Engels publish communist manifesto

**1861–1865** American Civil War

1790 1795 1800 1805 1810 1815 1820 1825 1830 1835 1840 1845 1850 1855 1860 1865 1870 1875

JACQUES-LOUIS DAVID

# DEATH OF MARAT

*The revolution had been raging in France for four years. The first enthusiasm following the overthrow of the monarchy was succeeded by fear during the Reign of Terror. Jacques-Louis David was a keen supporter of the National Convention, and as an official propagandist dedicated this picture to the revolutionary Jean-Paul Marat as a memorial.*

Marat was stabbed in his bath by young Charlotte Corday. The circumstances of the murder are known from the documents of the subsequent trial. The dead man suffered from a serious skin disease, and had retired to his bath to edit his paper, *L'Ami du Peuple* (The Friend of the People). Corday was a young aristocrat who had specially come from Caen to Paris to do the deed. She had intended to kill Marat at the Convention and then have herself immediately executed. In the morning she had not been admitted to him, and so had tried once again in the evening, this time with success, as Marat would now hear the "petitioner." The pretext for the call, her note saying "It is enough that I'm quite unhappy to ask for your goodwill," is still in his hand as he sits in his bloody bath. Charlotte Corday was seized immediately after the deed, and the death sentence carried out on her four days later.

David chose to depict not the actual assassination but the period immediately after. And in contrast with other renderings of the subject—for example by Paul-Jacques-Aimé Baudry (1828–1886), who also portrayed the murderess—David arranged his composition quite differently. There are very few details in the picture, which shows the victim lying dead in his bath. Bare and starkly lit, these elements stand out from the dark and undefined rear wall like a scene in a play. The soft facial features of the militant politician, whose skin has undoubtedly been "beautified," are reminiscent of an image of Christ. This association was intended, since it turns the dead man into a martyr. The Spartan furnishings, which show a plain wooden crate instead of what was presumably in reality a table, are intended to describe the modest circumstances in which the "selfless revolutionary" lived. Even at the moment of his death, Marat is shown working for the cause, pen in hand. He is supposed to have just sent money to a mother of five children whose husband had given his life for *la patrie*.

The painter thus sets up a monument to the dead man, establishing the foundation for his posthumous fame. Charlotte Corday also acquired fame as a martyr among those moderate adherents of the Revolution who were politically close to her. As such, she had sacrificed herself for her political conviction that France had not gone through the Revolution so that "a man such as Marat should seize power." Jacques-Louis David himself worked for the revolutionary government. In 1794, however, with the fall of Robespierre, he was put in prison, and on his release fell in with the new order under the rule of Napoleon. David became Napoleon's first painter, and after the defeat and exile of the Emperor he fled to Brussels. He took his memorial to Marat with him, which is why it is now to be admired in the Royal Collections there.

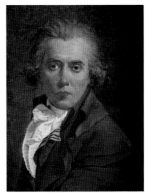

**1748** Born 30 August in Paris.
**1766** Becomes a student at the Royal Academy of Painting and Sculpture in Paris.
**1775** Wins the Rome Prize and spends five years in Italy.
**1784–1785** Back in Rome.
**1789** Takes active part in the French Revolution.
**1794** Imprisoned after the fall of Robespierre.
**1805** Becomes Napoleon's court painter.
**1814** Chooses exile in Brussels.
**1825** Dies 29 December in Brussels.

left page:
Jacques-Louis David, *Death of Marat*, 1793, oil on canvas, 165 x 128 cm, Musées Royaux des Beaux-Arts de Belgique, Brussels

above:
Jacques-Louis David, *Self-Portrait*, 1790–1791, oil on canvas, 64 x 53 cm, Galleria degli Uffizi, Florence

**1703** Work begins on Buckingham
House (now Palace) in London

**1707** Act of Union merges the kingdoms
of England and Scotland

**1749** *Johann Wolfgang von Goethe

**1769** Watt's improved
steam engine

**1770** *Ludwig van
Beethoven

1690 1695 1700 1705 1710 1715 1720 1725 1730 1735 1740 1745 1750 1755 1760 1765 1770 1775

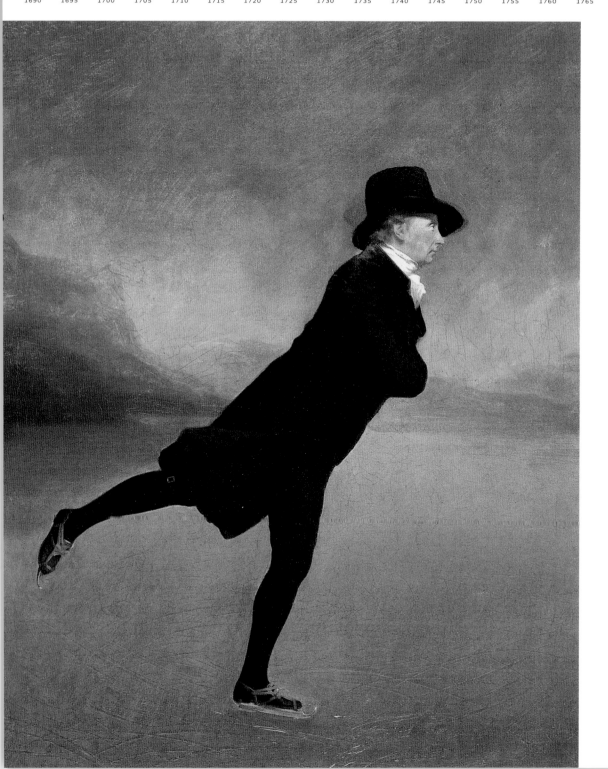

1776 American Declaration of Independence

1789 Storming of the Bastille launches French Revolution

1805 Battles of Trafalgar and Austerlitz

1857 Flaubert's *Madame Bovary* published

1861–1865 American Civil War

1780  1785  1790  1795  1800  1805  1810  1815  1820  1825  1830  1835  1840  1845  1850  1855  1860  1865

HENRY RAEBURN

# THE SKATING MINISTER

*A snapshot of everyday life rather than a formal portrait typical of the period, this depiction of the Reverend Robert Walker, an Edinburgh clergyman who was a keen skater and close friend of the artist Henry Raeburn, has become one of the best-loved images of Scottish art.*

The Skating Minister is arguably one of Scotland's most famous paintings, and is certainly the most famous by the artist Henry Raeburn, although this attribution has recently been called to question. Raeburn lived and worked all his life in Edinburgh, with the exception of an extended trip to London, and then another to Rome between approximately 1784 and 1786. He became Scotland's leading portrait painter, capturing the wealthy and eminent during the Scottish Enlightenment, when Scotland was at the forefront of scientific discoveries and philosophical thought.

There is no documentation pertaining to *The Skating Minister* in terms of either its date of execution, or indeed its author, since it is unsigned. For many years the small painting has been attributed to Raeburn, at first dated as an early work of around 1784, and then as a later work of around 1795. The small painting is certainly not typical of Raeburn's oeuvre, which was characterized by large, often full-size portraits such as *William Forbes of Callendar* (1798) or *Niel Gow* (1787), but does have the somber tonal palette and clarity of composition seen in Raeburn's work. Perhaps most convincing support in favor of Raeburn as the artist is his friendship with the subject of the portrait, the Reverend Robert Walker, who was also named as one of the trustees on Raeburn's will. In March 2005, Stephen Lloyd, a senior curator at Scotland's National Portrait Gallery, put forward the theory that the painting had actually been painted by a French artist, Henri-Pierre Danloux, who had fled Revolutionary Paris and settled in Edinburgh. It is a theory that has been met with some support as well as the expected controversy. Other paintings by Danloux include *Portrait of Charles of France, Count of Artois*; *Jean François de La Marche*; and *Portrait of H.R.H. Augustus Frederick*—though none displays the striking originality of *The Skating Minister*.

A clergyman in the Church of Scotland, the Reverend Robert Walker was the minister of the Canongate Kirk in Edinburgh. He was also a member of the Edinburgh Skating Society, and is shown skating with considerable skill. This skating club, which was the oldest of its kind, often met on the frozen waters of Duddingston, not far from Edinburgh, where the painting is set. After Walker's death in 1808, the painting was passed down through his family before being sold privately in the 1920s to Lucy Hume, a friend of the family. She auctioned it in 1949 at Christie's, when it was bought by the National Galleries of Scotland for just £525, and so finally came to the public's notice.

It is a most striking work and one of very satisfying composition. Part of the success of the painting is its perfect balance between motion and stillness, for though the reverend glides swiftly across the ice, his body is shown completely motionless. This convergence of movement and stasis creates enormous, though subtle, tension and the sense of rigidly contained energy. The simplicity of the figure's outline, heightened through the darkness of his shape, which lends him an almost two dimensional quality, is brilliantly conceived, as is the intensity of the reverend's expression. It is on all counts a work of outstanding merit, and, regardless of the controversy surrounding its maker, it remains one of Scotland's greatest paintings.

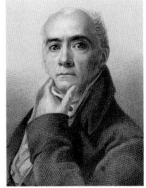

1756 Born 4 March in Stockbridge, Edinburgh.
1772 Apprenticed to goldsmith James Gilliland, later switching to painting under David Martin.
1784 Travels to London and makes the acquaintance of Joshua Reynolds.
1784–1786 Visits Italy.
1787 Returns to Edinburgh.
1815 Member of the Royal Academy in London.
1822 Knighted.
1823 Dies 8 July in Edinburgh.

left page:
Henry Raeburn, *The Skating Minister*, 1784, oil on canvas, 76.2 x 63.5 cm, National Gallery of Scotland, Edinburgh

above:
T.W. Knight, *Portrait of Sir Henry Raeburn* (after the self-portrait by Sir Henry Raeburn, c. 1815), after 1823, engraving, private collection

**1789** Storming of the        **1808** Napoleon appoints
Bastille launches                    his brother Joseph
French Revolution                    king of Spain

**1804** Napoleon declares
himself emperor

1725  1730  1735  1740  1745  1750  1755  1760  1765  1770  1775  1780  1785  1790  1795  1800  1805  1810

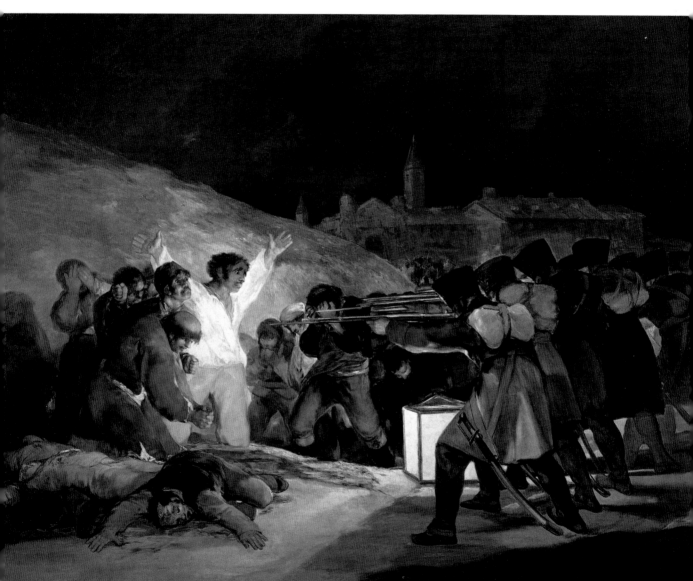

Francisco de Goya, *The Third of May*,
1808, 1814, oil on canvas, 268 x 347 cm,
Museo Nacional del Prado, Madrid

**1844** Alexandre Dumas writes
*The Three Musketeers*

**1865** Slavery abolished in the USA

**1887–1889** Eiffel Tower in Paris

**1886** Statue of Liberty erected
in the port of New York

**1812** Napoleon invades Russia

**1848** Karl Marx and Friedrich Engels publish
their communist manifesto

**1900** Boxer Uprising
in China

| 1815 | 1820 | 1825 | 1830 | 1835 | 1840 | 1845 | 1850 | 1855 | 1860 | 1865 | 1870 | 1875 | 1880 | 1885 | 1890 | 1895 | 1900 |

FRANCISCO DE GOYA

# THE THIRD OF MAY, 1808

*Surrounded by the darkness of night, a man in a white shirt and with raised arms stares with horror and incredulity at a squad of soldiers who are about to shoot him. It is clear that Goya's painting is not just a documentation of the events on 3 May 1808 in Madrid, but also a symbol of the cruelty and injustice of wars.*

French troops under Napoleon had swept through Spain (and indeed much of Europe) as occupiers. The population of Madrid took up arms to resist the invaders, as is shown in Goya's counterpart to this picture, *The Second of May, 1808* (1814, Prado, Madrid), which shows the Spanish Madrileños fighting Napoleon's Mameluke guards.

Many of those involved in the resistance (and many not involved) had to pay with their lives in a blood-thirsty settling of scores. Obviously several victims in Goya's *The Third of May* had already suffered the imminent fate of the white-shirted man, and there would be more to follow. Bloody corpses lie in front of him, while beside him and behind them are several terrified, confused and enraged people. The man with the white shirt and large dark eyes stands out as a representative not only of the rebels but of the human condition. Because he stretches out his arms as if on a crucifix, his appearance is reminiscent of that of Christ. In contrast, the soldiers are faceless: all we see of them are their identical, anonymous backs and their weapons, which they will use at the next word of command without mercy. In the foreground the scene is divided simply into victims and killers, while in the background part of the city stands out starkly against a dark sky. The dramatic lighting in the foreground comes from the yellow lantern in the middle of the scene. It makes the back view of faceless soldiers on the right of the picture look even more terrifying, and the frightened, helpless and in some cases already dead people crowding in on the left even more exposed.

Goya himself proposed the subject of Spain's martyrs against French rule "in order to record with the means of the brush the most remarkable and heroic deeds of our glorious uprising against the Tyrant of Europe." King Ferdinand VII, who returned to Madrid from exile in 1814 shortly after the sixth anniversary celebrations of the resistance struggle, failed to live up to the hopes placed in him by the Spanish patriots involved in the 1808 revolt.

All his life, Goya was torn this way and that between court commissions and his own vocation to paint pictures for the people. In this picture, he was able to combine both. Here, Goya actually took the particular historical incident only as an excuse to illustrate the horrors of a situation where civilians are at the mercy of soldiers—or, more generally, people are exposed to violence. That he was fully conversant with the glorious as well as the dark side of humanity Goya proved in numerous works. The *Tres de Mayo* was one of the most moving of them.

**1746** Born Francisco José de Goya y Lucientes 30 March in Fuendetodos, Spain.
**1760** Apprenticed to painter José Luzan.
**1771** Returns from Italy and is commissioned to provide paintings for the church of Nuestra Señora de Pilar in Saragossa.
**1773** Marries Josefa Bayeu, sister of painter Francesco Bayeu,
**1774** Commissioned to do designs for the Royal Carpet Manufactory in Santa Barbara. Works on this project for 18 years.
**1786** Becomes court painter.
**1799** Publishes the *Caprichos*.
**1810** Begins work on the *Disasters of War*.
**1824** Goes into exile in France.
**1828** Dies 16 April in Bordeaux.

Francisco de Goya, *Self-Portrait with Spectacles*, 1797–1800, oil on canvas, 54 x 39.5 cm, Musée Bonnat, Bayonne

below:
Francisco de Goya, *The Second of May,*
*1808,* c. 1814, oil on canvas, 266 x 345 cm,
Museo Nacional del Prado, Madrid

right page:
Francisco de Goya, *The Colossus,*
1808–1812, oil on canvas, 116 x 105 cm,
Museo Nacional del Prado, Madrid

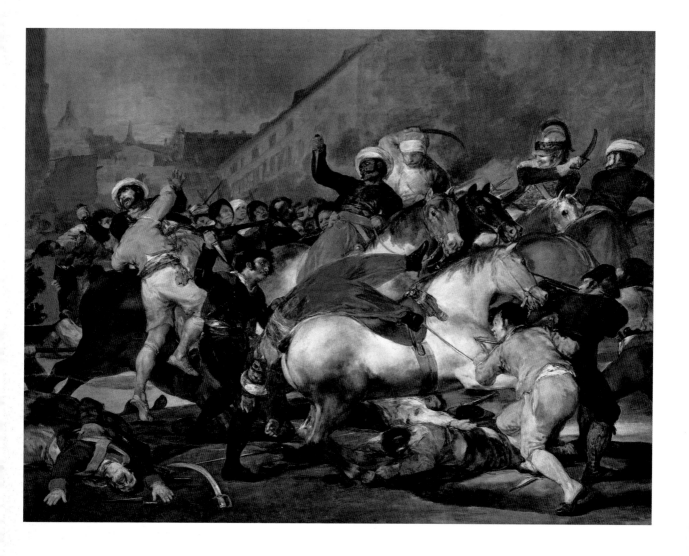

**1729** Catherine the Great becomes
Empress of Russia

**1749** *Johann Wolfgang von Goethe

**1769** Watt's improved steam engine

**1804** Napoleon
declares him-
self emperor

1725  1730  1735  1740  1745  1750  1755  1760  1765  1770  1775  1780  1785  1790  1795  1800  1805  1810

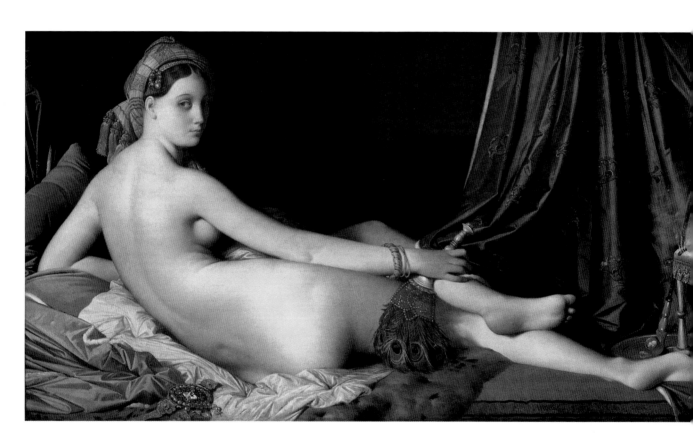

Jean-Auguste-Dominique Ingres,
*Grande Odalisque*, 1814, oil on canvas,
91 x 162 cm, Musée du Louvre, Paris

## JEAN-AUGUSTE-DOMINIQUE INGRES

# GRANDE ODALISQUE

*"She has three vertebrae too many!" complained a critic, who seemed more concerned with anatomy than art. Regardless of pedantic responses of this kind, viewers still delight in the odalisque's beautiful long back and the curves that Ingres managed to paint with the "zeal of a lover," as the poet Charles Baudelaire put it.*

Ingres painted his most famous nude in 1814, during the almost twenty years he spent in Italy. The commission came from the Queen of Naples, Caroline Murat, a sister of Napoleon. Five years later, the painter exhibited the picture, which had originally been painted for a private cabinet but had then come back into his possession, at the Salon in Paris. There it encountered a hail of criticism. It was said to be too old-fashioned, too dry, too unfeeling, too defective—the list of accusations was lengthy. Although Ingres's talent was generally recognized, the picture did not find wide acceptance. Undeterred, the artist did several more versions of his *Grande Odalisque*, including one in grisaille. The odalisque (a woman from the harem) looks knowingly at us over her shoulder. We see her naked body from the rear, and she turns her head to show us her right profile. She relaxes on a divan, lying propped on her left elbow, with her legs crossed and crooked at the knees. In her right hand, which rests on her left calf, she holds a fan of peacock feathers that brush her right thigh. All the materials shown in the picture demand the attention of our senses— the incense wafting from the burner on the right, the pipe with opium in it ready for smoking, quality fabrics, furs, feathers and jewelry … and of course the sitter's marble-smooth skin. As a viewer once remarked, these are feet that probably never encountered anything but deep carpets and the tiles of the *hammam* (bath house). The textures and consistency of the things painted with such detail are as immaculate as the beauty of the sitter. The Oriental décor was not just a fashionable extra. It represented a sensual ambience long familiar from Lady Mary Wortley Montagu's *Letters from Turkey* (1716–1718), containing her reports of her time in Constantinople. Her accounts of steam baths and harems released a wealth of fantasies not only on the canvases of painters. Ingres depicts the ideal of the female body and its sensuality with only a very sketchy narrative framework—she may be awaiting

a male visitor, as some details, such as the delicate feathers that are already caressing her thigh, may suggest. The writer Théophile Gautier caught the extraordinary grace of Ingres's painted body with his description of the elegance of the curves, which he compared with the movement of flower stems in water.

The erotic tone of the painting is still powerful today. Even if it was too much for its first critics, the *Grande Odalisque* inspired many an artist of the 20th century. A particularly colorful example is the (green) odalisque of Martial Raysse (*Made in Japan*, 1964, Hirshhorn Museumn, Washington).

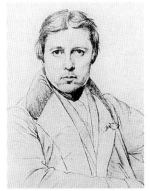

1780  Born 29 August in Montauban, Tarn-et-Garonne, France.
1791  Becomes a pupil of the Académie Royale in Toulouse.
1797  Student of David's at the Academy of Art in Paris.
1801  Wins the Academy's coveted Rome Prize.
1806  Moves to Italy, remaining there for 18 years.
1814  Paints his *Grande Odalisque*.
1824  Returns to Paris with his painting *The Vow of Louis XIII*, and gets an enthusiastic reception.
1825  Accepts pupils to his studio in Paris, now being an influential teacher.
1834  Returns to Rome as director of the Académie de France.
1841  Returns to Paris.
1867  Dies 14 January in Paris.

Jean-Auguste-Dominique Ingres, *Self-Portrait*, 1835, pencil on paper, 26.5 x 20.4 cm, Cabinet des Dessins, Musée du Louvre, Paris

**1749** *Johann Wolfgang von Goethe

**1776** American Declaration
of Independence

**1804** Napoleon declares
himself emperor

1730  1735  1740  1745  1750  1755  1760  1765  1770  1775  1780  1785  1790  1795  1800  1805  1810  1815

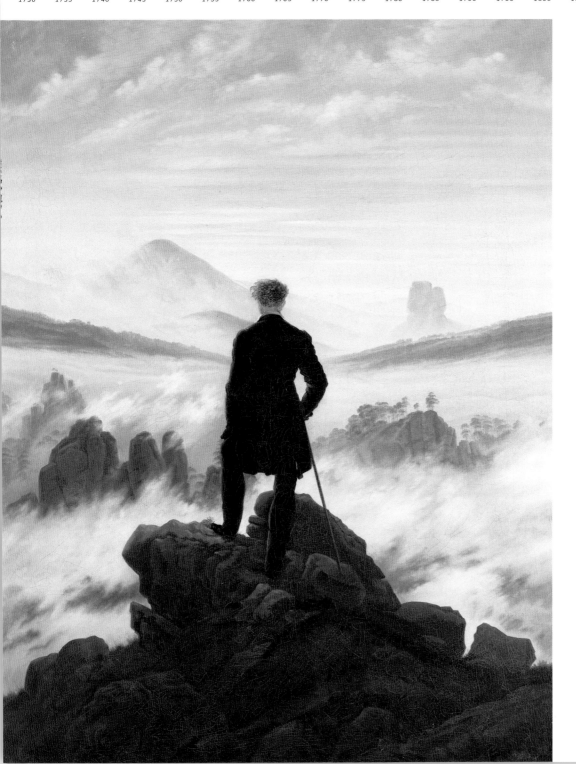

1812 Napoleon invades Russia

1848 Karl Marx and Friedrich Engels publish
their communist manifesto
1848–1849 Revolutions in
numerous European countries

1865 Slavery abolished in the USA

1870–1871 Franco-Prussian War

1877 Queen Victoria becomes Empress of India

1905 Revolution throughout
Russian Empire

1820  1825  1830  1835  1840  1845  1850  1855  1860  1865  1870  1875  1880  1885  1890  1895  1900  1905

CASPAR DAVID FRIEDRICH

# THE WANDERER ABOVE THE SEA OF FOG

*On his wanderings through the mountains, a man arrives at an overwhelming viewpoint. Standing on a rocky promontory, he looks out over the mist-covered valley, from which a number of rock formations protrude. The artist intended this encounter with the sublime to promote philosophical reflection on the nature of life.*

One of the most celebrated images of 19th-century Romanticism, *The Wanderer above the Sea of Fog* embodies Caspar David Friedrich's central theme—the impact of nature on man's thoughts and feelings. The dark-clad wanderer facing away from us forms the focal point of the picture. He has placed his left foot on one of the highest rocks and rests his right hand on his walking stick. Compositionally, he is made the focus of the painting by the dark triangle of rocky outcrop on which he is standing, and by the two lines formed by the wooded slopes visible across the gray, ragged swathes of mist. No other living creatures or any scenic features divert our attention from the man's encounter with unspoiled nature. The use of light is subtle: a diffuse glow invests the landscape, and the figure's head appears to have a light shining on it. The man is thus the unquestioned center of interest. He can be under-stood as reacting directly to the impressively rendered drama of nature represented by rocks, mist, and clouds. Nature reflects the wanderer's thoughts: it becomes a vehicle of meaning, a "landscape of the soul" spreading out the wanderer's sensibilities in front of him. Because the figure is facing away from us, it is easy to identify with him—indeed, we are invited to share his viewpoint. At the same time, the view of the landscape is an introverted view. In a figurative sense, Caspar David Friedrich plumbs the depth of the human soul. In mystic fashion, his wanderer encounters the full power and majesty of nature, which for Friedrich was created by God. There are landscapes in many of Friedrich's pictures. These touched him deeply, and he expressed his faith and his veneration for divine creation through painting. Only in solitude and meditative contem-plation could one perceive the true greatness and sublimity of nature—a view common to Friedrich and many of his contemporaries. The wanderer is wholly alone and absorbed in his thoughts, just like the protagonists in Friedrich's *The Monk by the Sea* and *The Woman at the Window*. The people in his works are shown in situations in which they confront nature and themselves.

The wanderer wears an old-German style frock coat, a garment worn in particular by those displaying their opposition to Napoleon's campaigns in Europe. Friedrich was indeed particularly concerned about German affairs, and he painted German landscapes, those around Greifswald and Dresden, where he liked to walk. Unlike his fellow painters, he was not attracted to Italy. It is therefore scarcely surprising that his works have been frequently used to explore differing notions of German national and cultural identity.

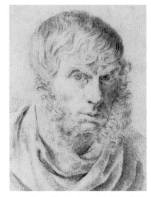

1774 Born 5 September in Greifswald in what was then Swedish Pomerania on the Baltic coast.
1787 His brother drowns in an attempt to save him.
1794–1798 Student at the Academy of Art in Copenhagen.
1798 Moves to Dresden.
1801 Travels regularly, doing land-scape studies. Makes the acquaintance of Philipp Otto Runge.
1808 The showing of his *Cross in the Mountains* leads to controversy about religious and Romantic painting.
1810 Paints the *Monk by the Sea*, reviewed by the writer Heinrich von Kleist in his Berlin newspa-per. Becomes member of the Royal Academy of Art, Berlin.
1818 Marries Caroline Bommer.
1840 Dies 7 May in Dresden.

left page:
Caspar David Friedrich, *The Wanderer above the Sea of Fog*, c. 1818, oil on canvas, 74.8 x 94.8 cm, Kunsthalle, Hamburg

above:
Caspar David Friedrich, *Self-Portrait*, c. 1810, engraving, Kupferstichkabinett, Staatliche Museen, Berlin

**1804** Napoleon declares
himself emperor

**1755** *Marie Antoinette      **1769** Watt's improved steam engine      **1789** Storming of the Bastille
launches French Revolution

**1810** *Frédéric
Chopin

1730    1735    1740    1745    1750    1755    1760    1765    1770    1775    1780    1785    1790    1795    1800    1805    1810    1815

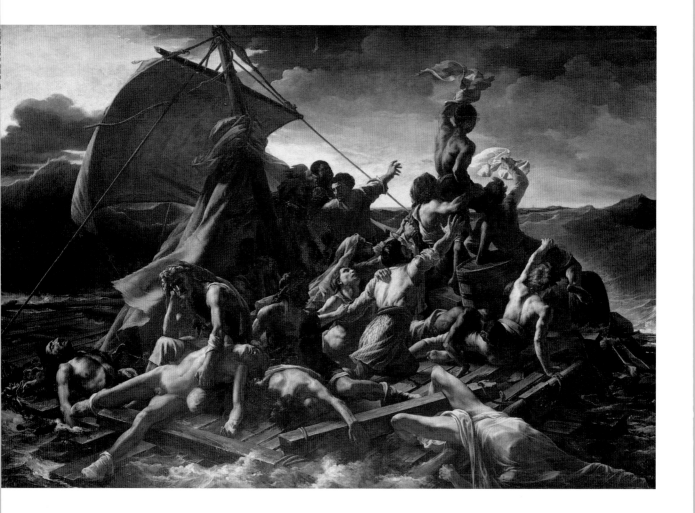

Théodore Géricault, *The Raft of the
Medusa*, 1819, oil on canvas, 451 x 716 cm,
Musée du Louvre, Paris

**1848** Karl Marx and Friedrich Engels
publish their communist manifesto

**1871** Charles Darwin publishes *The Descent of Man*

**815** Napoleon defeated at Waterloo

**1844** Alexandre Dumas writes
*The Three Musketeers*

**1865** Slavery abolished in the USA

1820 1825 1830 1835 1840 1845 1850 1855 1860 1865 1870 1875 1880 1885 1890 1895 1900 1905

## THÉODORE GÉRICAULT

# THE RAFT OF THE MEDUSA

*In* The Raft of the Medusa, *those who had survived a shipwreck are shown drifting towards their fate more dead than alive. A ship discernible on the horizon is their last hope, and one man waves to it, summoning up the last strength of despair.*

The incident was not an invention: a real event, it occurred in 1818 after a ship called the *Medusa* was wrecked off the coast of Africa. Far from being the last to leave his ship, the captain was among those to take to the boats, even though there was not enough room for everyone. Slaves and others were left behind. They joined forces to build a raft, and subsequently suffered a terrible odyssey at sea. All the things that must have happened on the raft on the open sea can scarcely be described. Hunger, derangement, cannibalism—eyewitness accounts of the condition of the few survivors picked up by a passing ship after over two weeks at sea caused a great sensation and scandal in Paris.

Géricault must also have been shocked by the reports, because he shut himself up in his studio for several months with an outsize canvas so as to paint a visual memorial to the incident. His choice of a news item that in no way touched on the great themes of history painting is remarkable. He tackled a contemporary event, and in doing so managed to make it a symbol of our vulnerability to the vagaries of fate—and of human endurance. It still has a strong impact 200 years later.

Géricault's preliminary work on his gigantic painting became notorious because he used bits of corpses from a hospital morgue for his sketches. This being illegal, he had them brought to him secretly, and friends reported the horrible smell of putrefaction in his studio. Géricault was said to have descended into hell as the "Dante of painting," which no doubt referred not only to the unappetizing models but also to the depths of the human suffering depicted. Thanks to this thoroughness, however, he managed to render the bodies and particularly the morbid flesh tones and skin with great accuracy and so to powerful effect. The moment he chose to depict shows neither the captain's cowardly flight, nor the horrors that took place on the raft. He chose instead the dramatic moment in which hope flared up for the last time. After that, it would have been too late, for very few of the shipwrecked had the necessary energy—or even the willpower—to flag down ships passing at a great distance. To the left sits a bearded man looking without illusion at the viewer, surrounded by the dying and the dead, having literally already turned his back on hope. In a complex and dynamic composition, the surging mass of interwoven bodies, gestures, and poses on the raft rears up like a wave, culminating in the muscular man with his back to us, raising a white cloth. Everything depends on him. With this painting, Géricault wanted not only to illustrate a real incident. He also wanted to depict a theme typical of the Romantic era—hope and resignation in the face of human tragedy. The vision is so gripping that *The Raft of the Medusa* is often alluded to in the French press even today, if some group is drifting helplessly towards an uncertain fate.

**1791** Born 26 September in Rouen, France.
**1808** Studies painting in Paris under Carle Vernet and Pierre Guérin.
**1816** Spends a year in Italy at his own expense after failing to win the Rome Prize.
**1818** Begins work on *The Raft of the Medusa*, shown at the Salon the following year.
**1820** Accompanies a year-long touring exhibition of his works around Britain.
**1821** Visits Jacques-Louis David in exile in Brussels.
**1824** Dies 26 January in Paris.

R. Feillet, *Théodore Géricault*, 1816, lithograph from a painting by Alexandre Colin, Cabinet des Estampes, Bibliothèque Nationale de France, Paris

GUSTAVE COURBET

**1755** *Marie Antoinette

**1812** Napoleon invades Russia

1745   1750   1755   1760   1765   1770   1775   1780   1785   1790   1795   1800   1805   1810   1815   1820   1825   1830

Eugène Delacroix, *Liberty Leading the People*, 1830, oil on canvas, 260 x 325 cm, Musée du Louvre, Paris

**1848** Karl Marx and Friedrich Engels publish their communist manifesto

**1871** Charles Darwin publishes *The Descent of Man*

**1877** Queen Victoria becomes Empress of India

**1891** Construction of Trans-Siberian Railway started

**1905** Revolution throughout Russian Empire

**1911** Blauer Reiter group founded

**1908** First Ford Model T rolls off assembly line in Detroit

**1912** The *Titanic* sinks on its maiden voyage

1835 1840 1845 1850 1855 1860 1865 1870 1875 1880 1885 1890 1895 1900 1905 1910 1915 1920

EUGÈNE DELACROIX

# LIBERTY LEADING THE PEOPLE

*The French Revolution and its democratic ambitions were already long in the past when in 1830 the French monarch Charles X sought to change the constitution with a drastic limitation both of press freedom and popular involvement in government. This caused a public outcry, during which for three days fierce fighting broke out on the streets.*

Delacroix's scene of the popular revolt in the streets is a mixture of reality and symbolic fiction. The violent conflict has already produced corpses, amongst which the armed insurrectionists pick their way forward. Their leader is Liberty, here embodied by a young woman in yellow with her dress torn in the heat of the fighting to reveal her breasts. She holds high the fluttering red, white and blue flag that had represented the French nation ever since the revolution of 1789. The figure combines classical sculptural models with both real and allegorical elements. Beside her on her left is a street urchin brandishing a pistol in each hand, while on her right is a man in a top hat with a musket. The boy in the beret is supposed to have been the inspiration for Victor Hugo's character Gavroches in his novel *Les Misérables*, while the raffish, conspicuously armed gentleman kneeling beside Liberty is according to some commentators the painter himself, or one of his friends. Clinging to a pile of cobbles on the left is a boy with a saber in his hand. Lying in the street in front of the group of figures is a chilling and dramatic scene of dead and wounded bodies. Beyond them on the left, an enraged crowd of protesters streams forward. In the right background, the streets of Paris emerge from clouds of smoke.

Delacroix himself probably did not figure in the front ranks of the July revolutionaries. It does no harm to his image to mention this, since he himself notes in a letter to his brother: "I have begun a modern subject, a barricades scene, and if I haven't fought for France, I will at least paint for her. That has put me in a good mood."

It should be mentioned in his favor that the painter is supposed to have stood guard at night protecting the collection of the Louvre from attack, thereby sustaining a heavy cold in the normally warm Paris July weather!

The romantic depiction of Liberty in the form of a proud woman waving the French flag is timeless and can be used to symbolize the spirit of freedom of any period. In recognition of this, the French state—where meantime Louis Philippe had taken over as king of the French—acquired the painting for its collections immediately after the 1831 Salon. The picture has been in the Louvre since 1874. The subject also featured in French everyday life on the hundred-franc note until the introduction of the Euro.

**1798** Born Ferdinand Victor Eugène Delacroix 26 April near Paris.
**1815** Starts training as a painter.
**1822** First shows at the Salon, with *The Barque of Dante*.
**1828** Shows the *Death of Sardanapalus* and 12 other paintings.
**1831** *Liberty Leads the People* exhibited.
**1832** Travels to Morocco.
**1855** His work is shown at the World Fair in Paris.
**1863** Dies 13 August in Paris.

left:
Eugène Delacroix, *The Barque of Dante*, 1822, oil on canvas, 189 x 242 cm, Musée du Louvre, Paris

above:
Eugène Delacroix, *Self-Portrait*, c. 1837, oil on canvas, 65 x 54.5 cm, Musée du Louvre, Paris

JOHN CONSTABLE

THÉDORE GÉRICAULT

ALFRED SISLEY

**1837** Victoria becomes
queen of England

**1776** American Declaration of Independence

**1815** Napoleon defeated at Waterloo

**1842** China cedes
Hong Kong
to Britain

**1781** Immanuel Kant publishes the
*Critique of Pure Reason*

**1805** Battles of Trafalgar and Austerlitz

**1830** Liverpool-Manchester
Railway opened

| 1760 | 1765 | 1770 | 1775 | 1780 | 1785 | 1790 | 1795 | 1800 | 1805 | 1810 | 1815 | 1820 | 1825 | 1830 | 1835 | 1840 | 1845 |

William Turner, *Rain, Steam and Speed:
The Great Western Railway*, 1844, oil on
canvas, 91 x 121.8 cm, National Gallery,
London

**1848** Karl Marx and Friedrich Engels publish
their communist manifesto

**1914–1921** James Joyce works on *Ulysses*
**1914–1918** First World War

| 1850 | 1855 | 1860 | 1865 | 1870 | 1875 | 1880 | 1885 | 1890 | 1895 | 1900 | 1905 | 1910 | 1915 | 1920 | 1925 | 1930 | 1935 |

WILLIAM TURNER

# RAIN, STEAM AND SPEED

*His Swiss fellow artist Henry Fuseli claimed that Turner was "the only landscape-painter of genius in Europe." Of course, other 19th-century artists produced successful landscapes, but Turner's pictures are in a category of their own.*

The sky is overcast and it's raining. Mist links the clouds with the water beneath a bridge, which an early steam train is crossing. A dinghy is visible downstream, with another bridge visible in the distance beyond it. In the far distance on the right is London, though only sketchily represented. Cloud and mist seem to run seamlessly into one another. A train—the transport of the future—hurtles towards us at high speed through this vortex of rain, water, and steam. The turmoil in the landscape is reinforced by the sensational experience of railway speed. The atmosphere of the picture is brilliantly staged— it is very easy to imagine the wind, speed, the rain. The title indicates the conditions represented in the painting and underlines the effect of the adroitly use tones of brown and ochre and the white and yellow highlights. Individual details are precisely recognizable, whereas in other areas the paint is thick and looks almost as if thrown on the canvas. The subtle effects of light and water are caught atmospherically by blurred, flowing transitions within one tone to the next. Turner used a particular mixture of more diffuse areas and more meticulously painted elements in his paintings that underlines the impression of speed, weather and changing light.

Turner had the inspiration for this picture while in a train crossing the bridge over the Thames at Maidenhead near London. A train was coming in the opposite direction, though the other line is removed in the picture. At the time it was painted, railways— and high speeds—were relatively new and exciting phenomena. The extraordinary thing was that Turner was able to incorporate the motif of mechanical speed into a landscape painting. Natural phenomena were tried and tested motifs representing the sublime. Here the steam engine appears as a force of nature, demanding that we stand and stare in amazement. It was a subject wholly after Turner's heart.

At the date this painting was produced, Turner could already look back on a career as one of Britain's most prominent artists. Shortly after painting it and thematicising not only the landscape but also one of the most important innovations of the industrial age, he completely withdrew from public life. Thackeray wrote of this picture: "There comes a train down upon you, really moving at the rate of fifty miles an hour, which the reader had better make haste to see, lest it should dash out of the picture …," acknowledging the effect the painter was looking for. Turner was an admirer of "cataclysmic, elementary events," whether storms, hail, rain or speed. The spark of this artistic interest fired the French Impressionists a generation later. They paid close attention to the works and techniques of Turner, and some of their pictures drew direct inspiration from his.

**1775** Born Joseph Mallord William Turner 23 April in London.
**1789** Goes to Royal Academy School.
**1796** Following drawings and watercolors, shows his first oil painting at the Royal Academy.
**1802** Becomes a member of the Royal Academy, and travels to France and Switzerland.
**1807** Studies perspective and begins to teach it.
**1819** Travels to Italy.
**1823** Commissioned to paint the *Battle of Trafalgar*.
**1839** Paints *The Fighting Temeraire*.
**1846** Retires from the public eye as Admiral Booth.
**1851** Dies 19 December in London.

J.T. Smith, *William Turner in the Print Room of the British Museum*, c. 1825, watercolor and pencil, 22.2 x 18.2 cm, British Museum, London

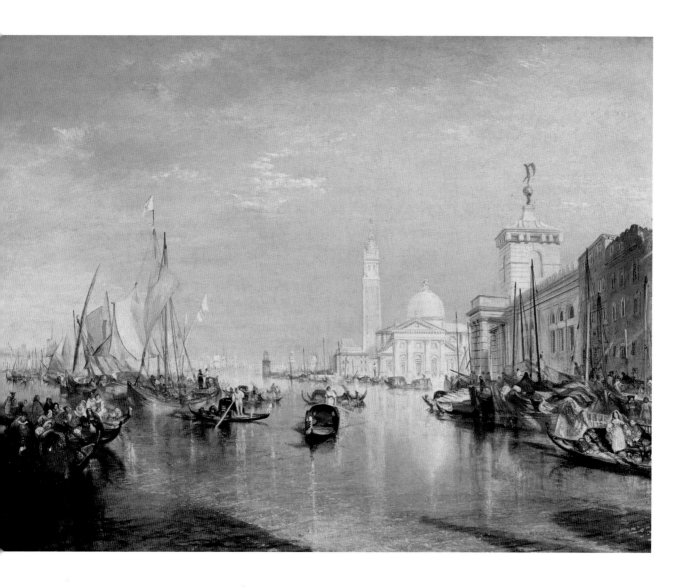

William Turner, *The Dogana and San Giorgio Maggiore, Venice*, c. 1834, oil on canvas, 91.5 x 122 cm, National Gallery, London

William Turner, *Peace–Burial at Sea*,
1842, oil on canvas, 87 x 86.5 cm, Tate
Gallery, London

AUGUSTE RODIN =========

GUSTAVE COURBET =========

CLAUDE MONET =========

**1789** Storming of the Bastille launches
French Revolution

**1865** Slavery
abolished
in the USA

1780   1785   1790   1795   1800   1805   1810   1815   1820   1825   1830   1835   1840   1845   1850   1855   1860   1865

Edouard Manet, *Le Déjeuner sur l'Herbe*,
1863, oil on canvas, 208 x 264 cm, Musée
d'Orsay, Paris

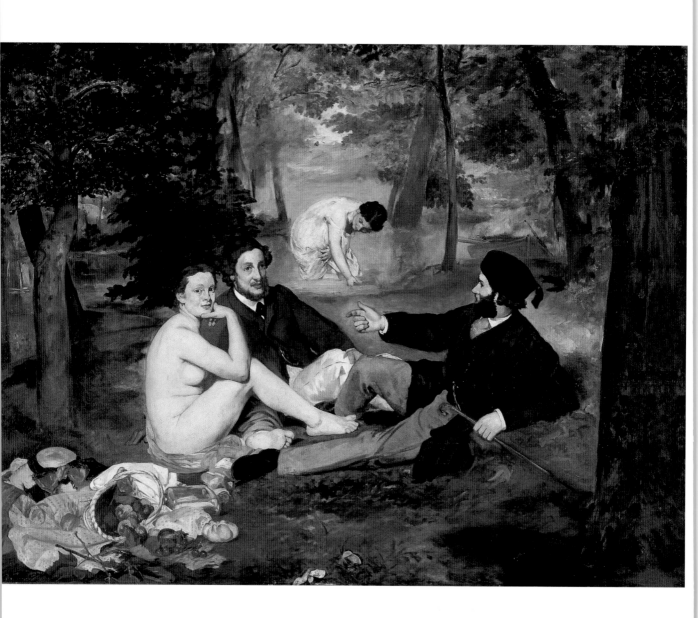

**1871** Charles Darwin publishes *The Descent of Man*

**1907** Picasso's *Les Demoiselles d'Avignon*

**1870–1871** Franco-Prussian War    **1887–1889** Eiffel Tower built in Paris

**1900** First line of French Metro opened

**1914–1918** World War I

**1929** Stock market crash heralds global economic crisis

**1877** Queen Victoria becomes Empress of India

1870   1875   1880   1885   1890   1895   1900   1905   1910   1915   1920   1925   1930   1935   1940   1945   1950   1955

EDOUARD MANET

# LE DÉJEUNER SUR L'HERBE

*Two couples are having lunch in the open air. A pleasant picnic on a sunny afternoon. Yet the whole thing seems artificial: one of the women is entirely naked, and the second woman looks like a figure from classical Greece or Rome, though the men are dressed in contemporary clothes. What exactly is going on in this scene?*

*Le Déjeuner sur l'Herbe* was first exhibited at the Salon des Refusés in 1863, where it was entitled *Le Bain* (Bathing). The Salon des Refusés was an exhibition put on parallel to the official Salon in Paris and showing works that the jury for the latter had rejected. As the scene of two men in contemporary dress with a naked woman and another woman bathing in the background lacked any pretext such as an allegorical, historical, or mythological subject, Manet's painting was predestined for the "alternative show."

Yet the subject is only apparently an everyday secular scene. It was inspired by Titian's *Concert Champêtre* (Pastoral Concert), though in Manet contemporary middle-class men replace gods and real women replace nymphs. Attention is often drawn also to the clear reference to Raphael's *Judgment of Paris* (known through an engraving by Marcantonio Raimondi), where two river gods and a nymph are shown. The people that Manet paints in his pastoral scene can be identified: the naked woman is Victorine Meurent (who was also his Olympia in the famous picture of that name), while the man behind her is Ferdinand Leenhoff, Manet's future brother-in-law. On the right is one of Manet's brothers. The woman in the background is possibly Manet's future wife, Suzanne Leenhoff. Contemporary critics also recognized them, of course, and were outraged at the "vulgarity" of the subject. They also objected to what they considered to be technical defects: the light seemed exaggerated and artificial, and the perspective, execution and proportions were, in their view, carelessly handled.

The painterly representation of nature in which the scene takes place is reduced to color fields that are intentionally not finished in detail. The four people are more or less implanted in the landscape, since with their much more prominent outlines they appear to have no real physical connection with the backdrop. The three figures at the front and the one at the back form a pyramid where the figures are only approximately proportionate to the surroundings.

Yet it is these very contradictions that make the painting interesting. Manet was adept at making exciting use of color, and the picture reveals conspicuous contrasts. The picnic basket with most of the picnic already removed is like a still life in the picture, which our eye alights on after the group of people.

Manet painted the world of his time, including the bars and the prostitutes as well as the people he knew. Dandies—and the two elegant gentlemen in the picture must be identified as such—calmly watch the pursuits of their female contemporaries and are not disconcerted by their nakedness, unlike the middle-class critics, who were concerned about morality and decency. Even though a great deal of time has passed, Manet's *Le Déjeuner sur l'Herbe* still has the power to puzzle and fascinate.

**1832** Born 23 January in Paris.
**1848** Turned down by the Navy, he decides to become a painter.
**1850** Apprenticed to Thomas Couture in Paris.
**1863** Shows *Déjeuner sur l'Herbe* at the Salon des Refusés.
**1865** His *Olympia* causes a scandal.
**1871** From now on frequently paints in the open air.
**1873** Dealer Durand-Ruel sells his works successfully.
**1882** Exhibits his *Bar of the Folies-Bergères*.
**1883** Dies 30 April in Paris.

Edouard Manet, photograph

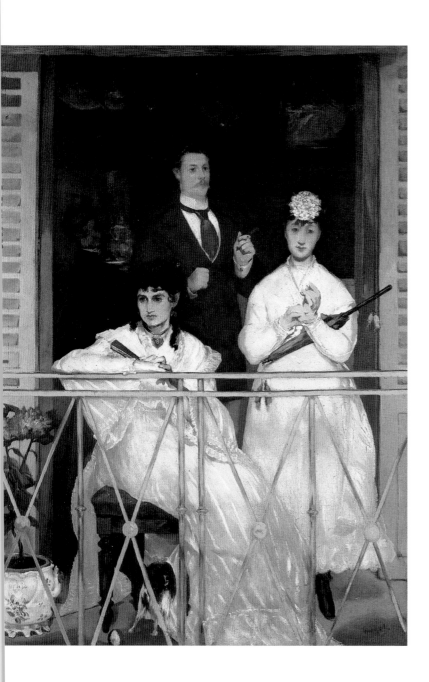

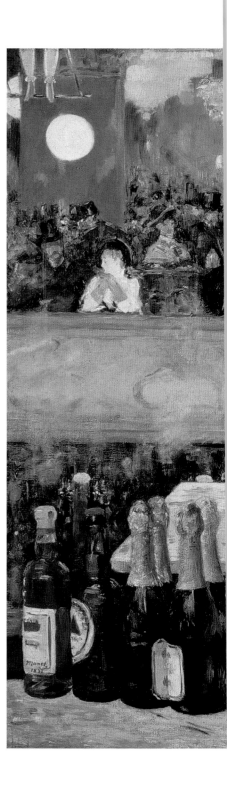

Edouard Manet, *The Balcony*, c. 1868/69,
oil on canvas, 170 x 124.5 cm, Musée
d'Orsay, Paris

Edouard Manet, *A Bar at the Folies-Bergère*, 1882, oil on canvas, 96 x 130 cm, Courtauld Institute Galleries, London

ODILON REDON

MAX KLINGER

**1804** Napoleon declares himself emperor

**1848** Karl Marx and Friedrich Engels publish
their communist manifesto

**1865** Slavery abolished in the USA

| 1795 | 1800 | 1805 | 1810 | 1815 | 1820 | 1825 | 1830 | 1835 | 1840 | 1845 | 1850 | 1855 | 1860 | 1865 | 1870 | 1875 | 1880 |

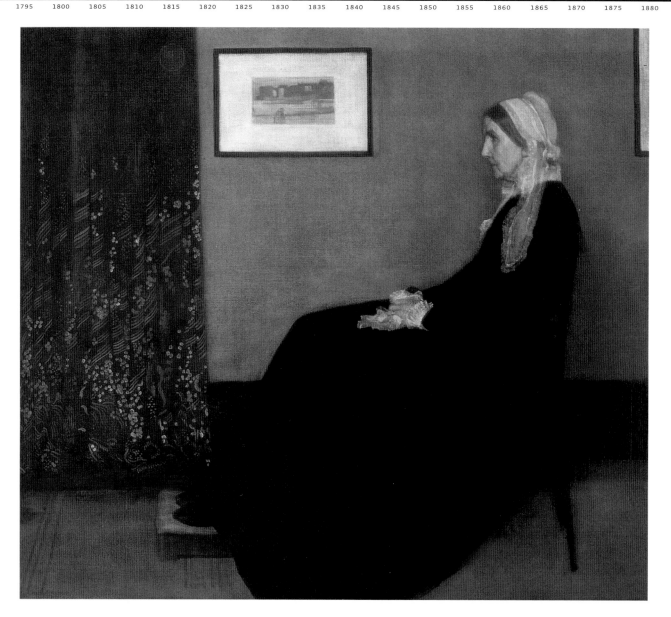

James Abbott McNeill Whistler,
*Arrangement in Gray and Black No. 1
(Portrait of the Artist's Mother)*, 1871,
oil on canvas, 144.3 x 165.2 cm,
Musée du Louvre, Paris

1886 Statue of Liberty
erected in the port
of New York

1900 Freud publishes
*Die Traumdeutung*
(Interpretation
of Dreams)

1908 First Ford Model T rolls off
assembly line in Detroit

1914–1918 World War I

1912 The *Titanic* sinks on its maiden voyage

1927 Charles Lindbergh flies
the Atlantic non-stop

1939–1945 World War II

1885  1890  1895  1900  1905  1910  1915  1920  1925  1930  1935  1940  1945  1950  1955  1960  1965  1970

JAMES ABBOTT MCNEILL WHISTLER

# THE ARTIST'S MOTHER

*Even Mr Bean took an interest in this world-famous painting in one of his films, in his own unique tragicomic fashion.*
*After wrecking it with his clumsiness and replacing it with a poster, he explained it to an American public.*
*The commentary could hardly have been more laconic: it was, he said, 1) quite big, and 2) showed a mother.*

Whistler's own title—*Arrangement in Gray and Black No. 1*— shows that this was first and foremost a composition involving colors and shapes. In his view, the title did not necessarily have to indicate what it depicted. The fact that the sitter was his mother he revealed only later.

Looking straight ahead in profile, an old lady sits motionless on a chair with her feet on a footstool and her hands on her lap. The dominant colors of the picture are gray, white, and black. Geometrically constructed, the composition consists of straight lines and axes at precise angles, which are only partly softened by the gentler shapes of the figure. Like the sitter herself, the tonal harmony of the scene radiates great peace.

There is much speculation about the sources that could have inspired this picture. Old ladies like this, in Victorian clothing consisting of a black dress and white lace head covering, are found mainly in photographs. Classical relief sculpture could also have been an influence.

Whistler experimented with portraits, and in particular with reducing colors to a few tones. The terminological borrowings from music (arrangement, symphony, and so on) are deliberate and reflect his approach to painting. He confirmed that this picture is first and foremost a composition and that the identity of the sitter has no relevance. Whistler supplied the theoretical basis for his approach in numerous essays and speeches. In these, he opposed the academic doctrine that art should convey a moral or historical content. His objective was to achieve an effect by artistic means alone, in other words through compositions and color harmonies. Art for art's sake was not only a motto the Parisian 19th-century dandy was fond of repeating, it was also an aesthetic position that asserted the autonomy of art. Everyday phenomena were thus lent beauty by their aesthetic enhancement and interpretation. Whistler said of the *Arrangement in Gray and Black* that the public could hardly care whether it was his mother or not. More important to him seemed the handling of black, the "queen of colors," as his teacher had called it. This very sober and austere coloration could also, of course, say something about the mettle and moral expectations of his very devout mother.

When the painting was first exhibited, a critic wrote that "it tells the story of a life as pen and ink could not tell it ... All the storms, all the fears, all the anxieties, all the burdens have gone from her life ... and left her a pure embodiment of spirit, of patient waiting."

Today, the picture is regarded as an icon of American painting, its appeal based not only on its painterly virtues but also on its subject.

1834 Born 11 July in Lowell, Massachusetts.
1843 Pupil at the Imperial Academy of Fine Arts in St Petersburg, Russia.
1851 Goes to military academy at West Point.
1855 Moves to Europe and studies in Paris.
1859 His etchings are shown at the Royal Academy in London.
1861 Paints *Symphony in White No. 1*
1864 Paints *Little White Girl* (1864).
1866 Travels to Chile.
1879 Has serious financial problems from a lawsuit.
1886 Becomes president of the Society of British Artists and gains an international reputation.
1903 Dies 17 July in London.

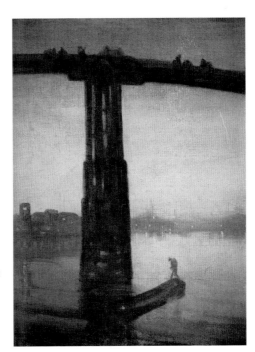

left:
James Abbott McNeill Whistler,
*Nocturne: Blue and Gold–Old Battersea Bridge*, 1872, oil on canvas,
66.6 x 50.2 cm, Tate Gallery, London

above:
James Abbott McNeill Whistler, photograph December 1878, Whistler Collections, University Library, Glasgow

CAMILLE COROT

**1804** Napoleon declares himself emperor

| 1795 | 1800 | 1805 | 1810 | 1815 | 1820 | 1825 | 1830 | 1835 | 1840 | 1845 | 1850 | 1855 | 1860 | 1865 | 1870 | 1875 | 1880 |

Claude Monet, *Impression—Sunrise*, 1872,
oil on canvas, 49.5 x 65 cm, Musée
Marmottan, Paris

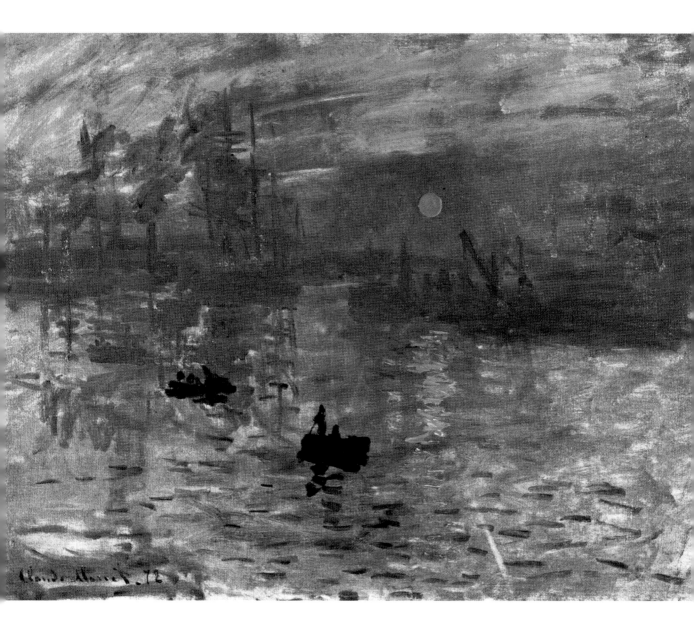

**1900** First line of French Metro opened

**1914** Assassination of Archduke Franz
Ferdinand of Austria in Sarajevo
triggers outbreak of World War I

**1936** Charlie Chaplin: *Modern Times*

**1902** First Aswan dam
completed

**1887–1889** Eiffel Tower
built in Paris

**1911** Rutherford develops
a model of the atom

**1919** Treaty of Versailles officially
ends World War I

**1939–1945** World War II

| 1885 | 1890 | 1895 | 1900 | 1905 | 1910 | 1915 | 1920 | 1925 | 1930 | 1935 | 1940 | 1945 | 1950 | 1955 | 1960 | 1965 | 1970 |

CLAUDE MONET

# IMPRESSION–SUNRISE

*Impression—Soleil was the title Monet gave to this little picture when he first exposed it to the criticism of the public at an exhibition. It gave a whole stylistic movement its name, because for critic Louis Leroy it was a matter of a moment to decide that this was what Monet and his colleagues were all about—impressions.*

In his picture, Monet painted not what he knew to be there, but only what he actually saw: an impression of the outer harbor of Le Havre at sunrise. The sun colors the sky orange and dispels the blue of night, which grows lighter as the early boats become visible in *contrejour*. The cranes, ships, and details of the view are shown only schematically, the way the eye would take them in in passing. A slight mist and smoke from the chimneys make their contributions, connecting with the clouds and depicting an awakening day. The human eye can indeed barely take in the details of an ever-changing reality spread out in front of it.

The shimmering of sunlight, the reflection of the waves, and the colors of the landscape at different times of the day became the subject matter for the Impressionists. It was a wholly different approach from one they had learnt at the academies. It did not involve long preparatory studies carried out in the studio, but the setting down on canvas of impressions of light and nature on the spot, out in the open, capturing a fleeting moment in time. Consequently the subject matter involved was also no longer that of the classic canon of painting— myths, allegories, or history. Instead, there were more or less everyday scenes: a view of the port, impressions of cathedrals, haystacks, or water lilies. Monet painted the last of these in endless varia- tions, as they were always there in front of him in constantly new light in his own garden. Sunlight and its effects on nature were the most important inspiration. Painting techniques also changed. The brushwork was quick and spontaneous, and shapes made up of lines, dabs and dots—only at a distance does what seems like a confusion of wildly applied paint turn into a recognizable composition. Recording transitory "impressions" of atmosphere, lighting effects and water reflections was what painters such as Monet, Paul Cézanne, Pierre-Auguste Renoir, Camille Pissarro, and Alfred Sisley were striving for. Though such artists often seemed to

work entirely spontaneously, their approaches were based on a very serious consideration of color theories, the nature of human perception, and the role of art in depicting everyday life (and not tired themes drawn from mythology or history). Interest- ingly, this painting was first exhibited, in 1874, in the studio of the photographer Nadar.

Today, Impressionism is considered one of the most successful artistic movements ever. Day after day, tourists from all around the world cluster round the pictures in the Musée d'Orsay, a treasure house of paintings of mainly French Impressionists. It was Monet and his paintings that showed these artists the way.

**1840** Born 14 November in Paris.
**1859** Moves to Paris and enrolls for painting classes at the Académie Suisse.
**1863** Meets Manet and paints open-air pictures in the forests of Fontainebleau.
**1874** His work *Impression–Sunrise* is the name-giving item at the first Impressionists exhibition.
**1883** Settles in Giverny.
**1889** Begins to paint pictures in series on subjects such as haystacks, the Thames Embankment, and Rouen Cathedral.
**1926** Dies 6 December in Giverny.

Claude Monet, photograph
December 1899

1795 1800 1805 1810 1815 1820 1825 1830 1835 1840 1845 1850 1855 1860 1865 1870 1875 1880

Vincent van Gogh, *The Starry Night*, 1889,
oil on canvas, 73 x 92 cm, Museum of
Modern Art, New York

EGON SCHIELE

1945 End of World War II

1911 Rutherford develops his model of the atom

1948 UN general assembly's Declaration
of Human Rights

1901 The King of Sweden hands out the first Nobel prizes

1933 Hitler seizes power

1891 Construction of Trans-Siberian
Railway starts

1914–1918 World War I

1967 Beatles' *Sgt. Pepper's Lonely
Hearts' Club Band* LP

| 1885 | 1890 | 1895 | 1900 | 1905 | 1910 | 1915 | 1920 | 1925 | 1930 | 1935 | 1940 | 1945 | 1950 | 1955 | 1960 | 1965 | 1970 |

VINCENT VAN GOGH

# THE STARRY NIGHT

*Vincent Van Gogh once wrote that he had often had the impression that night was even richer in colors than the day. Thanks to his palette, he was able to show convincingly what he meant through nocturnal scenes painted in the south of France—scenes of extraordinary vitality and depth.*

This painting shows an impressive night scene. It is busy, bright and enigmatic. The sky is a pattern of whorls above the landscapes of Provence. In the foreground, a black cypress tree writhes skywards like a flame, where blue arabesques and wave shapes envelope brilliant stars. The mixture of blue, orange, yellow and pink blends into an image of turbulence that expresses a fascination for the depths of night and the mystery of the universe. The scene is empty of human life. Thick brushwork and energetic, distinctive patches of color reinforce the dynamic, almost dizzying effect of the composition. This starry night scene dates to the period when Van Gogh was in a mental institution in Saint-Rémy in Provence, to which he had retreated after his notorious attack of paranoia during which he had cut off a piece of ear after a quarrel with Paul Gauguin. The expressive shapes and painterly gestures in the picture demonstrate the intensity of feeling that he must have had on looking at the nocturnal landscape in Provence. The artistic power of expression derives from the visible elements of a beautiful summer night combined with expressive shapes and energetic brushwork. The undulating shapes presumably bear witness equally to the painter's state of mind as much as turbulence in the night sky, and express deep-seated fears and hopes. Two elements, the cypress and the artificially elongated spire, link the earth with the sky. These figuratively establish the connection between human reality (the village) and spiritual aspirations. Being deeply religious and also profoundly im-pressed by the Provencal landscape, Van Gogh found in the night sky of Saint-Rémy one of the most emblematic motifs of his all too brief life, which he put an end to only one year later.
This painting from 1889 in the Museum of Modern Art in New York is on a similar subject to another painting in the Musée d'Orsay in Paris dated 1888, the year Van Gogh arrived in Provence. It shows a nocturnal view of the Rhône river with a bridge over

it. There are stars in the sky, and in the foreground a couple. The deep blue tones of the night scene are illuminated by the gas lamps on the bridge reflecting yellow on the water and the orange-yellow stars in the sky. Van Gogh felt attracted to stars as the ultimate destination. " Just as we catch the train to travel to Tarascon or Rouen, so we choose death to reach the stars."
The magic pull his paintings still exert is no doubt founded in part on Van Gogh's yearning for a life beyond.

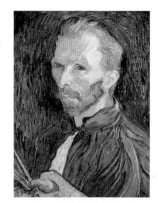

1853 Born 30 March in Groot-Zundert in Brabant, Holland.
1880 After initially feeling a religious vocation, he decides to become a painter. His younger brother Theo supports him all his life.
1886 Goes to Paris, where Theo works at the Galerie Goupil. Extends his technique and his circle of acquaintances.
1888 Moves to Arles, where Gauguin follows him. A quarrel between the two leads to Van Gogh's breakdown.
1890 Van Gogh sells a painting for the first time, in Brussels. Dies 29 July in Auvers-sur-Oise, France.

above:
Vincent van Gogh, *Self-Portrait as a Painter*, September 1889, oil on canvas, 57 x 43.5 cm, Mrs John Hay Whitney Collection, New York

page 114:
Vincent van Gogh, *Cafe Terrace at Night*, 1888, oil on canvas, 81 x 65.5 cm, Rijksmuseum Kröller-Müller, Otterlo

page 115:
Vincent van Gogh, *Still Life: Vase with Twelve Sunflowers*, 1888, oil on canvas, 92 x 72.5 cm, Neue Pinakothek, Munich

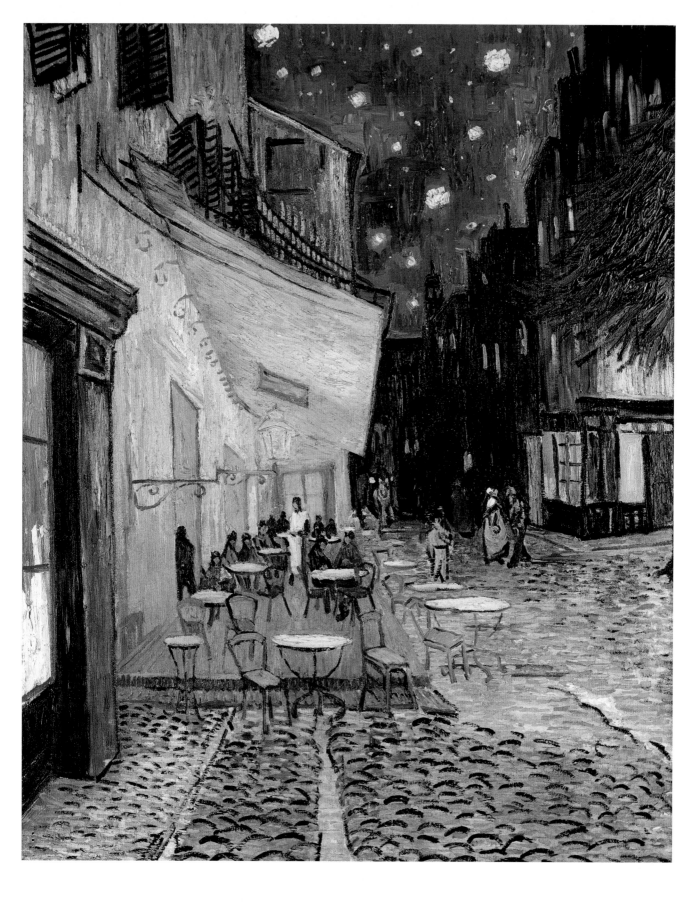

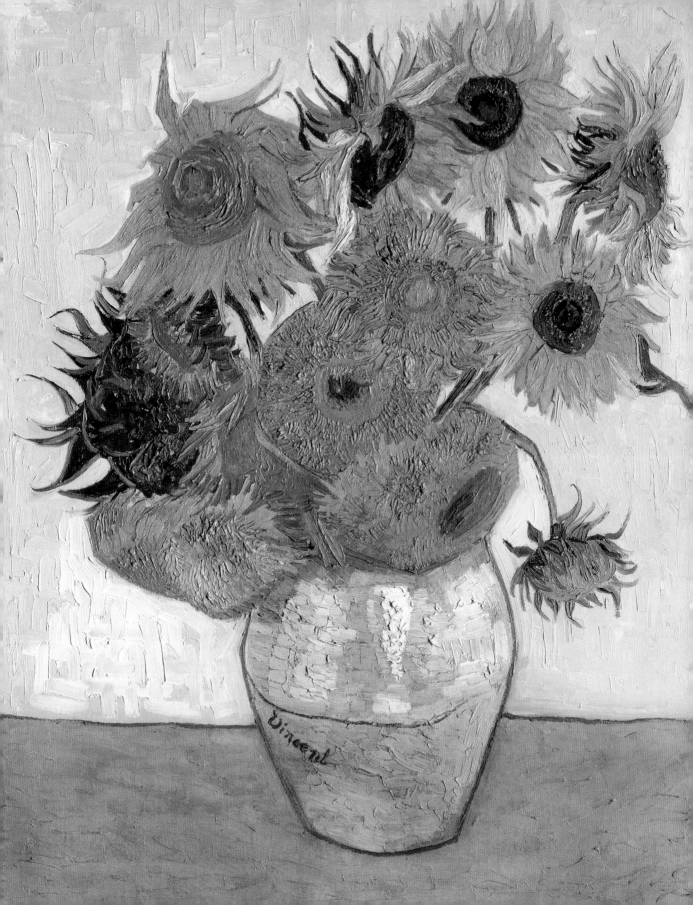

**1804** Napoleon declares himself emperor

**1865** Slavery abolished in the USA

**1871** Charles Darwin publishes
*The Descent of Man*

| 1800 | 1805 | 1810 | 1815 | 1820 | 1825 | 1830 | 1835 | 1840 | 1845 | 1850 | 1855 | 1860 | 1865 | 1870 | 1875 | 1880 | 1885 |

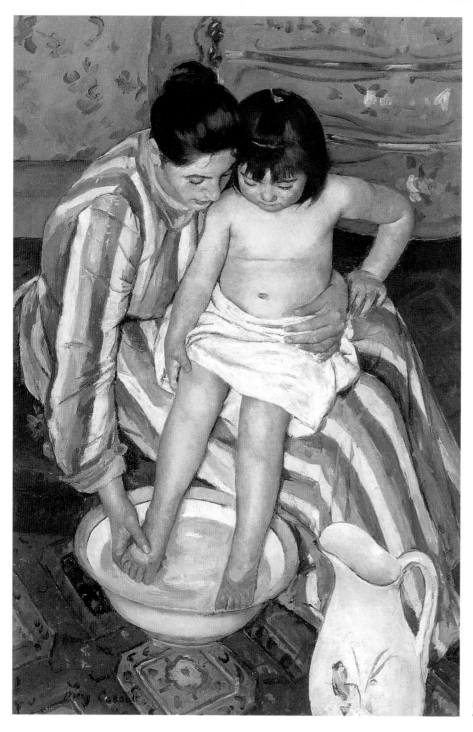

Mary Cassatt, *The Child's Bath*, 1893, oil on
canvas, 100.3 x 66 cm, Art Institute of Chicago

1917  November Revolution in Russia        1939–1945  World War II

1887–1889  Eiffel Tower built in Paris                        1929  Stock market crash heralds
                                                                              global economic crisis
              1900  First French Metro line opened in Paris              1946  UNESCO founded        1961  Berlin Wall built

1890    1895    1900    1905    1910    1915    1920    1925    1930    1935    1940    1945    1950    1955    1960    1965    1970    1975

MARY CASSATT

# THE CHILD'S BATH

*The visual world of Mary Cassatt was the traditional domestic life of well-to-do middle-class women. They drank tea, read, went to the opera, and looked after their children. Cassatt herself opted for a different way of life, and decided— against her parents' advice—to become a painter.*

*The Child's Bath* shows a woman holding a little girl in her lap. She is washing the child's feet in a bowl, with a pitcher standing on the carpet in front of them. They are both gazing intently at the child's feet in the water. All we notice of the surroundings is the floral pattern of the wallpaper and the chest of drawers in the background, with the woman's dress of green, white and mauve stripes dominating the composition. The engrossment of the two figures, their physical proximity and intimacy of gesture, reinforced by the fading out of other details, illustrates the heartfelt and loving care of a mother for her child. The everyday act of bathing becomes a harmonious and absorbing ritual that fully preoccupies both of them.

American artist Mary Cassatt spent most of her life in Paris, and travelled widely in Europe. Her friends included the artists Berthe Morisot, Edouard Manet, and Edgar Degas, and she exhibited her pictures with the Impressionists in Paris. Over and above her creative activity, Cassatt was a sought-after adviser to art buyers, and thanks to her good offices important works of French Impressionism entered American collections. The domestic scenes that she mostly painted thus show less of her own everyday life than that of the women of her time, and she often painted friends and relatives. In choosing to produce a large number of mother-and-child scenes she was certainly also aware of her public's taste— and thus willingness to purchase.

Even so, the works show a new interest in scenes of everyday life. Just as Manet painted honest middle-class citizens instead of heroes or divinities, so Cassatt painted the female members of the middle classes and their children instead of the Virgin and Child. She deftly caught the poses and spontaneous attitudes of children, who were not wont to adopt the most flattering poses, or who tilted their heads archly. The sensory experience that subjects of this kind convey was the decisive, innovative element. When we look at the scene, you are encouraged to

imagine the texture of the things depicted—of water, pottery, skin, fabrics, rugs etc. Impressions you can confirm from your own experiences are what mattered for Cassatt. The interior here is used to convey the peace and harmony of a domestic scene. The representation of a social class and the detailed rendering of an interior are not involved.

Mary Cassatt was fully aware that women could also have interests outside the family besides rearing children—her own life and successful career, and her championing of female suffrage in the USA, are evidence of that.

1845  Born Mary Stevenson Cassatt 23 May in Pittsburgh, Pennsylvania.
1861–1865  Studies painting at the Pennsylvania Academy of Fine Arts in Philadelphia.
1866  Travels to Europe and settles in Paris.
1877  Exhibits her works with the Impressionists.
1891  Exhibits at the Durand-Ruel gallery in Paris.
1893  Commissioned to paint the mural *Modern Woman* for the World Fair in Chicago.
1926  Dies 14 June in Mesnil-Beaufresne, France.

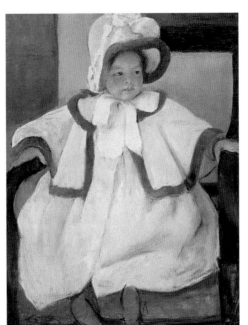

left:
Mary Cassatt, *Ellen Mary Cassatt in a White Coat*, c. 1896, oil on canvas, 81.3 x 60.3 cm, Museum of Fine Arts, Boston

above:
Mary Cassatt, photograph

**1865** Slavery abolished in the USA

1800    1805    1810    1815    1820    1825    1830    1835    1840    1845    1850    1855    1860    1865    1870    1875    1880    1885

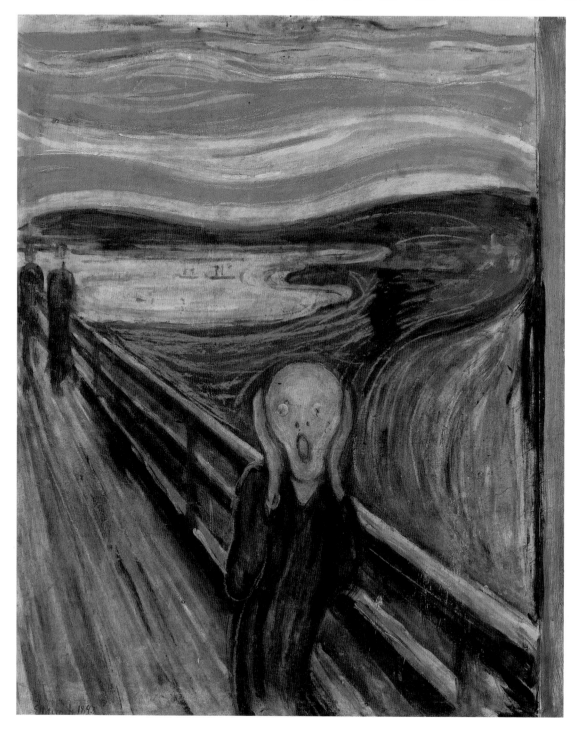

**1901** Thomas Mann publishes *Buddenbrooks* **1920** Nazi Party founded
**1907** Picasso's *Les Demoiselles d'Avignon*
**1933** Hitler seizes power
**1900** Freud publishes *Die Traumdeutung* **1914–1918** World War I **1927** Martin Heidegger publishes
(Interpretation of Dreams) *Existence and Being*
**1945** Liberation of Auschwitz
concentration camp
**1911** Roald Amundsen pips Captain Scott to the South Pole

1890   1895   1900   1905   1910   1915   1920   1925   1930   1935   1940   1945   1950   1955   1960   1965   1970   1975

EDVARD MUNCH

# THE SCREAM

*A scream also rippled through the art world when one of the two versions of this painting was the object of a spectacular theft in Oslo in 2004. It was recovered two years later and restored to the Munch Museum, where it now hangs as probably the artist's most famous picture.*

The painting shows a very sketchy, narrow figure standing on a bridge that vanishes diagonally into the left edge of the picture. The figure clasps its face in both hands, its mouth and eyes wide open with horror. The shape of the head is evocative of a skull. The landscape behind the figure is likewise only sketchily indicated, with an orange sky spreading over land and water in the background. The colors and shapes in the picture do not correspond to nature, but in their stark contrasts and dynamic movement underline the feelings visibly affecting the person in the foreground. The picture is a vortex, a dizzying whirlpool. Munch himself described this feeling very clearly: "I was walking along a path with two friends—the sun was setting—suddenly the sky turned blood red—I paused, feeling exhausted, and leaned on the fence—there was blood and tongues of fire above the blue-black fjord and the city—my friends walked on, and I stood there trembling with anxiety—and I sensed an infinite scream passing through nature."

The expressive treatment of this experience of existential fear comes out in the pale face, the rigid stoop of the "immaterial" body (it has been speculated that Munch based the body on the shape of Ancient Egyptian mummies). A piercing sound frozen in an art form that is *per se* silent gives the image an extraordinary power.

Munch did two versions of this picture, with the one in the Oslo National Gallery being securely datable to 1893. In 2008, the version in the Munch Museum, which was badly damaged during the theft but has now been restored, was tentatively dated 1910. The paintings of Munch indicate his state of mind like a "psychic diary," as he put it. They are a record of profound experiences in his life. His personal circumstances were not exactly simple—several of his siblings died young, while other family, financial, and emotional problems burdened him all his life. *The Scream* is a symbol of the profound despair that can overcome those grappling with the unfathomable nature of existence. The artist's message is also evident from the composition of the picture and the almost psychedelic, paranoid colors and lines. Driven into a corner, the subject finds no exit from this bridge, a situation described by Existentialist thinkers such as Jean-Paul Sartre and Martin Heidegger. The vortex of the landscape represents the human spirit incapable of understanding the complexity of its world.

The figure in the picture is so widely known that it has been marketed in the form of an inflatable doll. This eerie combination of the tragic and the comic has done nothing to diminish the impact of the original. It is a stark image that has often caught the mood of modern history.

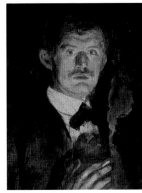

1863 Born 12 December in Løten, Norway.
1881 Enrolls at the Royal College of Art in Kristiania (Oslo).
1885 Begins work on the *Sick Child*.
1889 Lives mainly in Paris.
1893 Moves to Berlin and exhibits regularly in Germany.
1894 Paints several *Madonnas*.
1944 Dies 23 January in Ekely, Norway.

left page:
Edvard Munch, *The Scream*, 1893, oil, tempera and chalk on card, 91 x 74 cm, Nasjonalgalleriet, Oslo

above:
Edvard Munch, *Self-Portrait with Cigarette*, 1895, oil on canvas, 110.5 x 85.5 cm, Nasjonalgalleriet, Oslo

**1848** Karl Marx and Friedrich Engels publish
their communist manifesto

**1857** Flaubert's *Madame Bovary* published

**1891** Construction
of Trans-
Siberian
Railway begi

1810  1815  1820  1825  1830  1835  1840  1845  1850  1855  1860  1865  1870  1875  1880  1885  1890  1895

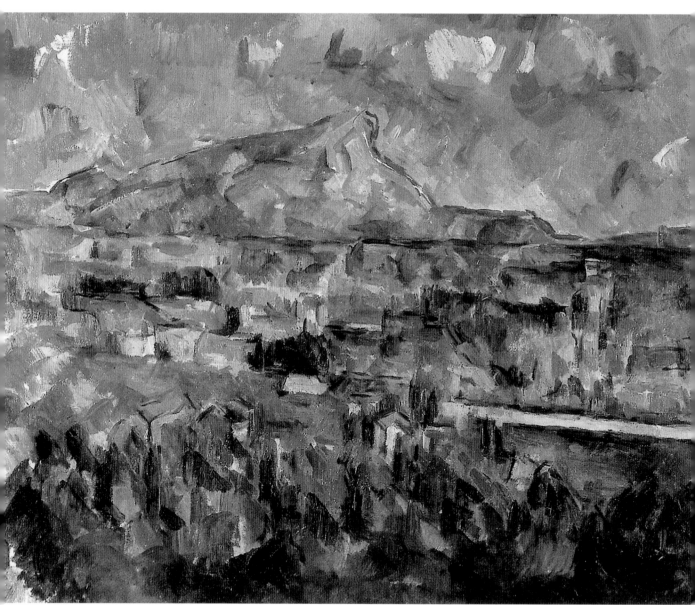

Paul Cézanne, *Mont Sainte-Victoire*,
1902–1906, oil on canvas, 65 x 81 cm,
Philadelphia Museum of Art

1909 Marinetti publishes his
Futurist manifesto

1937 Picasso's *Guernica*

1911 Rutherford develops
his model of the atom

1928 Alexander Fleming
discovers penicillin

1961 Berlin Wall built

1939–1945 World War II

1903 Henry Ford establishes the Ford Motor Company in Detroit

| 1900 | 1905 | 1910 | 1915 | 1920 | 1925 | 1930 | 1935 | 1940 | 1945 | 1950 | 1955 | 1960 | 1965 | 1970 | 1975 | 1980 | 1985 |

PAUL CÉZANNE

# MONT SAINTE-VICTOIRE

*Cézanne stalked his favorite mountain for years like a beast of prey, visiting it at all times of the day or night. Between 1870 and 1906, he depicted it over eighty times. In this respect he was approaching his subject matter almost in the meditative fashion of Chinese and Japanese artists.*

The view in this picture is of the mountain by day. The eye moves from the shadowy foreground over the sunlit, greenish-yellow landscape towards Mont Sainte-Victoire in the bluish-gray background. In coloration, the mountain is hardly distinguishable from the sky and clouds, and yet it is clearly stated. The block-shaped facets and the brushstrokes combine in the eye of the viewer, depending on distance, to either a coherent landscape or a patchwork quilt of colors.

This painting occupies an important position in Cézanne's oeuvre because it marks his transition towards a dissolution of shapes and volumes in favor of flat representation and Cubist structures. The function of the often strongly contrasting colors is clear—they bring the picture to life by creating a sense of perspective and movement. Cézanne portrays what he sees—but broken up analytically, creating various layers through which the picture gains depth.

His enthusiasm for this subject is expressed in a recorded remark: "Have a good look at this Sainte-Victoire mountain. What élan, what imperious thirst for the sun, and what melancholy when all this heaviness returns in the evening. … These blocks were once fire. There is still fire within them. Shadow and daylight seem to retreat, shuddering, in fear of them. Up there is Plato's Cave. When large clouds are passing, you see their shadows trembling on the rocks, as if scalded, immediately swallowed up in a fiery maw."

The reference to Plato's cave, a parable on human perception and the origins of ideas and reality, seems particularly interesting in this context. Like the people in the cave, Cézanne wants to see real objects instead of shadows and track down the fallacies of human sensory impressions. As a result of his analysis, objects mutate into a profound form of painting that does not stop at the surface of things. How seriously he went about this is evident from his comparison of artists with a priestly caste that can only be the province of people who are pure and wholly devoted to that art.

It appears to have been his sense of a lifelong duty that took Cézanne, after a time in Paris with his wife and son, back to the Aix-en-Provence of his childhood. There he could observe nature every day and seek painterly ways for rendering his impressions of it.

1839 Born 19 January in Aix-en-Provence, France.
1859–1861 Studies law.
1861 Studies drawing at the Académie Suisse in Paris.
1870 Moves to the vicinity of Paris.
1874 Exhibits with the Impressionists.
1883–1887 Lives in Aix-en-Provence.
1904 Has a room of his own at the Autumn Salon.
1906 Dies 22 October in Aix-en-Provence.

Paul Cézanne, *Self-Portrait with Palette*, c. 1890, oil on canvas, 92 x 73 cm, Stiftung E. G. Bührle, Zurich

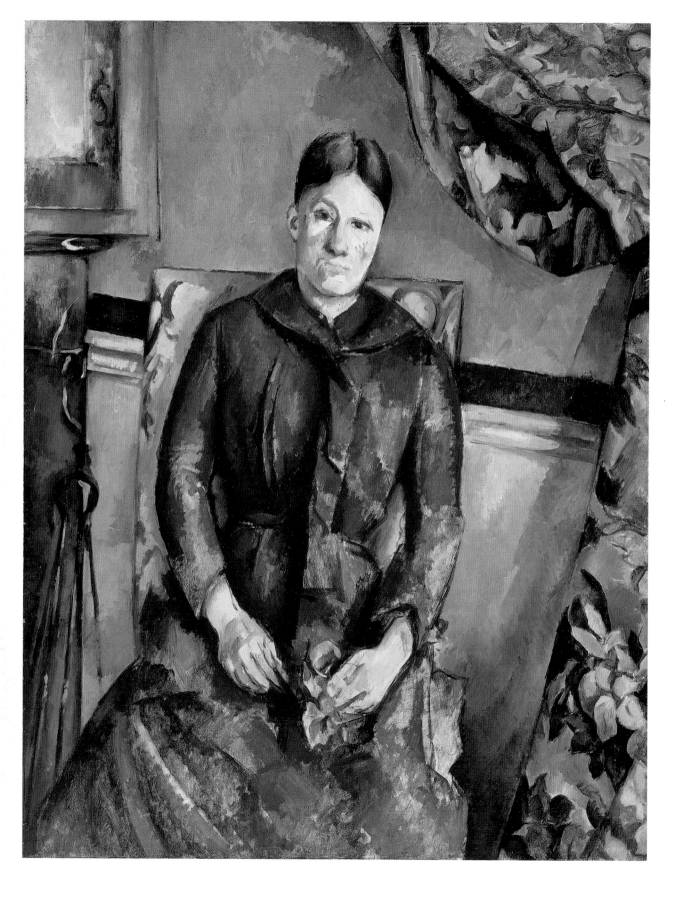

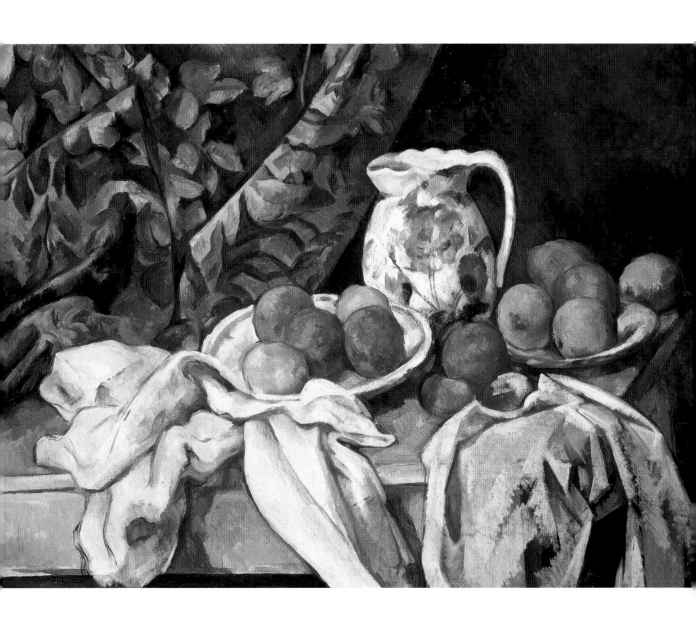

**1848** Karl Marx and Friedrich Engels publish
their communist manifesto

**1871** Charles Darwin publishes
*The Descent of Man*

**1900** Boxer Uprising
in China

1820 1825 1830 1835 1840 1845 1850 1855 1860 1865 1870 1875 1880 1885 1890 1895 1900 1905

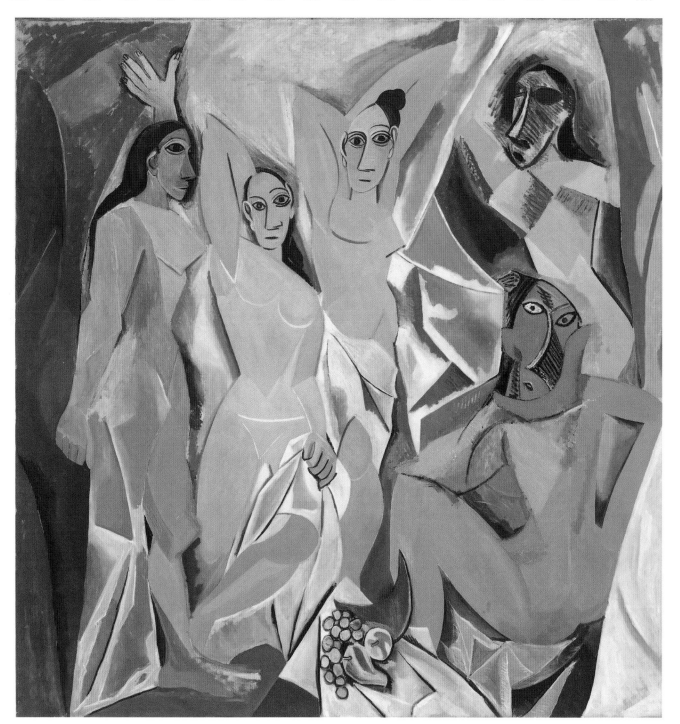

**1938** Kristallnacht pogrom in Germany

**1936–1939** Spanish Civil War **1950** Suspension of racial segregation in
the USA

**1914–1918** World War I

**1991–1995** Disintegration
of Yugoslavia

**1928** Brecht's *Threepenny Opera*   **1945** Beginning of Cold War

1910  1915  1920  1925  1930  1935  1940  1945  1950  1955  1960  1965  1970  1975  1980  1985  1990  1995

PABLO PICASSO

# LES DEMOISELLES D'AVIGNON

*The five "young ladies" of "Avignon" have been with us for more than a century. But the profession they carry on is far older. Picasso always called the painting* Le Bordel (*The Brothel*)*, and was annoyed at the sanitized new name. Both the subject and the style were controversial.*

The inspiration for the figures came in fact from prostitutes in a brothel in Barcelona's Avinyó (Avignon) Street. This large, revolutionary composition was preceded by literally hundreds of sketches. It shows an interior whose furnishings are limited to a table with a fruit bowl and elements that might be textiles. In it are five women, some standing and some sitting. In terms of color, naked skin prevails, though there are lighter and stronger tones. The bodies are no longer represented as well-proportioned, realistic volumes in naturalistic colors. Instead, they are dissolved into individual elements in flat, geometrical, and tonally reduced units. Nor is the room's perspective clearly defined. We are shown several aspects of a body or object at the same time, regardless of the laws of natural perspective. As a commentator once said, the geometrical shapes of the "bodies hacked apart with an axe" are juxtaposed or on top of each other. That the women assembled out of abstract elements look directly at the viewer reinforces the surprising and occasionally disturbing effect of the picture even more. The most innovative parts of the painting are the faces, which are shown de-familiarized to varying degrees.

The picture has been celebrated by critics as one of the most important paintings of the 20th century. This assessment has nothing to do with the beauty of the women in the picture, but refers to the striking manner in which Picasso depicts the bodies, faces, and room. He was paving the way for a new and radical visual idiom: Cubism.

In this painting, Picasso combines various elements that made their mark on him. On the one hand, he was a faithful client of the business, and could imagine an intimate scene. The not exactly happy faces of the women appear to be scarred, if not by disease as has been occasionally presumed, at least by a hard life. On the other hand, opportunities had opened up for Picasso in Paris, where he mainly lived from 1904, to familiarize himself with both ancient Iberian art with its female heads and masks and the newly fashionable African sculpture.

Critics may argue over what style of art is ultimately behind the work and this new way of showing heads in the picture. What matters is that Picasso succeeded in a way all his own of working these and other important influences from the history of art into something new in his painting. In order to be able to paint faces and bodies in this style, Picasso did numerous studies and sketches. He originally planned to have two male and three female figures on the canvas, but changed this into five females at the last minute. Painting several views of one person or object at the same time became one of his trademarks (in particular in his female portraits), an approach that had a profound effect on subsequent generations of artists.

**1881** Born 25 October in Málaga, Spain.
**1896** Exhibits his first oil painting *First Communion* in Barcelona.
**1901** Ambroise Vollard sells Picasso's pictures in Paris. Beginning of his Blue Period.
**1904** Moves to Paris. Start of the Rose Period one year later.
**1907** Paints *Les Demoiselles d'Avignon* and meets Georges Braque.
**1917** Works for Diaghilev's Ballets Russes.
**1937** Paints *Guernica* for the World Exhibition.
**1944** His dove of peace becomes a public symbol.
**1973** Dies 8 April near Cannes.

left page:
Pablo Picasso, *Les Demoiselles d'Avignon*, 1906–1907, oil on canvas, 244 x 234 cm, Museum of Modern Art, New York

left:
Pablo Picasso, *Self-Portrait*, 1901, oil on canvas, 81 x 60 cm, Musée Picasso, Paris

above:
Pablo Picasso, photograph

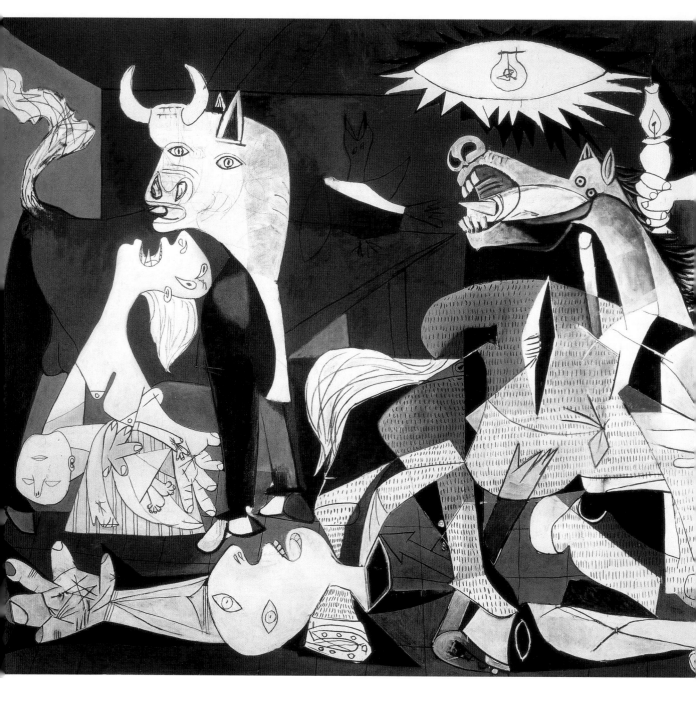

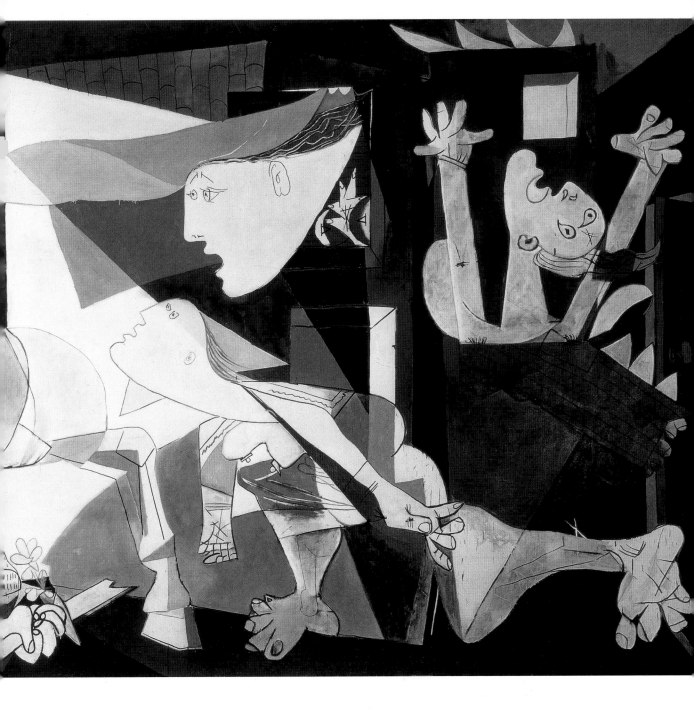

Pablo Picasso, *Guernica*, 1937,
oil on canvas, 349.3 x 776.6 cm,
Museo Nacional del Prado, Madrid

VINCENT VAN GOGH

VASSILY KANDINSKY

MAX KLINGER

**1865** Abolition of slavery in the USA

**1870–1920** Heyday of the Arts and
Crafts Movement in England

**1902** Completion of 1st
Aswan Dam

**1900** Freud publishes *Die
Traumdeutung* (Inter-
pretation of Dreams)

| 1820 | 1825 | 1830 | 1835 | 1840 | 1845 | 1850 | 1855 | 1860 | 1865 | 1870 | 1875 | 1880 | 1885 | 1890 | 1895 | 1900 | 1905 |

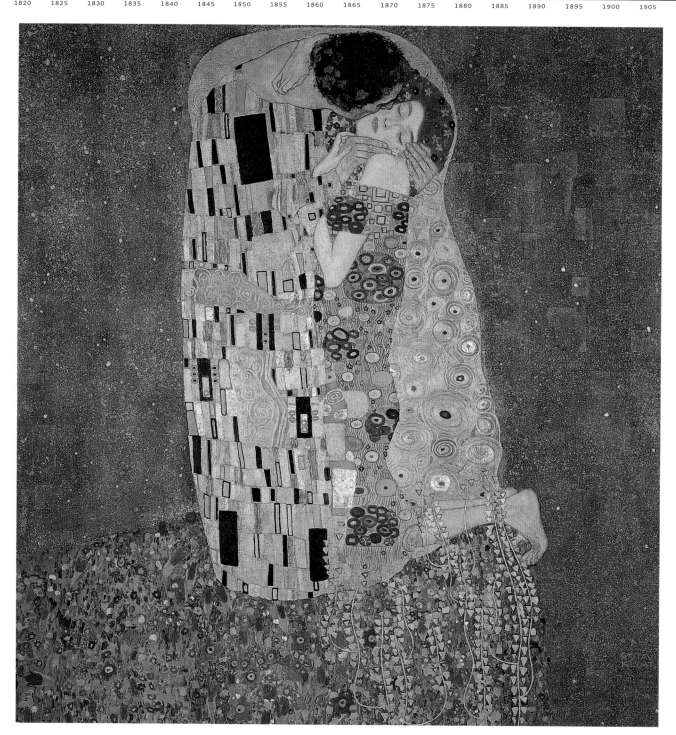

**1911** Founding of the
Blauer Reiter    **1922** Hermann Hesse publishes *Siddharta*    **1945** Atom bombs dropped on
Hiroshima and Nagasaki

**1914–1918** World War I     **1937** Exhibition of "Degenerate Art"
in Munich

**1907** Picasso's *Les Demoiselles d'Avignon*

1910   1915   1920   1925   1930   1935   1940   1945   1950   1955   1960   1965   1970   1975   1980   1985   1990   1995

GUSTAV KLIMT

# THE KISS

*Gustav Klimt was certainly not an icon painter in the traditional sense. Even so, in this painting he created what in effect is a monumental icon that is famous around the world. With its subject—a intense embrace—and its extraordinarily lavish depiction, it is hardly surprising that this painting has become one of the most frequently reproduced works of art.*

A self-absorbed couple are shown in a flowery meadow against a gold background. The man is standing on the left, bending over the woman kneeling in front of him on the right. She tilts her head to one side, eyes closed, while he kisses her cheek. Both have flowers in their hair, the green garland on the man's head being evocative of a classical wreath worn by heroes or poets. Although it is tempting at first to see the mainly gold-ornamented elements of the body as abstract and to treat the gold aura surrounding them as a phenomenon of light (given off by the two lovers), on closer inspection they can be identified as garments. The man is wearing a long smock (just as Klimt himself generally wore) that leaves his neck exposed. The decoration is made up of gold and black rectangles. The woman is wearing a close-fitting, off-the-shoulder dress whose pattern displays both gold and colorful floral motifs. The flowery meadow extends from the left only as far as the feet of the kneeling woman. Beyond that, the gold background continues, suggesting an abyss from which the kiss rescues the two lovers. But perhaps they are simply standing on a riverbank, a promontory or, more poetically, at the frontier of the world and the universe.

Though the two people in the picture have been taken to be Klimt and his long-standing lover Emilie Flöge, the kiss is generally a symbol of love. The absence of contemporary details in the picture supports this theory of timelessness. The subject of a kiss was also used by Klimt's famous contemporaries, one of the most celebrated works being a sculpture of that name by Auguste Rodin. This set a monument to love in stone for eternity, showing a seated couple embracing each other while kissing. Both in Klimt and Rodin the two lovers are totally detached from the exterior world, being fully absorbed in their embrace.

In Klimt's picture, everything around them is golden. Is this intended to lend an almost sacred significance to their union?

The symbolically charged content and characteristic style of Klimt are wonderfully expressed in this painting. The rich ornamentation adds to the artistic message and fulfills more than a merely decorative function. The elegant floral and geometrical elements and the delicate, slender forms of the couple underline both the otherworldliness of love and the tenderness of the scene.

1862 Born 14 July in Baumgarten near
Vienna.
1876 Becomes a pupil at the Viennese
College of Arts and Crafts.
1883 Forms a decorative painting busi-
ness with his brother Ernst and
Franz Matsch, working at the
Burgtheater and the
Kunsthistorisches Museum in
Vienna.
1897 Becomes a co-founder of the
Vienna Secession.
1902 Paints the *Beethoven Frieze* in the
Secession building.
1905 His clients are now drawn from
the upper middle classes, his por-
traits being particularly in
demand.
1907–1908 Paints *The Kiss.*
1918 Dies 6 February in Vienna.

left page:
Gustav Klimt, *The Kiss*, 1907–1908,
oil on canvas, 180 x 180 cm, Österrei-
chische Galerie Belvedere, Vienna

above:
Gustav Klimt photographed wearing
a painter's smock and holding a cat
outside his studio

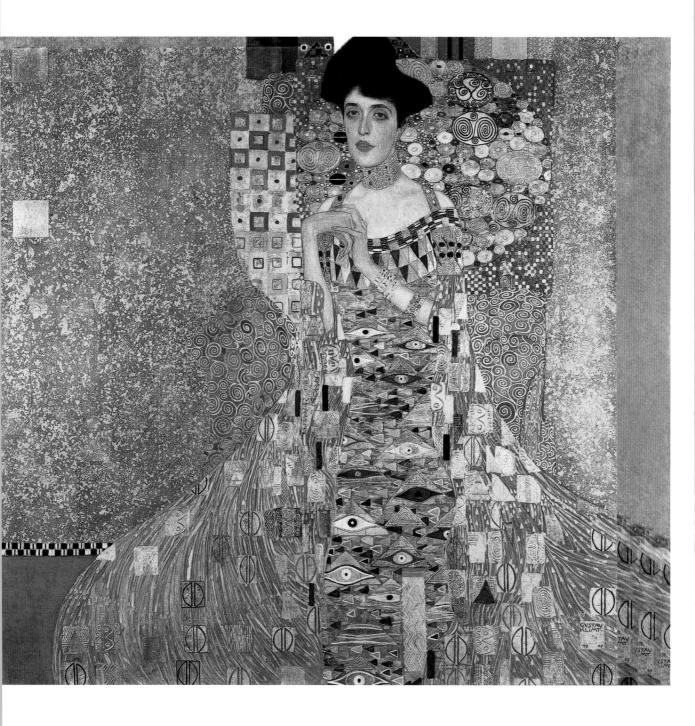

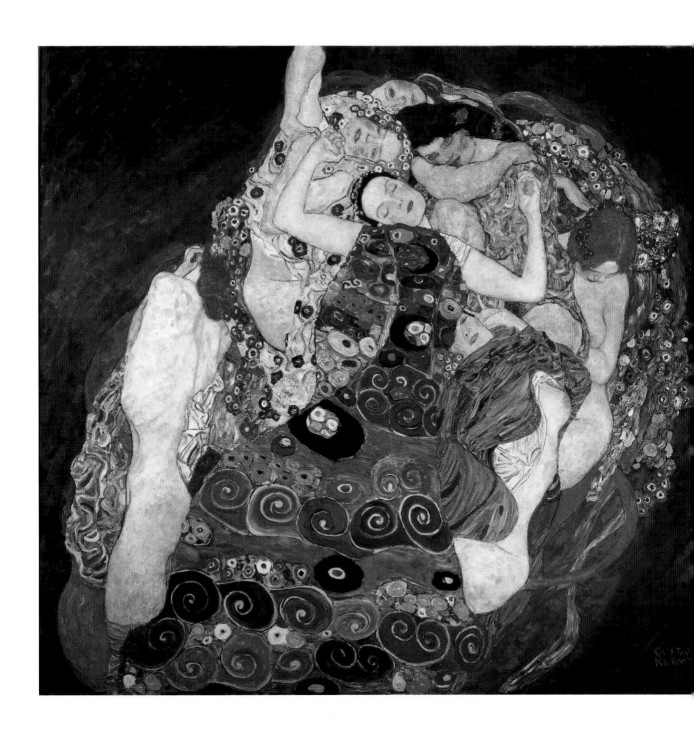

**1865** Abolition of slavery USA

**1900** First line of Parisian
Metro opened

| 1825 | 1830 | 1835 | 1840 | 1845 | 1850 | 1855 | 1860 | 1865 | 1870 | 1875 | 1880 | 1885 | 1890 | 1895 | 1900 | 1905 | 1910 |

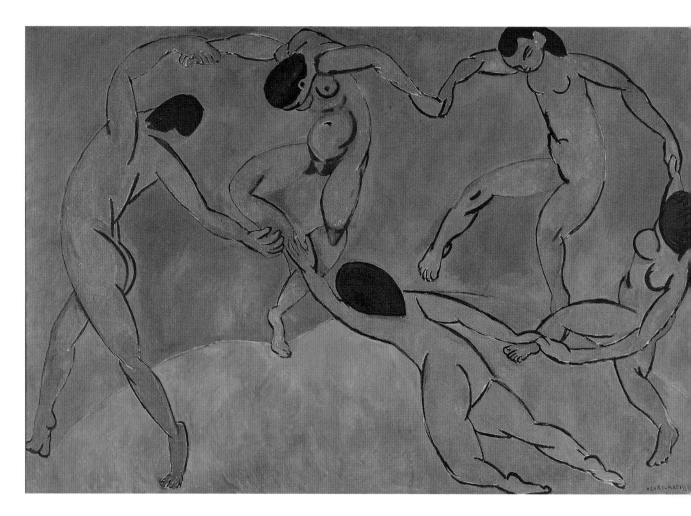

Henri Matisse, *La Danse*, 1909–1910,
oil on canvas, 260 x 391 cm, Hermitage,
St Petersburg

**1921** Schoenberg invents twelve-tone music
**1919** Treaty of Versailles official ends World War I
**1969** Woodstock Festival
**1914** World War I breaks out     **1939–1945** World War II     **1950** Abolition of racial segregation in the USA
**1922** Einstein awarded the Nobel Prize for Physics     **1948** UN general assembly's Declaration of Human Rights

| 1915 | 1920 | 1925 | 1930 | 1935 | 1940 | 1945 | 1950 | 1955 | 1960 | 1965 | 1970 | 1975 | 1980 | 1985 | 1990 | 1995 | 2000 |

HENRI MATISSE

# LA DANSE

La Danse *is one of two pictures that Matisse painted for his Russian patron Sergei Shchukin, who wanted* La Danse *and* La Musique *as decorations for his house. Both works illustrate the challenge of representing arts employing movement and sound—dance and music—in terms of an art that is immobile and silent, namely painting.*

Matisse's response to the task was to use bold colors and a markedly simplified landscape and figures. He shows only the essentials of each: the body shapes of the dancers and the colors of the landscape (just green for the ground, blue for the sky). Five red figures dance in a circle, moving so forcefully and dynamically that their circle threatens to fall apart—the slight gap left by the figure in the middle facing away from us, who has lost hold and is stretching out his hand to the person in front of him, can be seen as offering the viewer an opportunity to join in the dance. The sprightly prancing of the figures is emphasized, and they seem to almost to fly. They are completely wrapped up in the activity, and look neither at each other nor at the viewer, seemingly wholly absorbed in the dance.

Color itself becomes a form of expression, the energy-charged red of the figures forming a strongly contrasting pattern against the primary colors of the background. From 1905, Matisse had been known as one of the leading Fauves, painters who were celebrated for their daring and expressive use of color. These intense colors and painterly autonomy of shapes also feature in *La Danse*. The color fields of landscape and bodies are no longer formulated in detail or given three-dimensional depth, the only perceptible perspective being created by chromatic contrasts. The outlines of the figures lend them zest, life and movement. Matisse broke away from a naturalistic approach and allowed color and form a new autonomy.

The simplified and at the same time precise rendering of forms is a trademark of Matisse's style. His paintings and the later paper cut-outs are witness to a talent for close observation—he declared that one should always look at things like a child, as if for the first time—and a superb facility of execution. This joy of discovery and love of things, which in his view facilitated good painting, are reflected in his work. The empathy of the dance and apt rendering of the moving figures has come off. His colors are clear and forceful, his shapes flat and simple. In this painting he created a work full of the movement, energy and joy of dance.

**1869** Born Henri-Emile-Benoît Matisse 31 December in Le Cateau-Cambrésis, France.
**1887** Studies law in Paris.
**1891** Decides to become an artist and attends the Académie Julian in Paris.
**1895** Becomes a pupil of Gustave Moreau at the École des Beaux-Arts.
**1904** First solo exhibition at the Vollard gallery.
**1911** First trip to Morocco, where he is much impressed by the light.
**1913** Exhibits at the Armory Show in New York.
**1919** Shuttles between Paris and Nice.
**1943** Embarks on his series of *papiers découpés* (paper cut-outs), including *Jazz* and *Blue Nudes*.
**1946** Begins work on the window pictures for the chapel in Vence.
**1954** Dies 3 November in Paris.

Henri Matisse photographed in Nice, 1953

**1871** Charles Darwin writes
*The Descent of Man*

**1900** First line of Parisian
Metro opened
**1900** Freud publishes *Die
Traumdeutung* (Inter-
pretation of Dreams)

1825  1830  1835  1840  1845  1850  1855  1860  1865  1870  1875  1880  1885  1890  1895  1900  1905  1910

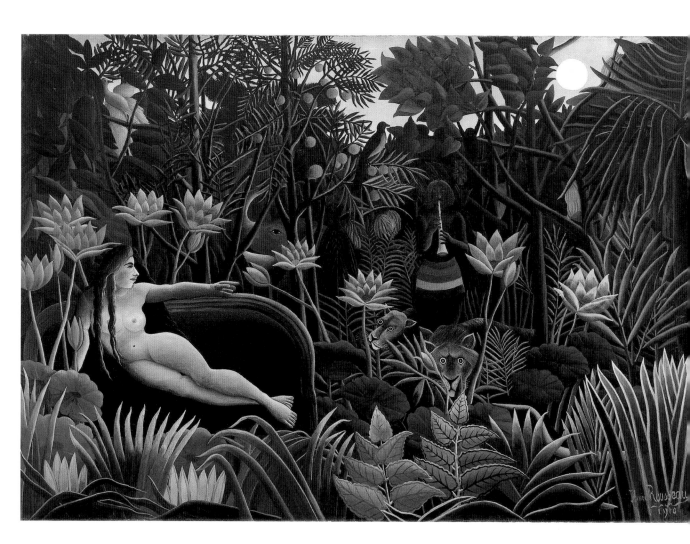

Henri Rousseau, *The Dream*, 1910, oil on
canvas, 204.5 x 198.5 cm, Museum of
Modern Art, New York, gift of Nelson
A. Rockefeller, 1954

**1908** First Ford Model T rolls off the production line in Detroit

**1911** King George V crowned Emperor of India in Delhi

**1929** Erich Maria Remarque's *All Quiet on the Western Front*

**1946** UNESCO established

**1969** Woodstock Festival

**1975** *The Rocky Horror Picture Show* hits the cinemas

**1986** Chernobyl disaster

1915  1920  1925  1930  1935  1940  1945  1950  1955  1960  1965  1970  1975  1980  1985  1990  1995  2000

HENRI ROUSSEAU

# THE DREAM

*A red sofa in the middle of the jungle. The woman reclining on it has just been awoken by the sound of a flute-player. The animals in the jungle round her also stop and listen. But whose dream is this—hers or the artists? Rousseau himself stated that his own visions sometimes terrified him, and he neither wanted nor even could always explain them.*

When he first showed his painting in public in 1910, Rousseau put beside it a poem about "Yagwigha" waking from a dream. Although the things in the picture are thus "explained," it remains an enigmatic work—as is quite right for a dream picture. Yagwigha, reclining on the red sofa placed on the left in the lush green setting, is oddly plain. She points at the black flautist with her left index finger. A pair of lions peer from out of the undergrowth, birds hold still as if listening, and a small elephant raises its trunk.

This is one of the last important jungle scenes that Rousseau painted. In the deep green of his jungle landscapes, numerous creatures crop up including exotic animals and birds and even fantasy creatures. Against the dense green jungle backdrop, the strong colors create an atmosphere of magic featuring stylishly simplified forms and fantastic scenery. A tax collector by occupation, Rousseau was largely self-taught as a painter, art being his great passion. He even took early retirement so as to concentrate on it. But the naivety often attributed to him was in fact a very complex thing, and it is unwise to focus on the superficial folk-art like simplicity of his images.

Rousseau exhibited regularly with other independent artists in the Salon des Indépendants in Paris. The showing of *The Dream* brought him the serious attention of a large number of critics for the first time.

Rousseau himself never travelled to countries where he could have seen a real jungle. As a minor civil servant in Paris, like his contemporaries he could only have experienced the flora and fauna of such exotic countries via the specimens on view there. However, there were plenty of opportunities in the form of zoological gardens. The Jardin des Plantes, for example, displayed tropical plants and animals, and had hothouses in which small jungles flourished. The world of the colonies was also on show at the World Fair in Paris in 1889, and public interest in exotica was enormous. The magic loosely associated with these alien cultures was also very fashionable. Spiritualist circles sprang up throughout Europe, and the supernatural was very much in vogue in Paris. In short, though the subject matter was outlandish, it was popular.

It is the combination of popular motifs with the poetry peculiar to him that makes Rousseau's picture such a vivid scene.

**1844** Born Henri-Julien-Félix Rousseau 21 May in Laval, France.
**1868** Marries and moves to Paris.
**1871** Becomes an employee of the City Excise department, hence his nickname "Douanier."
**1884** Takes up painting and exhibits for the first time with a group of independent painters in Paris.
**1890** Paints his self-portrait *Myself, Portrait-Landscape*.
**1893** Retires early to become a full-time painter.
**1894** Exhibits *War*.
**1907** After years of financial difficulties, he becomes involved in bank fraud.
**1910** Dies 2 September in Paris.

Henri Rousseau photographed in 1895

Henri Rousseau, *La Bohémienne Endormie*
(*The Sleeping Gypsy*), 1897, oil on canvas,
129.5 x 201 cm, Museum of Modern Art,
New York, gift of Mrs Simon Guggenheim

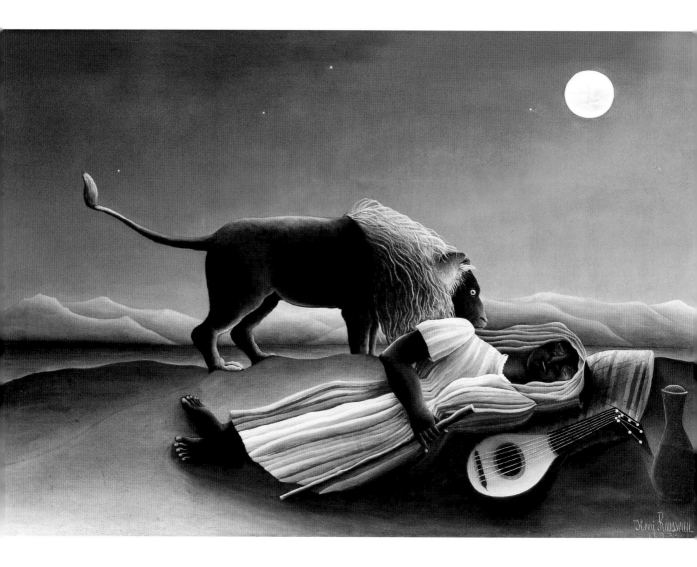

Henri Rousseau, *Exotic Landscape*, 1910, oil on canvas, 130 x 162 cm, Norton Simon Foundation, Pasadena

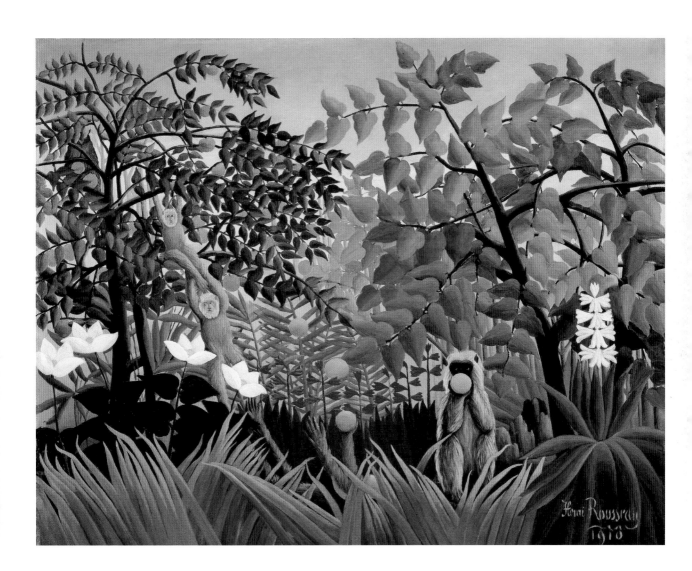

**1871** Charles Darwin writes
*The Descent of Man*

**1900** Freud publishes
*Die Traum-
deutung* (Inter-
pretation of
Dreams)

**1909** First 6-day cycling
event in Europe

**1911** Founding of
the Blauer
Reiter

| 1830 | 1835 | 1840 | 1845 | 1850 | 1855 | 1860 | 1865 | 1870 | 1875 | 1880 | 1885 | 1890 | 1895 | 1900 | 1905 | 1910 | 1915 |

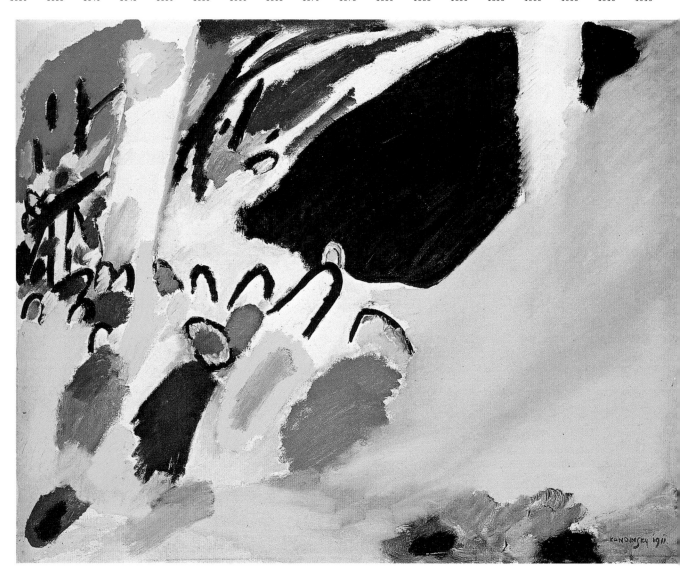

Wassily Kandinsky, *Impression III
(Concert)*, 1911, oil on canvas,
77.5 x 100 cm, Städtische Galerie im
Lenbachhaus, Munich

1920　1925　1930　1935　1940　1945　1950　1955　1960　1965　1970　1975　1980　1985　1990　1995　2000　2005

WASSILY KANDINSKY

# IMPRESSION III (CONCERT)

*For the Russian artist Wassily Kandinsky, 1911 was a defining year, for it saw him (and Western art) moving from representational painting to abstraction. In the process, he often drew parallels between colors and the sounds of musical instruments. Music, which he considered a "universal language," was crucial in defining abstraction.*

Kandinsky was a seminal figure in the transition from representational to abstract art during the early 20th century, with *Impression III* reflecting this shift within his own oeuvre. His writings and art theories were as important as his paintings, and he can be considered one of the most influential artists at a time when the arts were undergoing a complete transformation. Surprisingly for such an important artist, he began his career relatively late in life, after first studying law and then teaching at the University of Moscow. It was not until around 1896, and at the age of thirty, that he decided to become an artist.

By 1908 his style had already developed a uniquely recognizable language. He worked with vivid, brilliant and expressive colors, and began to move away from representational subject towards abstraction, a development seen by comparing *Beach Tents in Holland* (1904) and *Landscape with Tower* (1908). During this time his motifs remained recognizable, though color and line acquired a new significance in developing meanings that transcended the motifs. This introduction of elements meant to touch on spiritual and metaphysical concerns came to be a defining characteristic of his work.

*Impression III* was painted during a very productive phase in Kandinsky's development. The year was 1911 and he and Franz Marc (1880–1916), with others, had recently formed the *Blaue Reiter* (Blue Rider) group, publishing a yearbook, the *Almanach*, in the spring of 1912. The objectives and styles of the members differed, but their fundamental approach to art—seeing a link between art and spirituality, and between art and music—was shared by all. Music was of particular importance to Kandinsky, and it was after attending a concert by Arnold Schönberg in Munich on 2 January, 1911, that he began working on *Impression III*. Schönberg was also invited to exhibit his own paintings with the artists of the *Blaue Reiter*, and one of his scores was published in the *Almanach*.

Two preliminary sketches for *Impression III* exist that clearly show Kandinsky's gradual move to abstraction. The first sketch reveals perspective lines and identifiable elements that represent the concert hall, the audience, and even a chandelier. In the second sketch, the simplified shape of the piano has gained in importance, the defining lines of perspective are gone, and the figurative elements are greatly reduced. Finally, there is the painting itself, a vibrant collision of black and yellow: the audience is back though greatly abstracted and the overpowering sensation is one of the conflict of colors creating an impression of music resonating from the canvas. For Kandinsky the "language" of music and the "language" of art shared commonalities, most poignantly their capacity to express the inner spirit and soul of the composer/artist.

The teachings of Rudolf Steiner and of Theosophy, with its stress on the role of art and music in spirituality, were important influences on Kandinsky. This lies at the root of the artist's works beginning in 1911, especially his three very different series: *Impressions*, which he defined as "direct impression of nature, expressed in purely pictorial form"; *Improvisations*, such as *Improvisation 26*, in which he gave freer rein to his imagination; and *Compositions*, such as *Composition IV*, which were carefully planned works. His choice of titles that omit descriptive terms, with numbers used instead, further emphasized the move away from representational art.

**1866** Born 4 December in Moscow.
**1896** After training in law and economics, decides to become an artist and moves to Munich.
**1909** Lives with Gabriele Münter in Murnau, Germany.
**1911** He and Franz Marc found the *Blauer Reiter* group.
**1912** Publishes *Über das Geistige in der Kunst* (On the Spiritual in Art).
**1922** Appointed to the staff of the Bauhaus in Weimar (from 1925 in Dessau).
**1928** Gains German citizenship.
**1937** The Nazis confiscate his works as "degenerate art."
**1939** Gains French citizenship.
**1944** Dies 13 December in Neuilly-sur-Seine, France.

Kandinsky photographed in Ainmillerstrasse, Munich, June 1913

Wassily Kandinsky, *Improvisation 26*, 1912, oil on canvas, 97.2 x 107.5 cm, Städtische Galerie im Lenbachhaus, Munich

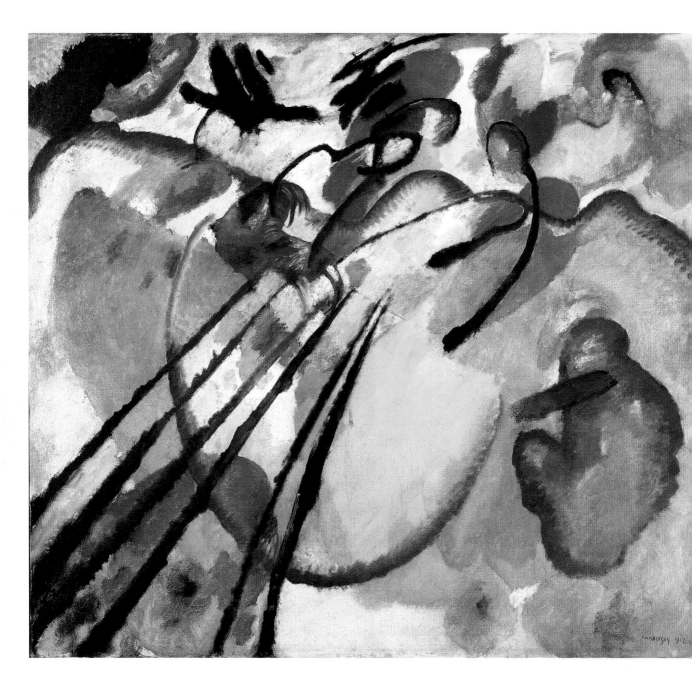

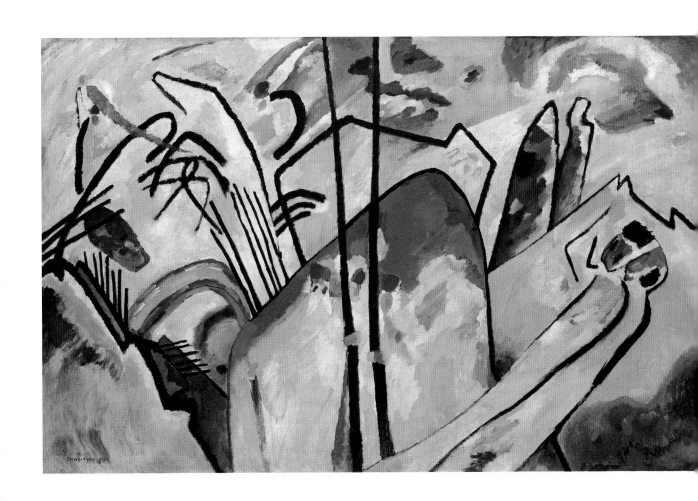

Wassily Kandinsky, *Composition IV*, 1911,
oil on canvas, 159.5 x 250.5, Kunstsamm-
lung Nordrhein-Westfalen, Düsseldorf

**1865** Abolition of slavery in the USA

**1891** Construction of Trans-
Siberian Railway begins

**1914** Outbreak of
World War I

**1906** First German U-Boat
launched

| 1830 | 1835 | 1840 | 1845 | 1850 | 1855 | 1860 | 1865 | 1870 | 1875 | 1880 | 1885 | 1890 | 1895 | 1900 | 1905 | 1910 | 1915 |

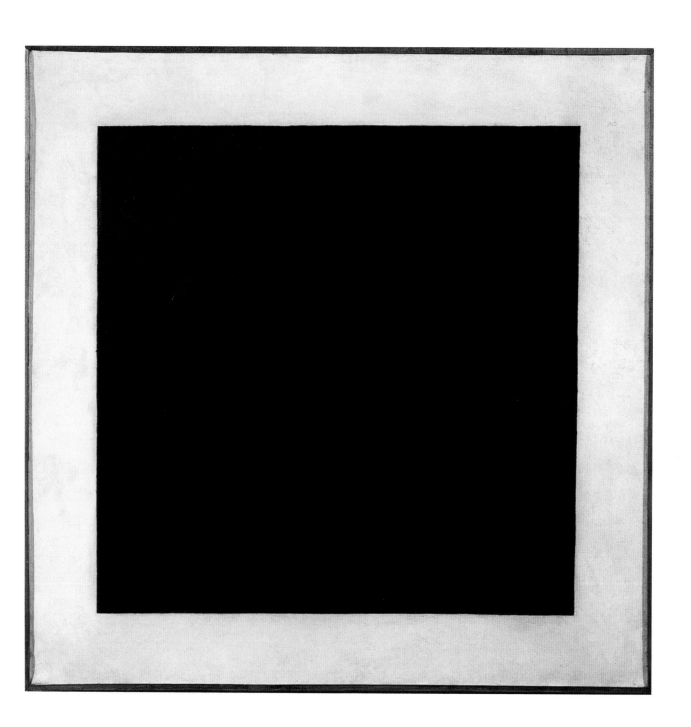

**1938** Kristallnacht pogrom in Germany

**1945** Liberation of Auschwitz
concentration camp

**1945** Start of the Cold War

**1968** Stanley Kubrick makes
*2001: Odyssey in Space*

**1989** Massacre in Tiananmen
Square in Peking

**1917** November Revolution in Russia

| 1920 | 1925 | 1930 | 1935 | 1940 | 1945 | 1950 | 1955 | 1960 | 1965 | 1970 | 1975 | 1980 | 1985 | 1990 | 1995 | 2000 | 2005 |

KASIMIR MALEVICH

# BLACK SQUARE

*Kasimir Malevich's position as a leading modern artist was reaffirmed in November 2008 when, despite worldwide financial turmoil, his painting* Suprematist Composition *(1916) sold for a record $60 million at Sotheby's in New York. This painting was executed the year after he painted his seminal* Black Square, *which is now his most famous work.*

It is only in comparatively recent years that the extent of Malevich's contribution to the development of modern, and specifically abstract, art has been realized. The Russian artist played a key role in a number of avant-garde movements in the early 20th century, but his work remained largely hidden in Russia until the 1950s, and much of his life is still surrounded in mystery. *Black Square* can be considered one of his most important works, representing a defining moment in the evolution of his style and the development of Suprematism, the art movement with which he is most closely identified.

Malevich, who was also a prolific writer, described the objectives and rationale of Suprematism, the movement he named, in his pamphlet *From Cubism and Futurism to Suprematism: The New Realism in Painting*, published in 1915. This was the year he painted *Black Square*, and other early abstract, geometric paintings, several of which were not given specific titles, being exhibited under the general heading of *Untitled Suprematist Painting*. The motifs of airplanes, speed and flying, however, are discernible in some of these works, one of which currently resides in the Museum of Modern Art, New York, and one in the Stedlijk Museum, Amsterdam. Suprematism—so named because of the supremacy of the new art over the traditional—stressed purity of form, with the square in particular being of quintessential and profound importance to Malevich. His aim was an art based solely on color and form, works unhindered by social or political content—an aspect especially pertinent given the volatile political situation in Russia at the time.

Malevich's earliest works were inspired first by the Impressionists, as seen in *Landscape with Yellow House* (c. 1904), and then by the Post-Impressionists, Synthetism, and finally Symbolism, reflected in his *Self-Portrait* (c. 1909), which can be compared to Emile Bernard's *Self-Portrait* (1888). The importance of color and its evocation of metaphysical phenomena was something that had always preoccupied

Malevich and became increasingly important. In 1910 he exhibited with the *Jack of Diamonds* group, who were very influential in modern Russian painting, his works of this period reflecting his current interest in contemporary French art and in new figurative themes, in particular peasants, as in *Man with a Sack* (1911). From 1912 to 1913 his style evolved rapidly, becoming increasingly abstract and revealing a debt to Cubism and Futurism, seen in *Morning after a Storm in the Country* (1912–1913). These paintings reveal a development that would culminate in his seminal *Black Square* and his geometric abstract works.

By the spring of 1915 he had rejected all figurative reference in his paintings and adopted pure geometric form, precisely painted and defined through areas of flat, bold color (including black and white). *Black Square*, the most important of these famous works, was first exhibited at the *Posiednyaya futuristich-eskayay vystavka kartin: 0.10 (The Last Futurist Exhibition of Paintings, Zero-Ten)* in Petrograd (St Petersburg), alongside *Black Circle* and *Black Cross*. Over the next two years his Suprematist works became more structurally complex, with a greater diversity of color—*Supremus No. 56* (1916)—but from 1917 to 1918 he reduced his colors and worked on the series *White on White*—*White Square on White* (1918) can be viewed as an inversion of his *Black Square*.

The importance of the black square as a motif for Malevich was underscored by the design for his own coffin, which had a black square on the lid. Later, one of his students designed a cube incorporating a black square to mark his gravesite. This monument was destroyed during World War II and a new one erected many years later by Vladimir Andreenkov, still a cube but now displaying a red square.

**1878** Born 23 February in Kiev, Ukraine.
**1896** His family move to Kursk, Russia.
**1901** Marries Polish-born Kazimira Sgleitz.
**1905** Enrolls at the School for Painting, Sculpture and Architecture in Moscow.
**1907** Marries a second time, to Sofia Rafalovich.
**1915** Publishes the Suprematist manifesto *From Cubism and Futurism to Suprematism: The New Realism in Painting.*
**1920** Sets up the UNOVIS group (Confirmers of the New Art) at Vitebsk art school.
**1922** Moves to Petrograd (St Petersburg). Marries a third time, to Natalya Andreyevna Manchenko.
**1923–1926** Becomes head of the Institute for Artistic Culture.
**1932** Takes over as head of a research laboratory at the Russian Museum in Leningrad (St Petersburg).
**1935** Dies 15 May in Leningrad.

left page:
Kazimir Malevich, *Black Square*, c. 1929, oil on canvas, 106 x 106 cm, Russian Museum, St Petersburg

above:
Kazimir Malevich, *Self-Portrait*, 1933, oil on canvas, 70 x 66 cm, Russian Museum, St Petersburg

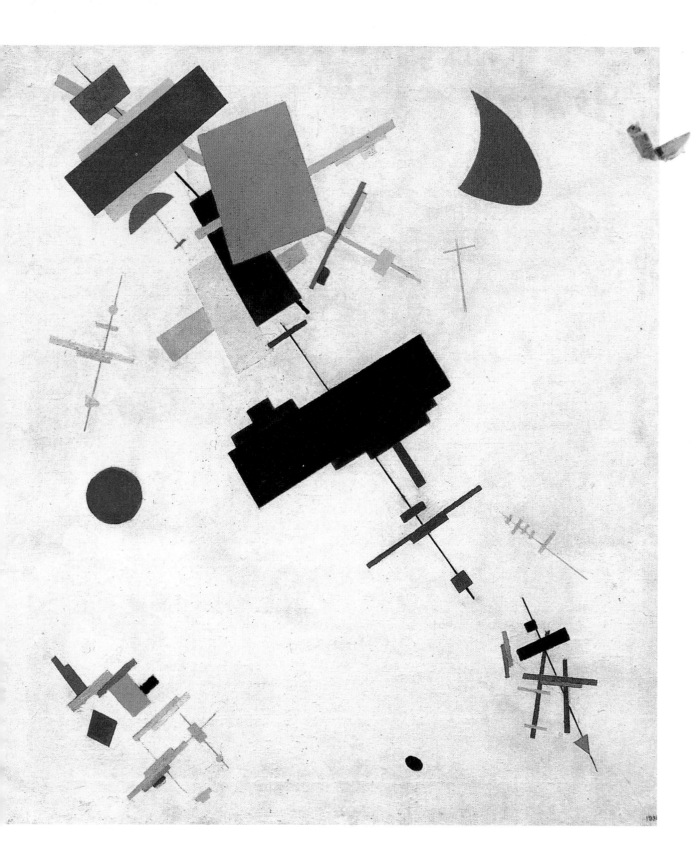

left page:
Kazimir Malevich, *Supremus No. 56*, 1916,
oil on canvas, 80.5 x 71 cm, Russian
Museum, St Petersburg

below:
Kazimir Malevich, *Landscape with White
House*, c. 1930, oil on canvas, 59 x 59.6
cm, Russian Museum, St Petersburg

FRIDA KAHLO ▬▬▬▬▬▬▬▬

MAX ERNST ▬▬▬▬▬▬▬▬▬▬▬▬▬▬▬▬
MAN RAY ▬▬▬▬▬▬▬▬▬▬▬▬▬▬▬▬▬▬▬▬▬

**1903** Kraft Foods founded in Chicago

**1882** *Virginia Woolf

**1912** The *Titanic* sinks on
its maiden voyage

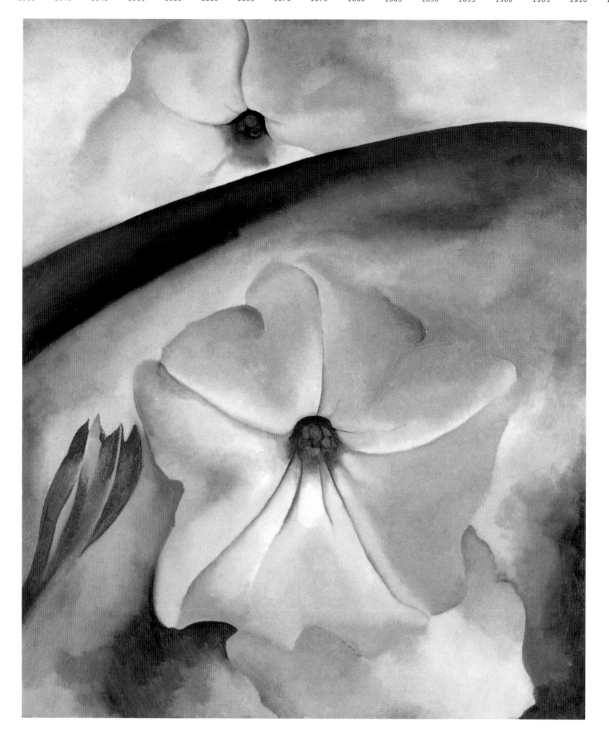

**1918** American president Woodrow
Wilson promulgates his 14-point
programme to end World War I
**1920–1933** Prohibition in the USA

**1940** Charlie Chaplin: *The Great Dictator*
**1945** Atom bomb dropped on
Hiroshima and Nagasaki
**1929** Stock market crash heralds global economic crisis

**1965–1975** Vietnam War

**1989** Fall of Berlin Wall

1925  1930  1935  1940  1945  1950  1955  1960  1965  1970  1975  1980  1985  1990  1995  2000  2005  2010

GEORGIA O'KEEFFE

# PETUNIA NO. 2

*Georgia O'Keeffe is perhaps most famous for her distinctive paintings of flowers, many of which have been widely reproduced. But she was an artist of great breadth and painted in many different genres. Later in her life, and inspired in part by the views seen from an airplane window, she returned to experimenting with abstract forms.*

*Petunia No. 2* was a groundbreaking work for Georgia O'Keeffe, being one of her first large scale oil paintings of flowers, and was also one of the first to be exhibited. The work went on show, alongside several of her similar large-scale flower paintings, at the important modernist *Seven Americans* show organized by Alfred Stieglitz in 1925 at the Anderson Galleries, New York. Although favorably received, the critics misconstrued her works by focusing their attention on the flowers' sexual organs, seeing them as representative of her gender, which is an assumption still rife among critics and historians. It was not until 1943, however, that the artist expressed her disappointment in the continued misinterpretation of her works, stating that the critics' perceptions of her paintings were in no way a parallel of her own artistic intentions.

*Petunia No. 2* represents O'Keeffe's concept of her flower paintings virtually at its inception, and it was from these beginnings that the artist developed her exotic and vibrantly colored works, such as *Canna Red and Orange* (1926) and *Calla Lilies on Red* (1928), on which much of her fame rests. The intense public focus on her flower paintings has overshadowed in part the rest of her work, which includes New York's urban landscapes, abstracts such as *Pelvis IV* (1944) and hauntingly beautiful landscapes, often of the area surrounding her home in New Mexico, such as *Untitled: Red and Yellow Cliffs* (1940).

O'Keeffe's artistic career was kick started at the end of 1915 when she sent some of her abstract charcoal drawings to a former classmate, who in turn showed them to Alfred Stieglitz, the celebrated photographer and gallery owner. It was a lucky move on O'Keeffe's part and led to a long collaboration with Stieglitz, and their eventual marriage. O'Keeffe had begun her art studies in 1905 at the Art Institute of Chicago and later at the Art Students League in New York, but she was left uninspired by traditional art and by the end of 1908 had given up her career in art. By chance in 1912 she was introduced to the innova-

tive artist Arthur Wesley Dow, whose concept of art rested in the belief that it should express ideas and emotion through a balance of line, color, and form. It was a turning point for O'Keeffe, who resumed her work, developing a personal and abstract visual language with early works such as *Black Lines* (1916) and *Blue II* (1916), characteristically minimalist but intensely evocative.

She returned to New York in 1916, exhibiting ten drawings at Stieglitz's avant-garde Gallery 291, and the following year staged a solo exhibition there. Photography became an important influence on O'Keeffe's works, which by 1920 had become representational rather than abstract. The flower paintings for which she is now most famous evolved during this period, with the artist depicting them in intense close-up, most often focusing on their reproductive organs and rendering them in hard, brilliant colors with precise, glassy precision. Stieglitz and O'Keeffe were a powerful partnership in both love and business, and Stieglitz continued to promote O'Keeffe's work through the rest of his life, organizing countless exhibitions for her. In 1929, O'Keeffe began to visit New Mexico in the summer, drawn by the vast and wild landscape, and in 1949, three years after Stieglitz's death, she moved there permanently, continuing to paint in oil and watercolor until 1984.

**1887** Born 15 November in Sun Prairie, Wisconsin.
**1903** Moves to Virginia.
**1905** Attends the Art Institute of Chicago, then swaps to the Art Students League in New York. Subsequently works as a commercial artist.
**1917** Holds first solo exhibition in the gallery of photographer Alfred Stieglitz.
**1924** Marries Alfred Stieglitz.
**1946** Alfred Stieglitz dies. She moves to New Mexico.
**1986** Dies 6 March in Santa Fé, New Mexico.

left page:
Georgia O'Keeffe, *Petunia No. 2*, 1924, oil on canvas, 91.44 x 76.2 cm, Georgia O'Keeffe Museum, Santa Fe, gift of the Burnett Foundation/Mr and Mrs Gerald Peters

above:
Alfred Stieglitz, *Georgia O'Keeffe in Profile*, 1932, photograph

Georgia O'Keeffe, *Untitled: Red and
Yellow Cliffs*, 1940, oil on canvas,
60.9 x 91.4 cm, Georgia O'Keeffe
Museum, Santa Fe

Georgia O'Keeffe, *Pelvis IV*, 1944, oil on hardboard, 91.4 x 101.6 cm, Santa Fe, Georgia O'Keeffe Museum

**1861–1865** American Civil War

**1903** Henry Ford founds the Ford Motor Company in Detroit

**1918** American president Woodrow Wilson promulgates his 14-point programme to end World War I

| | | | | | | | | | | | | | | | | | | |
|---|---|---|---|---|---|---|---|---|---|---|---|---|---|---|---|---|---|---|
| 1840 | 1845 | 1850 | 1855 | 1860 | 1865 | 1870 | 1875 | 1880 | 1885 | 1890 | 1895 | 1900 | 1905 | 1910 | 1915 | 1920 | 1925 | |

NEO RAUCH

**1918–1933** Neue Sachlichkeit
(New Objectivity) art

**1929** Stock market crash heralds world economic crisis

**1920–1933** Prohibition in the USA   **1936** Charlie Chaplin: *Modern Times*

**1927** Charles Lindbergh flies   **1933** Hitler seizes power
the Atlantic non-stop

**1974** Watergate affair ends with
President Nixon's resignation

1930  1935  1940  1945  1950  1955  1960  1965  1970  1975  1980  1985  1990  1995  2000  2005  2010  2015

GRANT WOOD

# AMERICAN GOTHIC

*No American painting has been parodied as often as this one. Countless versions of the couple with the pitchfork in front of house have been depicted—the First Couple, actors and comic heroes, even Miss Piggy and Kermit from the Muppets.*

In *American Gothic*, Grant Wood shows us an elderly, earnest-looking couple in rural clothes, standing in front of a white wooden house with a simple arched Gothic window. The man is holding a pitchfork. The composition is rigorously patterned: the prongs of the pitchfork, for example, correspond to the window bars, the shape of the pitchfork to the seams of the farmer's dungarees, and neatly parted hairstyle of the woman—who, depending on your interpretation, is either his daughter or his wife—echoes the arched shape of the upstairs window.

The facial expressions of the sitters are dour, perhaps even simple-minded. For some they appear to suggest a joyless life of limited horizons. Wood's sister and dentist were the models for the couple. The two figures are so close to the edge of the picture that they effectively hide the entire background in monumental fashion. The picture has given rise to the claim that Grant Wood was satirizing the rural folk of the Midwest, though he always denied this. It was a region where he himself lived and worked, and where he gained numerous local commissions. Regionalism was an American reaction to what was widely seen as an unnecessary dependence on European art and its move towards abstraction, and it favored detailed figurative portrayals of local life. Possibly there is a touch of criticism or parody—but at least as much pride and wry affection, which is why this work is so much in demand even today. The title *American Gothic* is also ambivalent. The style of the picture clearly echoes Northern European art of the 15th century, when the Gothic style was predominant, an era often seen as dark and imbued with faith and mysticism, to which the Renaissance brought light. There was no "American Gothic." In his painting, therefore, Grant Wood showed what must be considered a historical, outdated form of American life, the rural population of the Midwest. Painted in 1930, the title in fact refers to the period when the building in the picture was built, in other words the 1890s, when the

architectural style was called American Gothic. The house that inspired Grant Wood still survives in Eldon, Iowa, where it is a popular attraction for visitors. Tourists are offered an opportunity to don historic dress and pose before the camera with a pitchfork—so the image has spread in the popular imagination through countless snapshots.

Awarded a prize on its first showing and acquired by the Art Institute of Chicago, the picture is now an established image in American popular consciousness, as the countless parodies suggest. It is undoubtedly a typical (if far from simple) image in 20th-century America's view of itself.

**1891** Born 13 February in Anamosa, Iowa.
**1910** Studies art in Minnesota.
**1913** Moves to Chicago, where he becomes a student at the Art Institute.
**1920** First trip to Europe, where he encounters European art.
**1924** Lives in Cedar Rapids, gaining several public commissions there.
**1930** *American Gothic* exhibited.
**1932** Becomes a co-founder of the Stone City Art Colony.
**1934** Teaches painting at the University of Iowa.
**1942** Dies 12 February in hospital of the University of Iowa.

left page:
Grant Wood, *American Gothic*, 1930, oil on hardboard, 74.3 x 62.4 cm, Art Institute of Chicago

above:
Grant Wood photographed c. 1926, Cedar Rapids Museum of Art Archives

**RENÉ MAGRITTE**

**GIORGIO DE CHIRICO**

**JOAN MIRÓ**

**1871** Charles Darwin writes
*The Descent of Man*

**1900** Freud publishes *Die Traumdeutung*
(Interpretation of Dreams)

**1912** The *Titanic* sinks on
its maiden voyage

**1914** Assassination of Archduke Franz
Ferdinand of Austria in Sarajevo
triggers outbreak of World War I

**1918** End of World War I

| 1845 | 1850 | 1855 | 1860 | 1865 | 1870 | 1875 | 1880 | 1885 | 1890 | 1895 | 1900 | 1905 | 1910 | 1915 | 1920 | 1925 | 1930 |

Salvador Dalí, *The Persistence of Memory*,
1931, oil on canvas, 24 x 33 cm, Museum
of Modern Art, New York

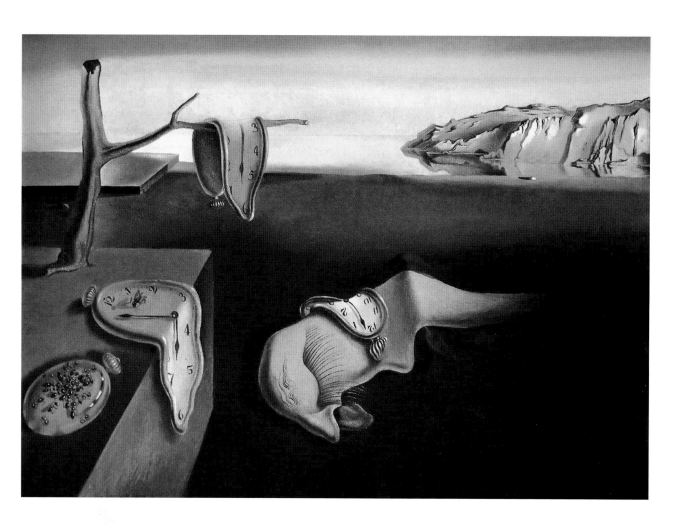

SALVADOR DALÍ

# THE PERSISTENCE OF MEMORY

*Whatever theories are produced to "explain" Salvador Dalí's famous* The Persistence of Memory, *it remains one of the quintessential images of Dalí and Surrealism—bizarre, elusive and disturbing, but also haunting and utterly compelling.*

"The difference between a madman and me is that I am not mad." Salvador Dali

The year before he painted *The Persistence of Memory*, one of his most famous paintings, Dalí had begun to experiment with what he called his "para-noiac-critical method" of painting, which involved self-induced psychotic hallucinations. These in part account for the fantastic, surreal and often disturb-ing content of his works, which tap deep into the sub-conscious psyche. According to the artist, how-ever, his chief inspiration for *The Persistence of Memory* was an over ripe Camembert cheese. Having studied the soft and pliable form of the cheese at length he returned to a previously unfinished canvas depicting the glassy cliffs of his Catalonian coast-line, and within two hours had devised his melting clock motif and had also added the recumbent, flesh-pink form. This monstrous creature is a pas-tiche of the artist's profile, with long insect-like eye-lashes and a penile projection emerging from the nose; it is reminiscent of the self-portrait that appears in his *Great Masturbator* (1929). Later Dalí described painting *The Persistence of Memory* with "the most imperialist fury of precision," in order "to systematize confusion and thus to help discredit completely the world of reality."

This is a desolate and nightmarish landscape that swings between the surrealism of its elements and the realism of the coastal scenery in the background, thereby encompassing a world of two halves. It is arguably this sense of part identification with reality that makes the image so disturbing. Dalí was fascinated with melting or amoebic-like forms, which reappear frequently in his paintings, as in *The Rotting Donkey* (1928) and *Daddy Longlegs of the Evening—Hope!* (1940), but nowhere with such force as in this image of melting clocks. Their interpretation, and indeed the interpretation of *The Persistence of Memory* as a whole, is open to debate, with the painting causing some excitement within the ranks

of contemporary psychiatrists, though they too were unable to form a definitive interpretation. Most obviously the clocks, limp and flaccid, and draped across a barren tree branch, an architectural block and the fleshy form, are resonantly sexual in their significance, suggesting both sexual impotence and man's powerlessness against the inevitable decay of time. With their faces reflecting time stopped at different hours, the clocks underline a sense of time-lessness, which emphasizes the frozen and dream-like quality of the scene. The fourth clock is lying face down, its back swarming with ants, which were another motif frequently used by Dalí, notably in works such as *Autumnal Cannibalism* (1936) and *The Surrealist Mystery of New York* (1935). The ants also represent decay, and congregate with a hungry fas-cination on the gold watch, which in turn has an organic presence.

An alternative interpretation of the painting sug-gests that the clocks are symbolic of Dalí's personal efforts to defeat time by creating an image which, by persisting unchanged, marks man's triumph over death and decay—an interpretation that contrasts with the familiar symbolism of clock, which are generally seen as symbols of the passing of time and therefore the transience of life. This inverted interpretation sees the painting as a monument to the artist's concept of decay, and it is indeed an image that once seen burns into the memory with infinite persistence.

The painting was first shown at an exhibition at the Pierre Colle Gallery in Paris in 1931, but raised little enthusiasm and remained unsold. It was bought by the American dealer Julien Levy after the show closed and taken to New York, where it became an instant success when exhibited at the *Surréalisme* show at the Julien Levy Gallery in 1932. The following year it was bought by Mrs Stanley B. Resor, who donated it to the Museum of Modern Art, New York, in 1934.

1904 Born 11 May in Figueras, Spain.
1921 Starts at the art academy in Madrid but drops out.
1928 Meets Gala, who is still married to Surrealist poet Paul Eluard.
1930 He and Gala settle in Port Lligat.
1935 André Breton throws Dalí out of the Surrealists.
1940 He and Gala go into exile in the USA for eight years.
1958 They finally marry.
1971 The Dalí Museum opens in Cleveland, though in 1982 it moves to Florida.
1972 Designs wall and ceiling paintings for Gala's mansion in Púbol.
1974 Teatro-Museo Dalí opens in Figueras.
1982 Gala dies in Púbol.
1989 Dies 23 January in Figueras.

Salvador Dalí photographed as a magician, November 1963

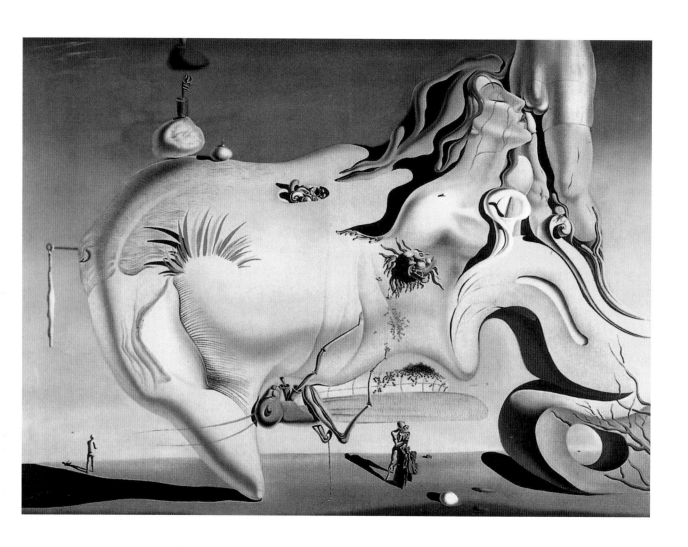

Salvador Dalí, *Great Masturbator*, 1929,
oil on canvas, 110 x 150 cm, Museo
Nacional Centro de Arte Reina Sofía,
Madrid

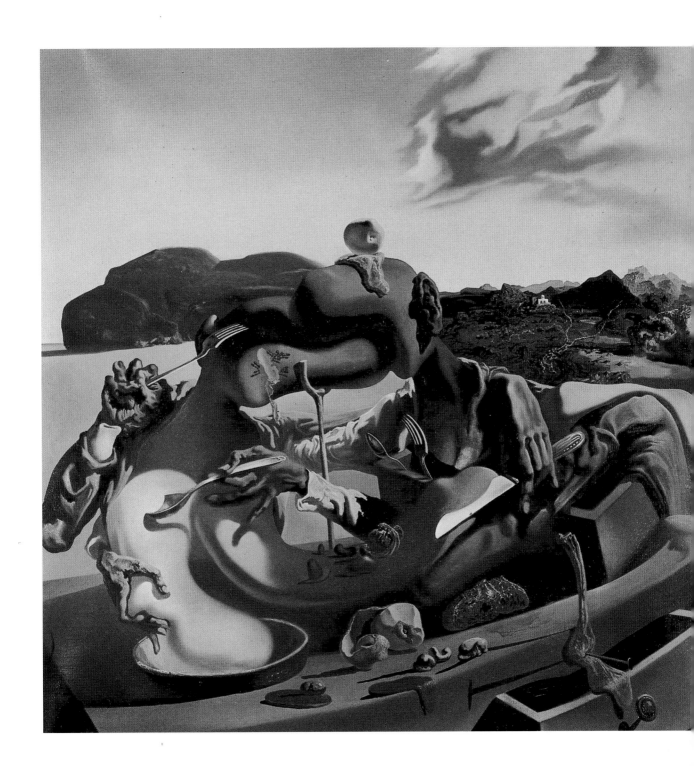

**1848** Karl Marx and Friedrich Engels publish
their communist manifesto

**1879** *Leon Trotsky

**1882** *Virginia Woolf

**1907** Picasso's *Les Demoiselles d'Avignon*

**1917** November Revolution
in Russia

1845  1850  1855  1860  1865  1870  1875  1880  1885  1890  1895  1900  1905  1910  1915  1920  1925  1930

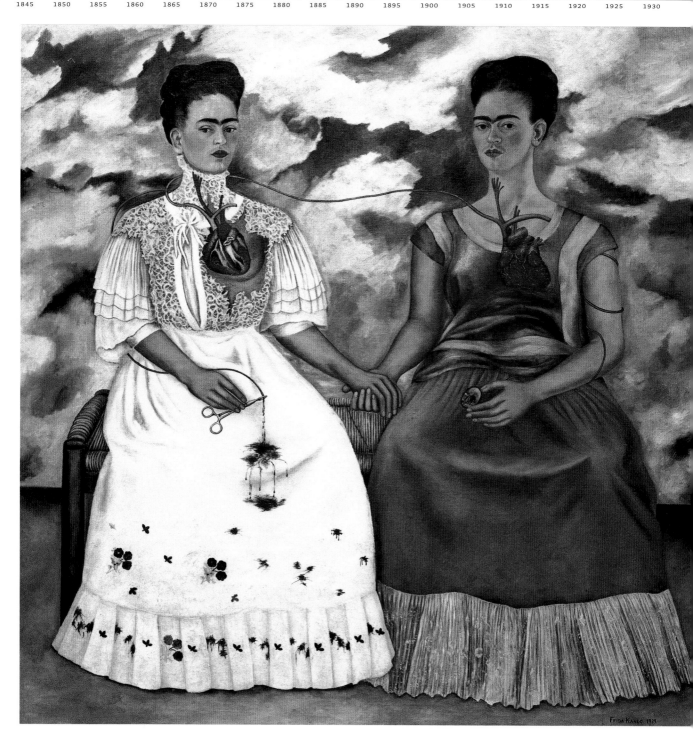

**1945** Beginning of Cold War

**1929** Stock Exchange crash heralds
world economic crisis

**1939–1945** World War II

**1983** Founding of the EZLN (Zapatista Army
of National Liberation) in Mexico

**1994** Nelson Mandela elected first black
president of South Africa

1935   1940   1945   1950   1955   1960   1965   1970   1975   1980   1985   1990   1995   2000   2005   2010   2015   2020

FRIDA KAHLO

# THE TWO FRIDAS

*The proud face of Frida Kahlo is very well known, as are her physical frailties, which formed the subject of her paintings time and again. The fame and myth surrounding her personality remain intact—feminists or fashion designers, they are all willing to claim her for themselves. She herself laid the foundations for this cult status.*

Fascinated by herself and her situation—as a woman, an artist, and the victim of a cruel accident—Frida Kahlo painted many self-portraits. They were her special subject. In this enigmatic picture, we literally get two views of her. She holds her own hand, and the two hearts are joined together to make a single circulation system.

Showing herself twice enabled her to have a kind of dialogue with herself, but the viewer gets only a coded version of it. The two Fridas sit next to each other on an upholstered seat looking at us stoically, against the backdrop of a turbulent, cloudy sky. They are dressed differently, one in a white, high-necked lace dress with a floral hem, the other in a plain two-piece outfit of different colors. Some interpreters have taken the first to be European dress, the second Mexican (she was of mixed European and Mexican descent). Whether this interpretation is correct is open to question. The great difference between the two Fridas lies more in the other details. Both of them have their heart exposed, but the heart on the left is cut open and sectioned. Blood drips red on the white dress from a still bleeding though clamped vein, the bloodstains matching the little red floral sprigs of the hem. The Frida on the right holds a medallion in her hand showing her husband Diego Rivera, with whom she had an intense and difficult relationship. Frida Kahlo confessed that as a child she had invented an imaginary friend who stood by her whenever difficult situations cropped up. From early childhood this friend always turned up whenever Frida wanted, and Frida could share everything with her. There are various clues to the deeply divided personality of the artist, who frequently dramatized the events of her troubled life. At one end of the circulation stands Rivera, at the other end a medical clamp that she herself operates. In this way, she questions the origin of her impulses and her control over herself, and indeed her destiny. The cryptic self-representation also leads to the assumption that Frida Kahlo had

an unclear perception of herself. When she painted this double self-portrait, she was divorce from Diego Rivera, who was twenty years older, charismatic and notoriously unfaithful. Is this why there is a clamped gap in her circulation? Kahlo bound her life to him in extreme fashion, and later married him a second time. One of the great themes of this painting is how important for her life this relationship was. She wrote to Diego: "My blood is the miracle that travels in the veins of the air from my heart to yours."

**1907** Born Magdalena Carmen Frida Kahlo y Calderón in Coyoacán 6 July near Mexico City.
**1913** Contracts polio.
**1925** Seriously and permanently injured in a bus accident, she abandons her medical studies to become an artist.
**1929** Marries painter Diego Rivera. Ten years later, they divorce, then remarry the following year.
**1938** An exhibition in New York brings her breakthrough as a painter.
**1939** Paints *The Two Fridas*.
**1944** Paints *The Broken Column*.
**1954** Dies 13 July in Coyoacán.

left page:
Frida Kahlo, *The Two Fridas*, 1939, oil on canvas, 173.5 x 173 cm, Museo de Arte Moderno, Mexico City

above:
Nicholas Murray, *Frida Kahlo*, photograph c. 1938/39

**1886** Statue of Liberty erected
in port of New York

**1903** Henry Ford founds the Ford Motor
Company in Detroit

**1925** F. Scott Fitzgerald publishes
*The Great Gatsby*

**1920–1933** Prohibition
in the USA

**1929** Stock market crash heralds
world economic crisis

1855  1860  1865  1870  1875  1880  1885  1890  1895  1900  1905  1910  1915  1920  1925  1930  1935  1940

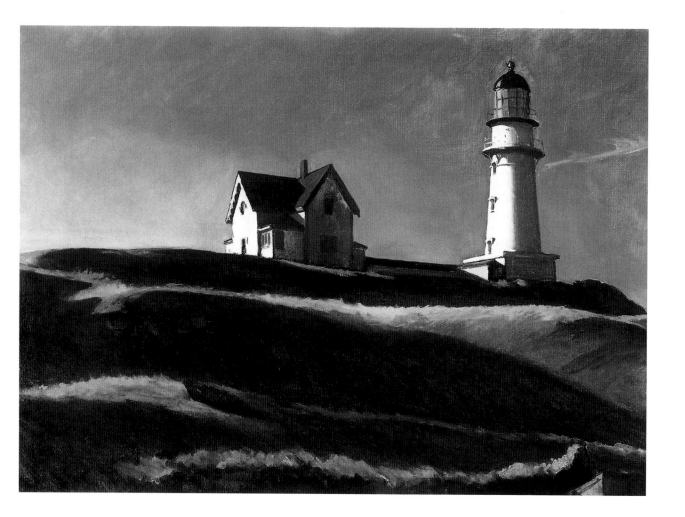

Edward Hopper, *Lighthouse Hill*, 1927,
oil on canvas, 73.8 x 102.2 cm, Dallas
Museum of Art, Texas

EDWARD HOPPER

# NIGHTHAWKS

*Though it may look like a film poster for a classic American film noir,* Nighthawks *has nothing to do with the cinema. If it seems familiar, it's probably because it is one of the most famous American paintings of the 20th century, and has enjoyed huge popularity as a poster.*

Edward Hopper's images are like photos of the everyday life and landscapes of the USA during the first half of the 20th century. There's a great quality of stillness to them: they are situations without a clear story, in which people are waiting; there is no interaction between them, and no one says anything. The same applies to this scene, set in an all-night diner. Three guests have ended up at the counter, which has been cleared. A solitary man sits with his back to the window, while on the other side a man stares in front of him, taking no notice of the woman in the red dress sitting beside him, who gazes at the cigarette in her hand. Behind the counter the white-coated barman clears up, his hands out of sight. The diner is filled with a bright neon light that spills out onto the sidewalk and even the buildings opposite. There is no other sign of life in this nocturnal city scene. From the viewer's point of view, the four people look as though they are in an aquarium, separated from us by huge sheets of glass: they seem isolated and inaccessible. There are no sources of noise in the picture, either: perhaps the silence inside is deafening.

This silence and the frozen immobility of the characters have a disconcerting effect. Our imaginations are stirred, and we can make up our own stories about the group, about the story so far and what will happen next. What brought them all here and what will happen next? Have they spent the whole evening here, or did they drop in, restless and unable to sleep, for a last drink? Will they all go home separately, never to meet again? The painting provides no clues. But as this is a scene from everyday life, it is not difficult to imagine oneself in the role of one of the figures seated at the bar, or as a nocturnal walker catching sight of the brightly lit interior, as if in a film.

Hopper himself was not very communicative; an acquaintance once remarked it really was an understatement to call him a quiet man. He used to roam the streets of New York by himself, forever finding new situations as motifs for his paintings. He

himself, his wife, and their friends modeled for the figures. His silent and static scenes take place in a typically American world: a world of gas stations, diners, hotel rooms, cinemas. Artificial light often gives the scenes a special atmosphere and occasionally lends the faces an additional hardness that emphasizes contours and shadows with its cold light. This atmosphere corresponds to the theme that Hopper returned to again and again—man left to himself and thinking about his life in silence.

1882 Born 22 July in Nyack, New York.
1901 Trains as an illustrator at the New York School of Art.
1906 Travels to Europe for the first time.
1913 Moves into a studio in Greenwich Village in New York.
1924 Marries Josephine Nivison and makes a living from painting.
1933 First great retrospective at the Museum of Modern Art in New York.
1950 His work is presented at the Whitney Museum in New York.
1967 Dies 15 May in New York.

Edward Hopper photographed in Cape Elizabeth, Maine, 1927

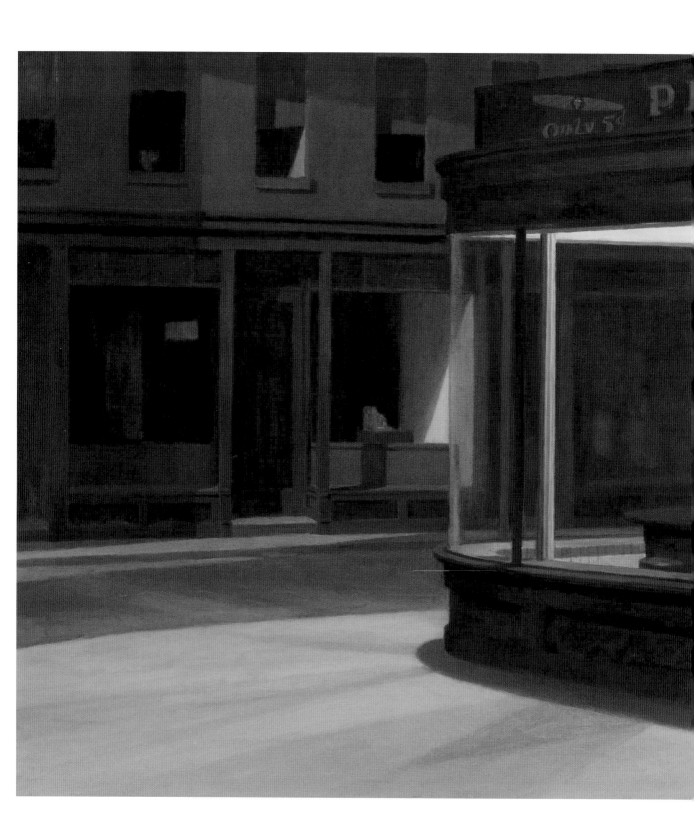

Edward Hopper, *Nighthawks*, 1942,
oil on canvas, 84.1 x 152.4 cm,
Art Institute of Chicago

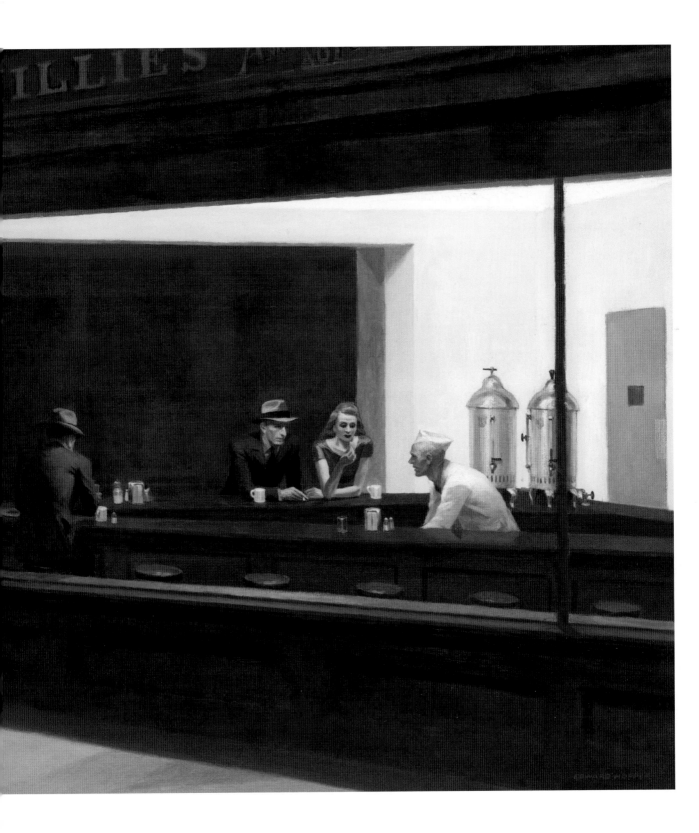

BARNETT NEWMAN

PHILIP GUSTON

JASPER JOHNS

**1911** Rutherford develops his
model of the atom

**1939–1945** World War II

**1914–1918** World War I

**1937** Picasso's *Guernica*

**1945** Atom bombs
dropped on
Hiroshima and
Nagasaki

1865  1870  1875  1880  1885  1890  1895  1900  1905  1910  1915  1920  1925  1930  1935  1940  1945  1950

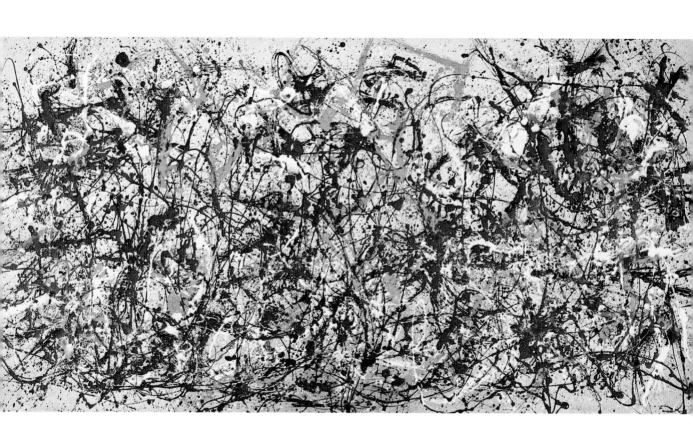

Jackson Pollock, *Autumn Rhythm No. 30*,
1950, oil on canvas, 270.51 x 538.48 cm,
Metropolitan Museum of Art, New York,
George A. Hearn Fund, 1957

**1969** Neil Armstrong lands on the moon    **1989** Massacre in Tiananmen Square, Peking

**1965–1975** Vietnam War

**1974** Punk band Ramones founded    **2001** Terrorist attacks on World Trade Center (9/11)

| 1955 | 1960 | 1965 | 1970 | 1975 | 1980 | 1985 | 1990 | 1995 | 2000 | 2005 | 2010 | 2015 | 2020 | 2025 | 2030 | 2035 | 2040 |

JACKSON POLLOCK

# AUTUMN RHYTHM NO. 30

*Pollock was a legend even in his lifetime. He was photographed and filmed at work. Life magazine wondered aloud in its columns in 1949, when Pollock was only thirty-seven years old, whether he might possibly be the greatest living artist in the USA. His death at the age of forty-four in an automobile accident helped to fix his image.*

The large canvas with a poetic title *Autumn Rhythm No. 30* dates from October 1950. White, brown, and turquoise lines form an impenetrable weave on a gray background. Despite the apparent randomness of the image, it has a balanced and carefully modulated composition. The abstract linear formations were the result of actions that were a fine balance between randomness and control.

The work was produced not with the canvas on a stretcher as in traditional painting but with it flat on the floor. A background pattern was applied as a first stage: lines in black, which were then thinned and extended. Pollock then added to this background a fine network of trails of paint—curved and straight, dotted and continuous, thick and thin. The arrangement is only partly random, and is so individual (like handwriting) that critics assert it is impossible to imitate a work of Pollock.

The name Jackson Pollock is generally mentioned in the same breath as the term "Action Painting." The action referred to is the physical activity of the painter, which is an integral part of the creative process. As a technique, it is a long way from the classic situation of the painter standing at his easel. Pollock applied paint (and occasionally other materials such as sand) with a variety of gestures, which rarely include brushstrokes. The physical action is an important element here, as it sets the rhythm of the whole thing. The paint was dripped, poured, thrown and hurled, producing a fascinatingly abstract and at the same time a very expressive look. As the technique was also known as "drip painting," one witty critic accordingly nicknamed Pollock "Jack the Dripper."

Pollock himself said that he preferred to express his feelings rather than illustrate them, and that "the modern painter cannot express his age, the airplane, the atom bomb, the radio, in the old forms of the Renaissance or of any other past culture. Each age finds its own technique."

Contemporary critics were not agreed about the meaning of Pollock's work. One of the main questions was whether the formal structure or the creative act is the key element of any work. What seems more important is that the artist developed a visual idiom that he felt was appropriate for the period after World War II, and it was one that proved very influential.

Thanks to the shock that his pictures caused, the strategic support of the wealthy collector Peggy Guggenheim, and also his forceful personality, Pollock became a real star. Not many artists can claim to have invented a completely new genre of painting. In Pollock's case, it is true. His wife, painter Lee Krasner, said that his paintings were like monumental drawings, or paintings that had the directness of drawing—either way, a completely new category. Pollack himself remarked he painted what he was.

**1912** Born 28 January in Cody, Wyoming.
**1928** Goes to Manual Arts High School in Los Angeles.
**1930** Moves to New York and studies there at the Art Students League.
**1936** Learns wall-painting techniques from David Alfaro Siqueiros.
**1943** First solo exhibition at the Peggy Guggenheim gallery.
**1945** Marries painter Lee Krasner and moves with her to Springs, Long Island. There he develops his own technique.
**1956** Dies 11 August in an automobile crash on Long Island.

Jackson Pollock, photograph c. 1955/56

KASIMIR MALEWITSCH

BARNETT NEWMAN

**1928** Alexander Fleming
discovers penicillin

**1945** Liberation of Auschwitz
concentration camp

**1922** Einstein awarded the
Nobel Prize for Physics

**1941** Japanese attack
Pearl Harbour

**1948** UN general assem-
bly's Declaration of
Human Rights

1870  1875  1880  1885  1890  1895  1900  1905  1910  1915  1920  1925  1930  1935  1940  1945  1950  1955

Mark Rothko, *Black on Maroon*,
1958–1959, oil on canvas,
266.5 x 366 cm, Tate Gallery, London

| 1960 | 1965 | 1970 | 1975 | 1980 | 1985 | 1990 | 1995 | 2000 | 2005 | 2010 | 2015 | 2020 | 2025 | 2030 | 2035 | 2040 | 2045 |

MARK ROTHKO

# BLACK ON MAROON

*Mark Rothko failed completely in his commission to provide paintings for an elegant restaurant in the new Seagram Building in New York—but in the process of painting the huge canvases he created works of extraordinary depth and beauty that are among his greatest achievements.*

In 1958 the celebrated Abstract Expressionist Mark Rothko began work on a commission that was potentially the most prestigious of his life, but it ended in bitter acrimony just one year later. The project was to provide wall decoration in the form of murals for the Four Seasons Restaurant in the newly built, and very prestigious, Seagrams Building. Designed by the celebrated architect Mies van der Rohe (1886–1969), this building was the pinnacle of New York accomplishment in the 1950s, a shining, crystalline monument to the progress of post-war corporate America. The restaurant matched the building in opulence, and was designed to provide the ultimate dining experience, with its lavish food and its exquisite surroundings decorated with a magnificent collection of fine art. Rothko, as the leading artist of his time, was suggested as the perfect choice to provide the art works, and an understanding was reached between him and the two designers, Phyllis Lambert and Philip Johnson. Between 1958 and 1959 Rothko produced thirty paintings for the architectural space, of which the brooding and resonantly introspective *Black on Maroon* is one.

Representing the artist's mature style, which had evolved with such intensity since his early works like *Subway (Subterranean Fantasy)* (c. 1936), these works are difficult to interpret; they demand time, attention and patient contemplation. They resonate with somber color and intense feeling, their size seeming to encompass the viewer with a strong magnetic force. Their inspiration lay, according to the artist, in his subconscious recollection of a visit he had once made to Michelangelo's Laurentian Library (c. 1524–1526) in Florence, notably of the cloister of the neighboring church of San Lorenzo in Florence. For Rothko the sense of oppression created by Michelangelo's building matched the somber vault-like effect he sought. Later, when confiding to the journalist John Fischer, he recounted that he wished to make the viewers of these works feel as though they were trapped in a room with no escape. This aim was hardly appropriate for restaurant decoration, and the paintings never come to grace the walls of the exclusive Four Seasons. In 1959 Rothko suddenly withdrew from the commission, paying back his fees and keeping the paintings, nine of which he subsequently gave as a gift to the Tate Modern, London.

There has been much debate over the precise circumstances of Rothko's withdrawal from the commission. Lack of communication certainly played a role: some accounts of the events suggest Rothko was unaware that the works were for the elegant and elitist restaurant, and believed them to be intended for a room more accessible to the public at large. This has been hotly disputed, however. Rothko himself explained to Fischer, whom he met on an ocean liner crossing the Atlantic in 1959, that he considered the restaurant "a place where the richest bastards in New York will come to feed and show off," going on to state that he hoped to "ruin the appetite of every son of a bitch who ever eats in that room." It is clear that the murals he produced were totally alien to the restaurant space for which they were initially destined—but also that are brilliantly evocative and deeply moving in the right context.

1903 Born Marcus Rothkovitz 25 September in Dvinsk, Latvia (then part of the Russian Empire).
1912–1913 His family emigrate to the USA and settle in Portland, Oregon.
1921–1923 Attends Yale University, New Haven.
1923 Settles in New York.
1932 Marries Edith Sarah.
1938 Takes US citizenship.
1945 Marries for a second time, to Mell Beistle.
1964 Commissioned to paint a chapel in Houston, Texas.
1970 Commits suicide 25 February in New York.

Mark Rothko photographed in front of *No. 7*, 1961

ROY LICHTENSTEIN

**1903** Kraft Foods founded in Chicago

**1886** Statue of Liberty erected
in port of New York

**1908** First Model T rolls off assembly line in Detroit

**1914–1918** World War I

**1937** Exhibition of "Degenerate Art" in Munich

**1944** Allied forces land in
Normandy (D-Day)

**1945** Beginning of Cold War

**1950** Suspension
of racial
segregation
in USA

| 1875 | 1880 | 1885 | 1890 | 1895 | 1900 | 1905 | 1910 | 1915 | 1920 | 1925 | 1930 | 1935 | 1940 | 1945 | 1950 | 1955 | 1960 |

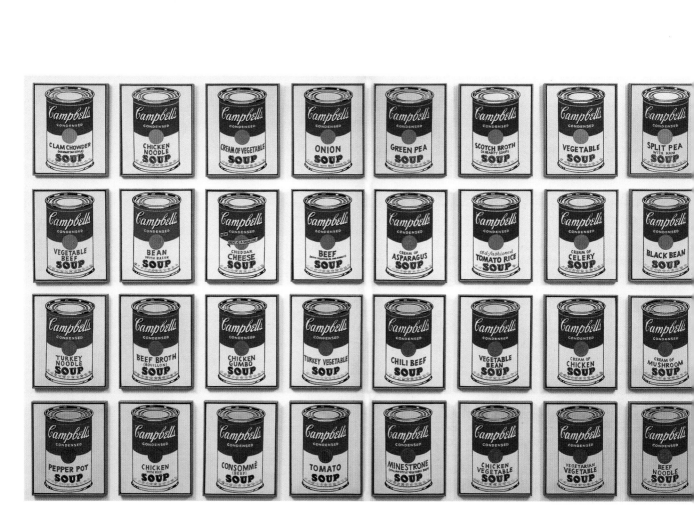

Andy Warhol, *Campbell's Soup Cans*, 1962,
32 silkscreen prints, each 50.8 x 40.6 cm,
Museum of Modern Art, New York

ANDY WARHOL

# CAMPBELL'S SOUP CANS

*Probably the best-known representative of American Pop Art, Andy Warhol created a potent symbol with his picture of tins of Campbell's Soup, reflecting a society immersed in advertising images. Some commentators consider the soup-tin motif the most famous image in American art.*

All varieties on offer by the Campbell Soup Company in 1962 are shown on 32 canvases. The soup tins are depicted larger than life, two-dimensional, and without any context.

Warhol is said to have asked an acquaintance to suggest something to paint, and been told to paint what he saw. As Campbell's soup tins were something he saw every day, they seemed an obvious choice. The red-and-white, easily recognizable label represented products of the beautiful colorful world of consumer goods available in America in the 1960s. We can only speculate as to whether he really had such a fervent taste for the soups as he sometimes claimed. Perhaps there was a certain nostalgia associated with the product.

Although on their first showing they were present as if on sales shelves, the cans have been removed from the consumer context. Of course, the reference to the latter is all too obvious, which is why they were called an "American industrial still life." Conversely, as works of art—since that is how Warhol presented them—they also refer to the art world, which is thereby invaded by a mass-produced article that cannot carry any kind of elitist association. With the halls of the sacred muses thus under attack from everyday products (albeit in defamiliarized form), Pop artists drew attention to the discrepancy between high art and popular culture, and endeavored to eliminate it at a stroke.

The subversion affects not just the traditional cultural rating of visual products on the principle of art versus commerce but also ironically exposes the principles of a society accustomed to the mass media and mass products. Given that art had long been the domain principally of religious subjects, possibly Warhol's works suggest that consumerism is the true religion of America.

Andy Warhol originally worked in advertising and so was familiar with the mechanisms of product marketing. In subsequent years, he turned his workshop (which significantly he called the "Factory") over to producing whole series of images of everyday subjects—consumer products, banknotes, or photos from newspapers and magazines—as silkscreen prints. He even marketed himself as a pop product along with his works. With his insistence on repetition instead of originality, surface instead of hidden depths, serial production instead of uniqueness, Warhol thoroughly undermined the whole definition of art and the art trade. His workshop was not an ivory tower but indeed a factory—and yet a factory that was the haunt of artists, stars and starlets.

As he himself asserted, he wanted above all to be famous. As a glittering personality on the New York art and social scene, he managed this for more than the much-quoted fifteen minutes that he predicted for everyone.

1928 Born Andrew Warhola 6 August in Pittsburgh, Pennsylvania.
1945 Becomes a student at the Carnegie Institute of Technology.
1949 Moves to New York, where he has great success as a commercial artist.
1960 Begins to use comics and adverts in his work.
1962 Renames his studio the Factory, which becomes popular with the social set. Holds his first solo exhibition in Los Angeles.
1968 Narrowly escapes being murdered by radical feminist Valerie Solanas but is permanently injured.
1987 Dies 22 February in New York.

Andy Warhol, photograph